CHRIS PACKHAM

100 THINGS THAT CAUGHT MY EYE

BLINK
bringing you closer

BLINK
bringing you closer

Published by Blink Publishing
Deepdene Lodge
Deepdene Avenue
Dorking RH5 4AT, UK

www.blinkpublishing.co.uk

www.facebook.com/blinkpublishing f
twitter.com/blinkpublishing E

ISBN: 978-1-90582-583-7

...tion

...rm

...able

Design by www.envydesign.co.uk

Printed and bound in the United Kingdom by
Butler, Tanner & Dennis Ltd

Colour reproduction by Aylesbury Studios Ltd.

1 3 5 7 9 10 8 6 4 2

Papers used by Blink Publishing are natural,
recyclable products made from wood grown
in sustainable forests. The manufacturing
processes conform to the environmental
regulations of the country of origin.

Blink Publishing is an imprint of the
Bonnier Publishing Group
www.bonnierpublishing.co.uk

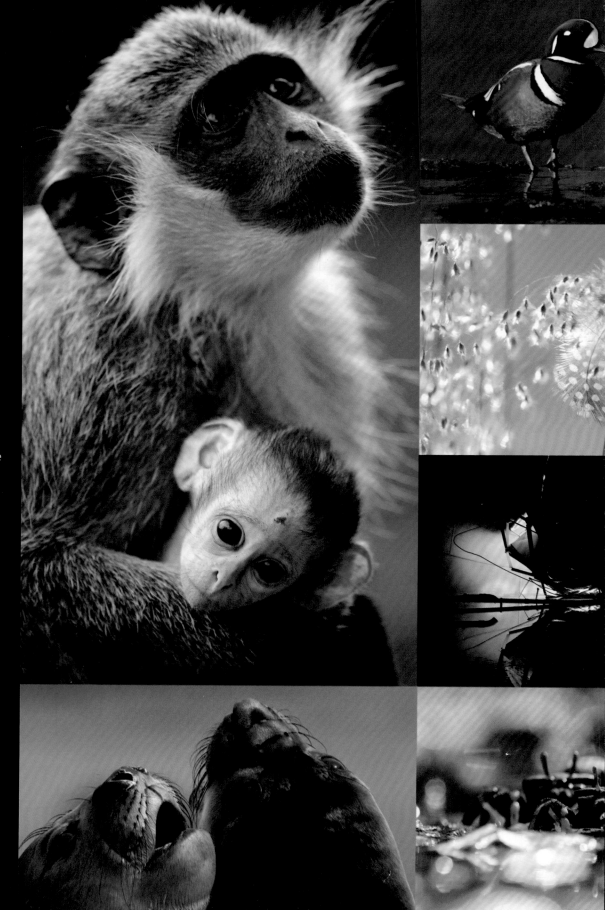

CONTENTS

INTRODUCTION
100 THINGS THAT CAUGHT MY EYE

Taking a photograph is incredibly easy these days, we just press the shutter button to exact our power to preserve a moment of time forever. Actually it's possibly too easy, maybe even too cheap, so close to costless that it divorces the practice from serious contemplation for the vast majority of exposures we make. We snap away because we can, and perhaps this instils a mental and moral laziness from the time we first pick up a camera. Without doubt contemporary photographic equipment is phenomenally forgiving, it can make so many accurate and essential decisions for us that many people never take the trouble to understand the principles behind the technology. Combined, I think these factors are real handicaps to those who wish to raise their game and improve the standard of photographs they take. Because for all its implied ease, taking a great photograph is almost impossibly difficult.

But then I'm not sneering at snaps because sometimes when we pick up a camera we don't need to achieve greatness, we just need a 'snap' to preserve a personal moment – a child's birthday or a great night out. The resulting image will lie in a drawer or a hard-drive until we retrieve it for a nostalgic chuckle years hence. Its technical quality, composition, overall artistic attributes are and will be forever irrelevant. It's just a snap, which is fine. But what if at the point of collection we try just a little bit harder – move a little so the smoking candles are not sticking up little Jimmy's nose or that man who is nothing to do with your revelry is not leering in the corner of the frame – then we might produce a better image, a photograph. Properly exposed, well framed, sharp, balanced and with a pleasing composition, this may find its way into a frame on your sideboard. It's still very personal, it wouldn't excite or interest me or anyone else who doesn't know those featured, but it's a definite step up in the quality scale and not too difficult to achieve with a bit of practice and a modicum of technique. Unfortunately, the next rung requires a quantum leap in ability and intent, and moving from photograph to a picture is very difficult. It is the goal of any serious photographer so although many aspire, few succeed. A picture is something that I would instantly admire, even if it featured your drunken chums; it would have the ability to communicate something unique and personal to all who see it and would be the product of your examination of a moment and your individual creative response to it. The picture would

be eye-catching, powerful, beautiful; it would elicit a reaction from others; it would make them think of something. And most important and difficult of all it would be something new, something never seen before, all aspects which are quite obviously far from easily achieved.

The most common mistakes photographers make when they set off to make pictures are a pre-occupation with equipment and technique; thinking that being in the right time and place will just happen one day; that it's a mechanical process involving the camera as a tool; that you can learn it as you might learn to ride a bicycle; that by reading books or attending seminars you will improve your success rate or that you have already cracked it. I'm afraid it's none of the above; making great pictures requires the mind, not just the knowledge of science or of which lens does what, but that part of the brain which feels for the picture, learns how to see it coming and then in that critical instant makes all the decisions from the heart, because as Antoine de Saint-Exupéry said in *The Little Prince*, 'it is only with the heart that one can see rightly, what is essential is invisible to the eye'. So no book of technique will help you, that type of advice has to be far behind you when you are poised finger on button, this is just you, alone, at the only moment in all time when, if you feel it, the picture may be there. It's not spiritual, it's equally not scientific or empirical; it is artistic – that fusion of all disciplines which some of our species can manifest as a great gift.

In this book I am not going to patronise you with the idea that I can train you to find pictures. I'm not going to provide essays on 'Photographing Cathedrals' or 'Getting Better Photos of the Sea'. I'm equally not going to lecture on the attributes of the wide angle lens or shooting in low light. If you think this type of knowledge will help you then find it elsewhere because my objective is to get you to see and to feel for your ultimate image. To achieve this my technique is simple: I've chosen 100 of my own photographs, taken in 25 years of travelling, and I'm going to explain in an accompanying 500 word caption why I made the picture and in most cases I'm going to candidly murder the result. I don't like my own work, I don't think I'm a good photographer, certainly some of these photos are not much cop, but that's not the point. This is not about me showing off, pretending I have all the answers; this is just me being open and honest about my desire to get my idea of the perfect picture, to do something new, to finally maybe think I may have come close in that quest. So some images have been chosen just to make points, highlight their or my inadequacies whilst others I hope will make you think 'I could have/will try that' or 'not bad, but I could do it better'. Some of the captions have a traditional photographic content, one or two even mention equipment; some are pure critiques but others may initially strike you as abstract, even confusing and out of place, particularly those which are like travelogues or even fictional essays. But I've tried to use this spread of devices to get you

into my mind as it was when I was thinking about or making the photograph, to allow you to see what I was able to at the time or feel what made me make the decisions which led to the picture.

In terms of a narrative I have tried to weave a visual thread through a number of topics, subjects or approaches rather than let the philosophy or any geography or chronology lead the choice of pictures or their order. I have tried to exclude any repetition which is quite difficult as some concepts are frequently of significance and have had to accept that some of the singularly most important ideas are not allowed any real prominence of order. Thus this is not a book that you need to study from beginning to end in order, there is no epiphany at its conclusion; it is, I think, best dipped into and considered a picture and a caption at a time.

I've chosen to use this collection of images from my expeditions to illustrate and discuss my various ideas because the vast majority of photographers take more photos when they travel. The attraction of novelty is undeniable for all of us and consequently stimulates our creative urges more generously than the everyday. It's sad but stopping familiarity from breeding contempt is very difficult. Exceptions include our personal passions which supply us with energy and enthusiasm to motivate our skills and visions. My particular genre is wildlife photography but as so many of the points I'm trying to make are very

fundamental I didn't want to isolate or expand on ideas which might only be applicable within this field, and because many of us are able to travel I hope the wider appeal and access of this subject area will be more inclusive.

Finally, I find taking pictures intensely frustrating. I would go so far as to say that I really don't enjoy the process at all, that the pain far outweighs any rare and fleeting pleasure. This is because I am a perfectionist so nothing but perfection would ever be good enough, but because I believe that true perfection is in fact unattainable you might well wonder why I bother. Very often so do I! But for me it's about the process of improvement, honing my skills to be just that little bit better next time; it's about trying to nudge my pictures ever closer to that ideal and, of course, any satisfaction would soon stifle that desire and cut off the constant fuel of failure which continues to drive my ambitions.

FORGET ME NOT
INDIA, 2006

'It's such a small eye for such a big animal' she said when I pointed the dusty little screen on the back of my camera at Megan, aged 11. Put like that it is undeniably true and I like the refreshing way children go straight for the jugular that runs from the heart to the fundamental, it betrays their raw perception and restricted ability to contaminate anything with wasteful complexity. I returned to the elephant and re-shot its eye, only this time much looser to reflect my young protégé's viewpoint. That the eye of these creatures, an eye which watches ages pass with steady attention and good vision, could be a mere pinhole into a possibly monstrous memory and to represent it as such definitely adds to its charm. Thanks Megs.

People like elephants because they so enthusiastically anthropomorphise them. We are excited by parallels between their existence and our own. It's true they live about as long as us (given the chance), they process a long gestation, and a long period of maturation necessitates a similarly protracted investment of parental care; we also know that they are sociable and live in relatively stable groups, that they care for one another and they have a broad ability to communicate using a wide repertoire of a

'language'. This, and more, causes some to eulogise almost spiritually about these creatures and for many others to constantly rank them amongst their favourite animals. But that, of course, is a 'western' perspective: if you have had your family's subsistence crops ravaged in minutes by a greedy herd of these mega-veggies then Nellie and Dumbo are not top of your pops. The individual pictured is a traditional 'beast of burden', a working elephant that was extremely well looked after and pampered, but not romanticised. Of course it had a name, which I can't recall – but I bet both the elephant and Megan can!

The photo, which unashamedly preys on the above affections, is also about texture: the close-up/abstract approach focuses upon the bristly sparse hairs, the pitted hide, the concentric chart of crinkles, the gloopy moisturising mud and the red dust on its crown. And set in its centre is that glassy globe which sees me crouching, ducking and diving to exclude my shadow and avoid its furtive and curious trunk. I like them too.

2

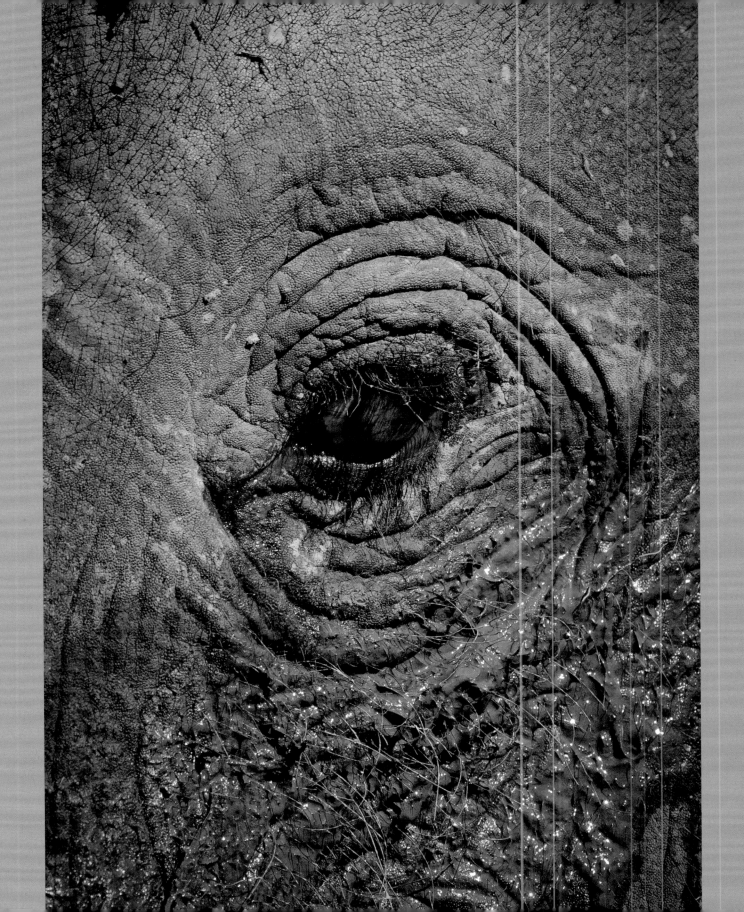

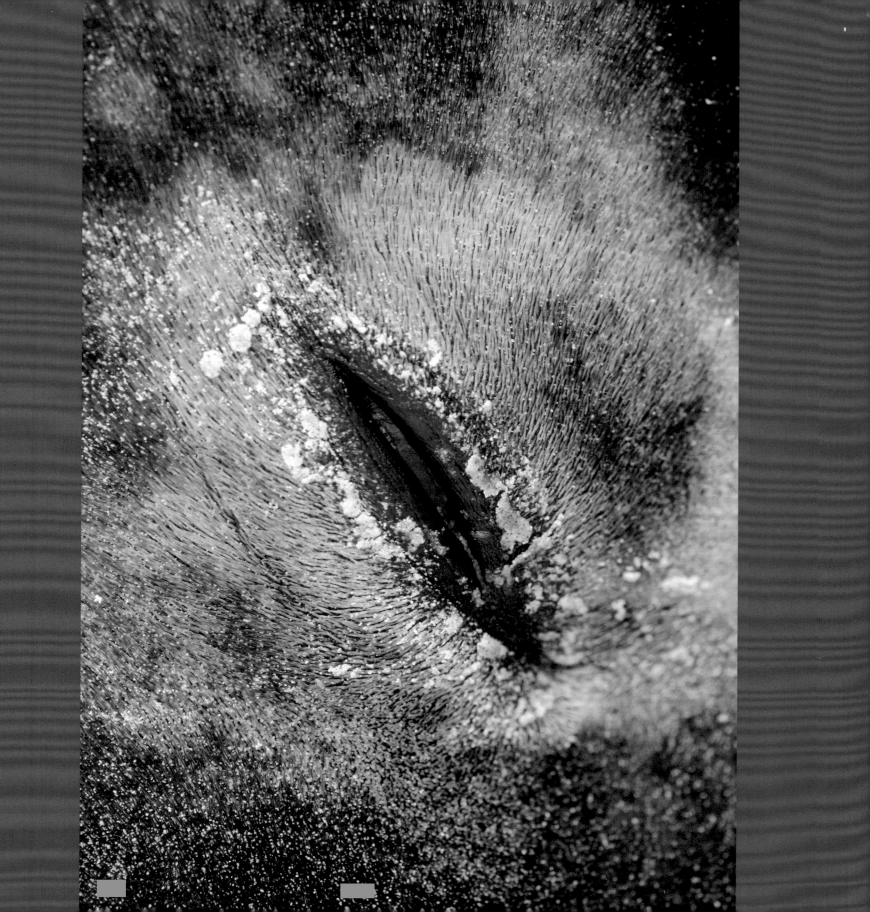

EYE SORE THIS
FALKLAND ISLES, 1995

This is the bruised and bloodshot eye of a bull elephant seal. More of a wound, a slash with sand in it, squinting in pain. It was that resonance of sharp discomfort that drew my eye to this one.

You see, our eyes are drawn to others. We focus upon them, gaze into them, search for truth. They are revealing, beautiful, varied and individual; they command our attention, some threaten us and others can melt our sensibilities. They are magical, mysterious, worshiped and evil. They are universally regarded, unique to animal life, complex and utterly invaluable organs. The eyes both have and give it. They translate reflected sunlight into images and we see them. We see! We can look, make real a world of phenomenal riches. Think about it – it's incredible.

When we make photographs we make permanent two dimensional representations of an infinitesimally small fraction of all the things we see in our lifetimes. There are 100 pictures in this book and they correspond to approximately less than ten seconds of my 47 years of looking. If we took out the three or four long exposures which give an unfair bias, the rest would equate to less than a second in time. So I've seen virtually all this in a sub-second of my existence. Thus when we push that button we have been tremendously selective, even the most prodigious photographers would only fill a few minutes with a life's work. To take pictures we have to learn to isolate those things which truly define our experiences, we need to train ourselves to see that clearly, to filter out the vast majority of clutter and focus on the minute moments that matter to us. We have to search for and find very special things and then we have to develop the skills required to catch them, fix them forever and sometimes make them special enough for other people to want to see what we have seen. It's not easy – many millions of people try and all but a few fail. But then these days with cameras so globally commonplace, competition among them to seize the eyes of the world and show them what they see is intense. To succeed you must therefore record extraordinary subjects from all the world's offerings, things which only you have seen and felt. To take truly great photographs that feeling has to be visible in them.

5

PEEPING LIZARD
ANTIGUA, 2008

On a searing Caribbean afternoon I wandered the streets with my telephoto wrapped in a polythene bag – its urban disguise – looking for some candid action. But nothing stirred, radios hummed out of focus tunes and a few manky cats peered from behind cracked shutters while everyone slept and sweated inside the pretty clapboard cottages. I sought my own refuge in the shade of the cavernous pitch pine cathedral and its glorious leafy grounds. The light was caustic, high, white and hot.

It was a walk going nowhere photographically until I spotted this Anole lizard on the churchyard railings. I tried lining all the iron rods up to make a graphic rusty grid and then began to chivvy the reluctant reptile into position. After ten minutes of craning, swearing and blaspheming, I got a snap. Nice-ish but never worth a second glance so I got a couple of mug shots, switched to the macro lens and went for a quick portrait just for something to do. But the super-fast subject was less congenial than the local people when it came to posing and it shot off down the fence. When I rounded the tree in determined pursuit this is what I saw. Well, of course my eyes saw a whole lot more, but this is what I found when

I looked deep and close into this part of the world, just the lizard's eye, glistening, fresh and brilliant with diamonds of that blasted sunlight.

Capturing it took another half an hour – trying to get the little chap to hide beneath the metalwork and only reveal his head was the key. I shot it on minimum aperture so that there was as little in focus as possible and used the metal spikes to blur out everything else. It came out a bit bluish so I warmed it up a little, not much, just enough to make that ring of yellow mascara really count. I don't like the scales beneath the eye which are still a bit 'sharpish'. I did try lowering the lens to hide them behind the fuzzy foreground but the eye went with them – a problem which could be rectified by Photoshop. I had intended the pupil to be right in the centre but it actually works better canted to one side on account of the angle of the animal's head. It's a bit of a something from nothing snap – bad light, no subjects, an unremarkable lizard scampering along a fence... I'd give it a three for effort and a three for the idea.

6

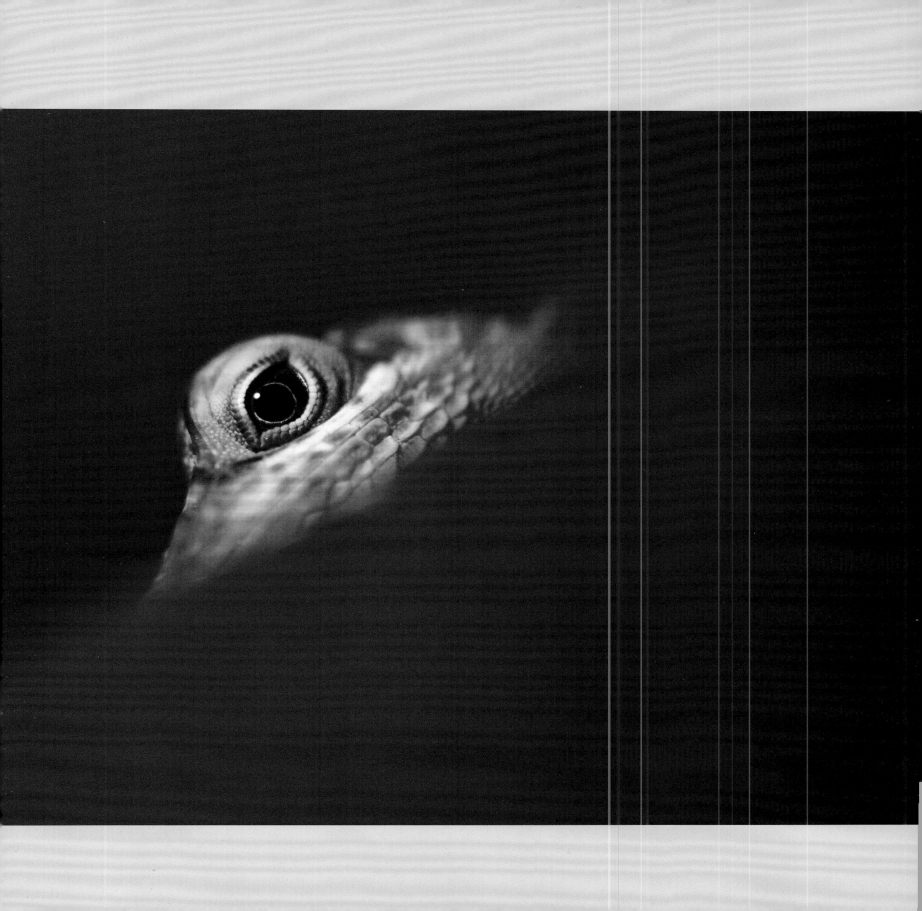

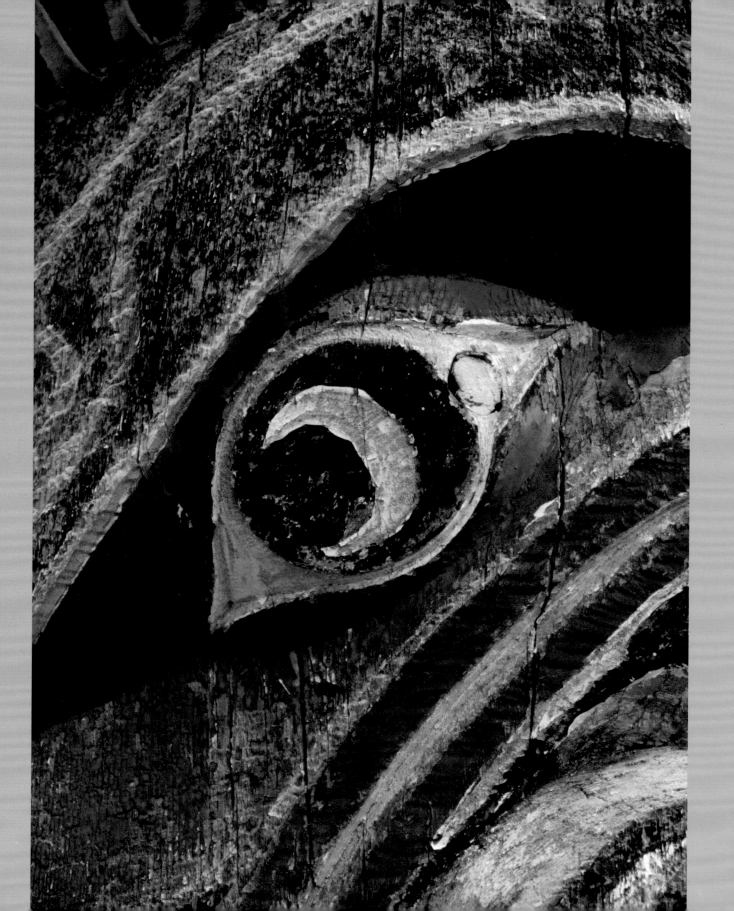

TOTEMIC SADNESS
CANADA, 1997

We are taught to think that the equatorial forests are the richest sources of life's diversity and that coral reefs are the most colourful marine environments. Of course the facts, the stats and the science is irrefutable, but a visit to the northern coast of British Columbia will challenge, at least subjectively, these preconceptions. The virgin forests, which appear vast, give an immediate sense of unspoiled wilderness; you can fantasise that your footfalls are human firsts as they plunge through the deep flora in the shadows of moss-clothed giant trees that have germinated in an age of legend. And the colours! Those pre-historic photographers still using Fujichrome will hurt their eyes when their little green boxes rattle onto the door mat. Lightroom's 'Saturation' tool is redundant for the rest of us. The density of the green is unreal. Wet, lush and unpolluted – and then you look over the side of the boat and you cannot believe your eyes as they gaze through the crystal water into a world crammed with brilliant living things – glowing. If I was looking for Nemo I'd check here!

We went north of Vancouver Island and explored some of the smaller islets. Things went a little downhill in terms of my mood when we kept finding old settlements in terminal decay and with them literally dozens of ancient totem poles. Bent over, split, crumbling and encrusted with lichens and ferns, lying fallen and forgotten, beautiful and important historical artefacts, discarded and dead. I was told about a totem pole museum so I went to try and find some excuses for the aforementioned neglect. On a bleak hillside a motley collection of poles stood between overgrown paths and one pathetic interpretation board, sun-bleached and indecipherable, was all that told of their past. There was a drop box but the leaflets were a mulch of papier-mâché . I took a few photos; I couldn't do 'wides' because the sky was bright white and featureless, so I went for details of their decrepitude and this paint-peeling specimen is one of the more colourful.

I read *Bury my Heart at Wounded Knee* and *The Conquistadors* by Hammond Innes in my late teens and was left confused about our hypocritical attitudes to genocides in the new world. It seems sad that some Canadians cannot summon much guilt and haven't the retrospective interest in the cultures they destroyed either.

GOLDEN EYES
NEPAL, 1997

The great temples of Kathmandu and its valley are, when all the coaches have gone and the culture shock has subsided, extraordinary places to be. They are complex in every way and taxing of all the senses, and despite the inherent peace and available tranquillity, they can be both intimidating and tiring environments to visit. Visually they attack head-on with a richness of forms and colours that rivals the Vatican's outrageous bling but also from an unfamiliar heritage, presenting a challenge for western eyes to orient and equate. Acoustically, the constant tinkling of bells and chimes, the occasional chants and the purring of pigeons offer a unique symphony, still punctuated by the tooting of car horns. Aromatically, food, flowers, oils and spices jostle with incense and swamp you with the flavours of central Asia. And lastly these places feel sticky, waxy, they are swept but unwashed and have the grime of ages coating them. Monks wander, monkeys bicker, hawkers smile; there's a heartbeat to these arenas but it's a slow one.

Each of the sides of the square tower that surmounts the largest stupa at the Swayambhunath temple complex has a huge pair of eyes staring out of a golden plated wall. They see all, peering from beneath their scanty wisp of a veil; their slightly hooded gaze has a definite air of menace – a serious vision not to be hidden from. As the sun sank into the smog it cast a final wave of light onto this face, gilding the gold. Of course the whole temple suddenly looked stunning but, if anything, this illumination drew even more focus towards the eyes, so I cropped in and concentrated on just this piercing feature.

10

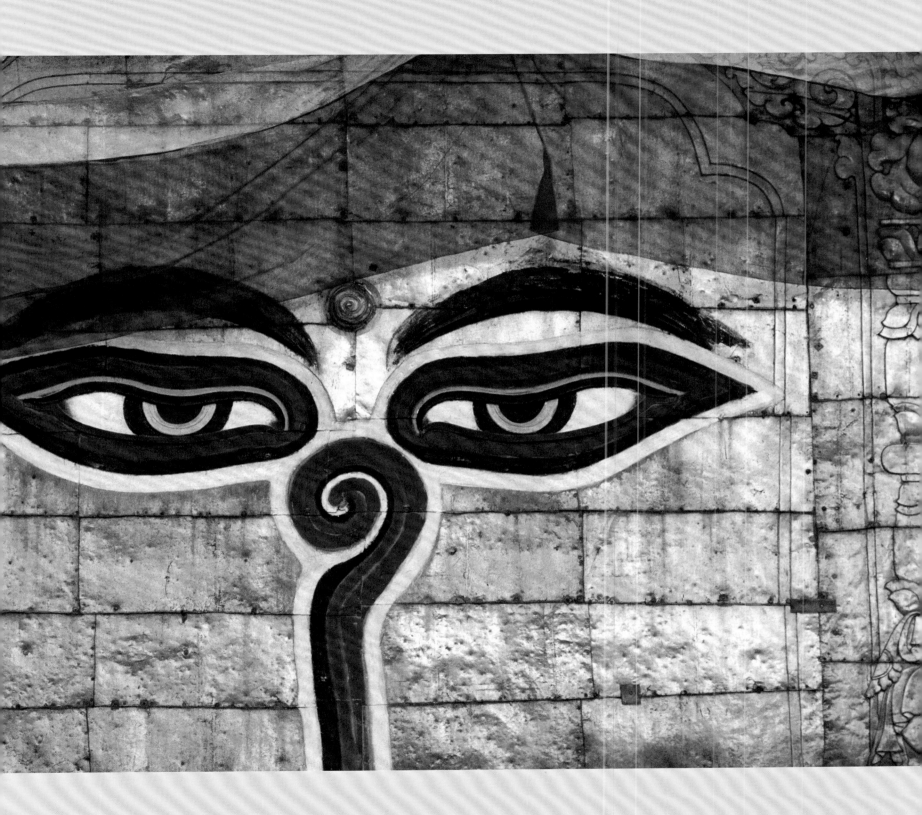

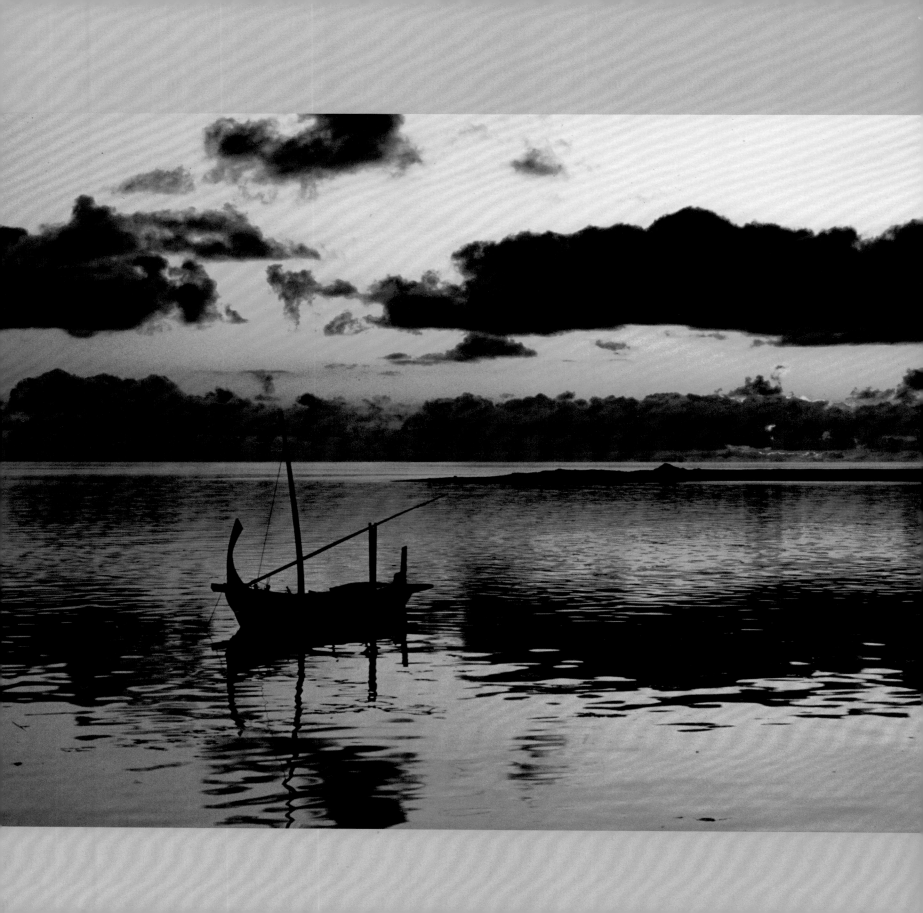

YOU NEED A BOAT
MALDIVES, 1993

Or something, because subject-less sunsets have to be extraordinary to stand on their own. Not least because the sun is setting somewhere 24 hours of every single day and you can bet that, wherever it is right now, it's happening through a viewfinder or on a screen. They are the perennial favourite, and while so-called 'serious photographers' therefore deride 'The Sunset' as 'cheese' they are just snobs. And liars, too, from my experience, because as soon as a good one starts glowing they are clicking with the rest of us, muttering 'of course I'll never use it, it's just to show "the wife/mother/kids/partner" back home.' Rubbish, they can't resist it, they have to have a go because the fact is they think that this one is the best sunset they've ever seen. And it's a fair belief because sunsets are too commonplace in our lives to be that memorable. Go on, think, which is the greatest sunset you've ever seen, artistically or photographically; where was it and when? You might remember the one when you got down on your knee and proposed or gazed at whilst conceiving your first child, but those don't count as they have personal points of reference. I've been lucky, I've seen some crackers, but I can't recall the structure, shapes and colours of a single one in any detail; in fact I didn't even know I had this photo

before I started trawling for one to write about. And within 15 minutes of taking it I was actually doing the 'kneeling and asking'.

I've often wondered exactly what the appeal is. Photographically the warm light is a factor I'm sure, so much more appealing than cold blue or bleached white. But people without cameras from all over the world feel the need to stop and watch our sinking star. Is it that there is an ancient response fuelled by the success of having lived and survived another day? Being diurnal creatures this would infer that we had also survived to see another dawn. But we don't get so excited about sunrises do we? They are pretty similar but most of us are either not up or too busy to look at these, so we choose the setting sun as the ultimate disposable 'Oooh!' photography, or waterfalls, which I simply don't get at all. Water, falling... it happens when I turn on my kitchen tap! Yeah, I know, the power and unstoppable forces of nature – tell that to those Chinese displaced by the Three Gorges Dam Project.

13

ROGER DEANVILLE
ANTARCTICA, 2005

It was before my time but do you remember all those early seventies *Yes* and *Osibisa* album covers with kinda surreal hippie drugscapes made of wobbly shapes painted in soft colours inspired by trips to lava lamp land? God knows what the music was like, I was saved by punk rock, but when I stood on the deck watching this float by I can't say I didn't feel a little stoned and wondered what ever happened to Roger Dean the artist.

It's luscious, isn't it? Just imagine if Monet or Turner had ever got down here; it's their palette, it's like looking through the eyes of an impressionist genius, orange highlights and mauve shadows with strokes of violet and grey, all laid over a lavender wash. And the three peaks of this iceberg have all the architectural form of a melting Notre Dame. I'm afraid our vessel lacked the character of the *Fighting Temeraire* so the Brit wouldn't have wanted it on his canvas, but as the sun sets on calm Antarctic nights you can see into a new part of the spectrum and gaze upon another world. But this photograph is not that special, there are more picturesque icebergs and a breaching whale in the foreground would have helped or an Albatross wending past, maybe some penguins, anything

to move this from the sphere of 'snap' to 'picture' – perhaps something to invest it with some real longevity. So aside from being 'nice' what has it got going for it? Well perhaps one very important thing: it makes you think 'I wish I'd been there'.

On its own that reaction cannot be enough, it won't transform this or any other ordinary photograph into a classic, but if people look at it and think that, then it's taken something from an instant and communicated it to the viewer. It hasn't said 'great picture' but it has said 'great moment'. Maybe there wasn't an amazing image there, certainly no leviathans leapt for me in this twilight, but it was I hope clearly better than the view down the pub doing the quiz. Given this, all you can do is your best, if you think it's worth it. The jagged peaks on the snowy slopes beyond and the two layers of clouds both help to give the scene some depth and more substance than some naked ice floating alone. But to be fair this is a cheap shot, it relies on an exotic location and the lovely light that plays there – and that is not enough. Must try harder. 1/10.

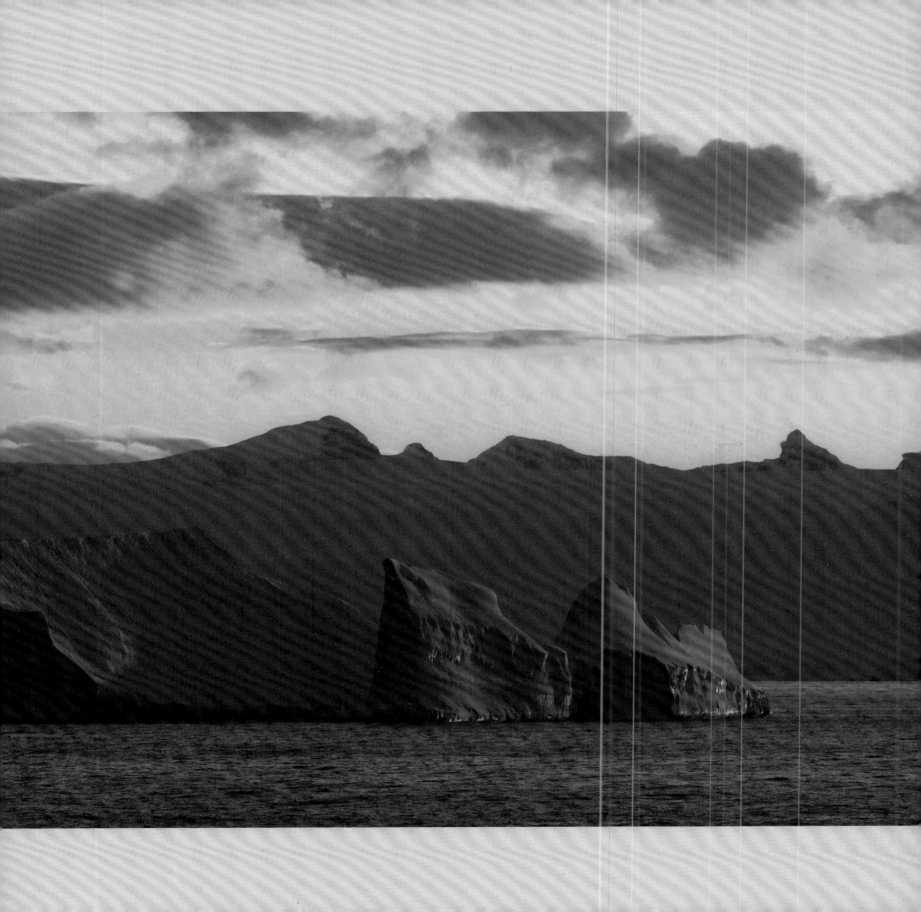

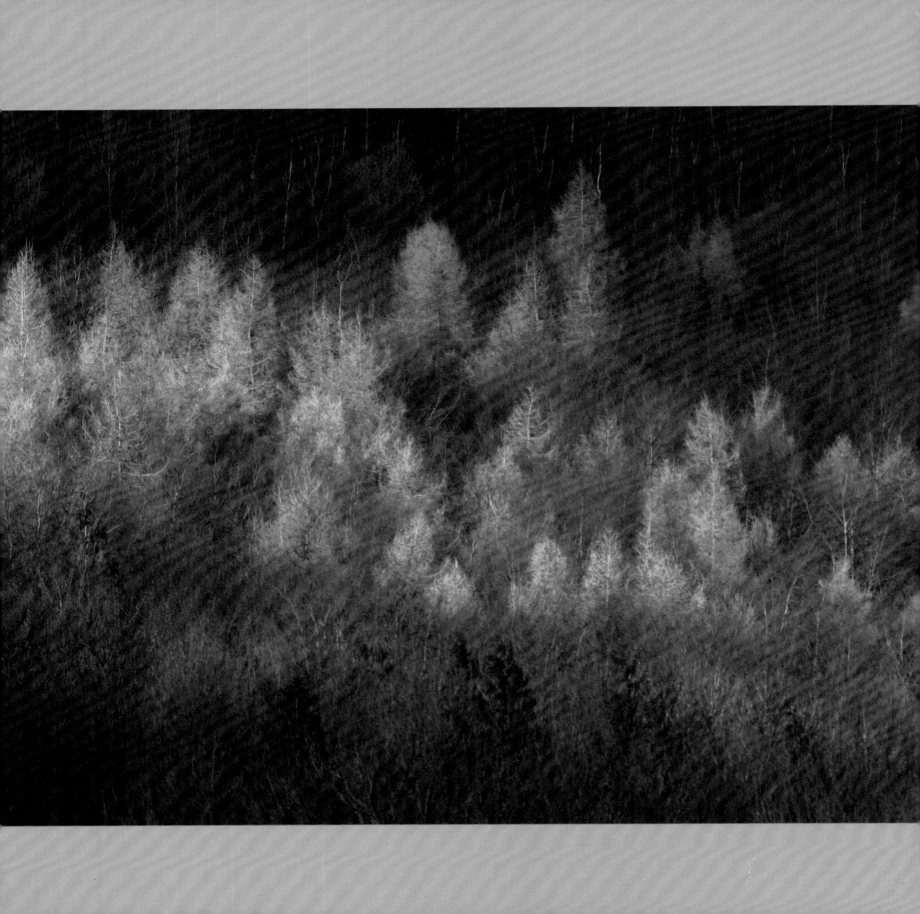

SMOULDERING MEDIOCRITY
ENGLAND, 2005

Relatively often I tentatively agree to present films for television offering photographic tips. Thus I find myself in an unsuitable location, on a wholly inappropriate day, at the wrong time of year and invariably in the pissing rain. Fine, I can still attempt to impart the little I know with genuine enthusiasm, my employers might be happy with my pieces to camera, and my self-made-up spontaneous scripts may make enough sense to actually communicate to the audience. But of all my presenting jobs these are about the only ones which get me worried, nervous even. You see, while I'm standing there mouthing-off about 'do this, don't do that', I'm setting myself up for a massive fall because, as we all know, the proof is in the pudding, or in this case the photographs. And aside from mincing about in front of a TV camera trying to make a silk purse out of a sow's arse, I know that I also need to get some decent pictures to put on the screen, or else you'll all be saying, 'look at that rubbish, I could do better than that, what a prat, calls himself a photographer...' But I don't get any sympathy from the crew, I get no real photo time because there is never any and at the 'wrap' they'll be asking for my downloaded images. I consider that

I have no choice but to deliver the goods. Sometimes this is not only difficult, it's nigh on impossible.

This tawdry shot of some trees splashed with a smidgeon of November sunshine was taken from a hill fort that overlooks the Goodwood Estate in West Sussex. It was a desperate stab at a modicum of art at the end of a day which had been spitting mischief at me in bouts of freezing rain. By 3:30pm the evil sky which had never really given up any light was now sucking what there was back into a grimy 'dusk'. I had spouted a lot of 'expert' hot air about finding abstracts in the landscape but had banked nothing. But then, as I braced myself on the muddy slope of despair, something celestial happened and a dismal glimmer ghosted over these Larch trees for a minute and I grabbed this. Phew! The green tops in the foreground don't help, but the colour and the texture are okay, and they are not the typical Beech, Birch or Maples famed for their fiery shows. And I'm always a bit fed up when I hear about folk going to New England for the 'fall colour'. Suckers for hype I say, we've got plenty of autumn palettes of our own thanks!

127 SISTERS

ANTARCTICA, 2005

As the midnight sun tried to set we came upon this vast slab of ice drifting with a quiet menace into the southern seas. It took more than an hour to pass on just one of its sides. It was probably 40 metres high but immeasurable in terms of area – its own little breakaway nation, all it needed was a landing, a flag and an anthem. Its sheer and stark white sides rose cliff-like from the sea but in places there were caves and cracks which gave it a chalky complexion reminiscent of the Sussex coast of the English Channel. It was eerily silent: no birds, no wind. You could hear the waves lapping at the base of the ice and the wash from our bow as we crept by in clear, bright air, and the awe generated by the presence of a comatose giant.

These are the true colours. The sky all but black and the sea a leaden blue whilst the 'berg reflected the low contrast sunlight, having stolen any warmth and replaced it with a lime wash of pale yellows, insipid blues and tints of peppermint green. But it changed to a strong blue green, to near white and finally to a rusty orange. That's one of the unexpected abilities of big chunks of ice – it is not merely a material that reflects light, the ice takes it in and transforms the

light before spitting out another part of the spectra. Sometimes the quality of that light is reflected, at other times the ice appears to be glowing in the light or even radiating its own luminosity and with it incredibly intense colours. Blue ice is remarkable on this account, it gives its clean, cool hue with such vigour even on foul dark days when it actually looks wrong, bizarre, painted on, it's like a jewel you always wanted to stare into the heart of as a child, and it sucks you in with an inexplicable richness of otherworldly elegance. And you can only look; you can't own that type of ice.

Of all the faces of this tabular iceberg I photographed I like this most, the way it barges into the frame and cuts it in half with a great wedge of brutal brilliance. The tiny reflections on the waves give some depth but it has a crude cubist quality. If it were a painting I would admire its audacity, but probably not want to own it – it is too heavy to live with, oppressive, perfect for the foyer of the evil Ice Queen's headquarters.

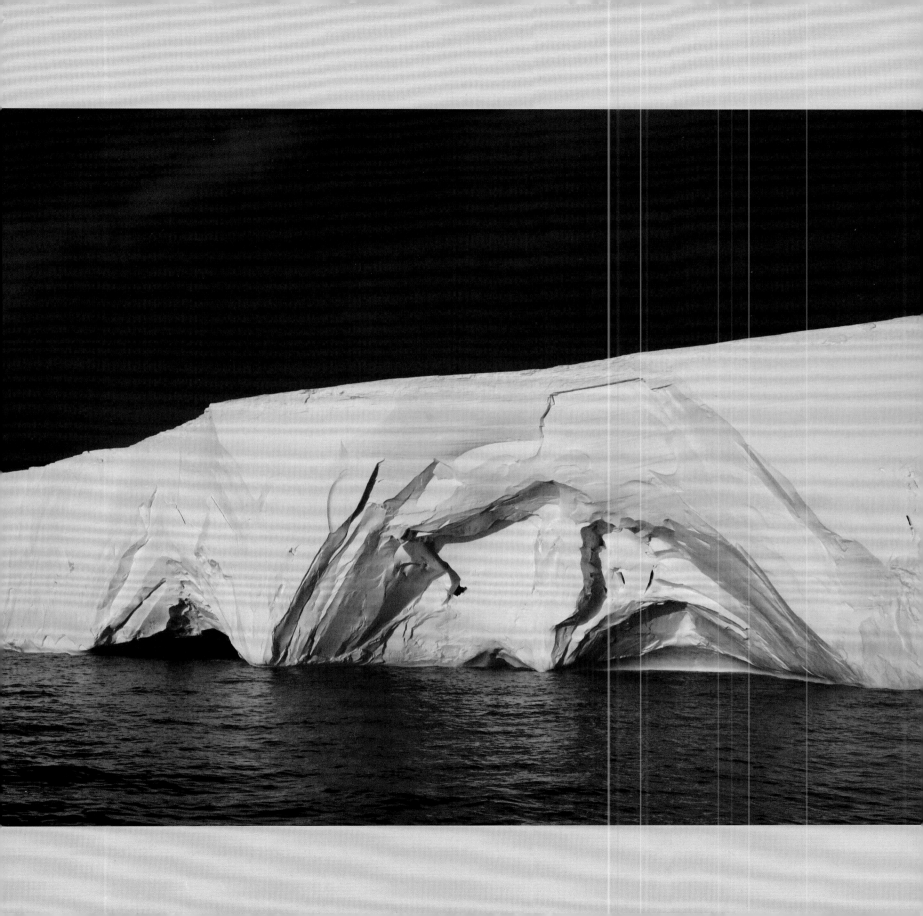

20

CAUSTIC HEAVEN

KENYA, 1996

Far beneath the clifftop crag from where I took this 'sunset', a host of candy-pink birds amble in the shallows of an alkaline lake so caustic that it would strip the skin from your bones should you feel like joining them for a dip. The birds are imperceptible specks in this image but scattered across the mirrored sky are thousands of Lesser Flamingos, each panning furiously for zooplankton in the bitter waters. Elementaita is one of the string of lakes which line up along Africa's Great Rift Valley and millions of these wacky creatures depend on their variable riches for their survival. As the density of their food diminishes in the peculiar soup, they all up and fly off to the lake which has the optimum amount of plankton, which makes their continual sifting actually metabolically worthwhile. Despite an abundance of millions they are a fragile species in an imperilled environment. One of their most famous and important resources, Lake Nakuru (also in Kenya), lies adjacent to the country's second city and is suffering from serious over abstraction of its waters. If one lake goes...

The viewpoint overlooking Elementaita offers many sunsets of distinction. Maybe you or one of your friends have one of your own. The great expanse of still water reflects thousands of square miles of the continent's sky and here, with a crowd of clouds parting to allow a smattering of late evening sunshine to fall upon it in a near perfect reflection, it was irresistible. The symmetry is framed by the concentric lines of lacy scum which so delicately complement the colours and patterns in the bulk of the picture. The density of the image is greater in the reflected part, something I considered 'fixing' in Photoshop. This would increase the unreality of the landscape, flatten it to a far more painterly two-dimensional form. But I decided against it and what you see here is what I got on my Kodachrome original. The land itself is simple too, no distracting trees or man-made features, so it offers a feeling of a primal wilderness. And we always seek to admire nature's perfection in our absence – at least we are generally honest about that.

I watched two secretary birds on their nest below the rise while our guides barbecued an impala as the moon rose. It was delicious and the last time I ever ate meat. Good place to stop anything, I reckon.

BAY OF MEMORIES
ENGLAND, 1985

Bosherston Ponds on the coast of southern Wales remains for me an almost utopian ideal. I've not been there since the night I made this picture 29 years ago and I'm not sure I will ever return – why risk destroying a dream if it can last a lifetime, even if that dream is a lie, made up and maintained by that vile bitch nostalgia. It is the eighth deadly sin; it corrupts our truths, perverts our perceptions of history and tints our spectacles with the blood of our blind ifs, buts and maybes. And yet we all pay homage to it, we all think things were better, that the ol' days were good, that the grass was greener and the music better. Clearly it can't be, so I don't want to be re-united with my friends, restore my childhood or return to a place where I walked in paradise with my first true love. I'm just too scared to accept the discovery that it wasn't actually that brilliant. Or was it? Surely a photograph never lies?

An overgrown and rain soaked footpath led over a nettle-clad stile and wound down to the edge of a series of large ponds which were brimming with water lilies. A delicate mist of golden midges played in the shade of overhanging trees whose boughs bent down into the cool, green waters. Dragonflies sparkled, swallows strafed and frogs plopped out of sight as we wound around the banks of this pre-Raphaelite dreamscape. It was enclosed, it was a secret place, a lost world where all the beautiful things still lived; at the end the path the scene opened to a small deserted beach where the fresh water mixed with the salt and where I took this photograph as the sun set. And that is my nostalgia, here is the photograph.

For some reason the shot looks un-British to me: it's all about the stripe of bright water across the centre, of course; the reeds give some consistency to the foreground's silhouette, while the others lay up the frame to produce a pleasing composition. I'm not sure if it needs more colour or not. I quite like the rather monochrome aspect, and critically the horizon is straight; unless it's a dramatic device it absolutely has to be whenever water is in vision. There is probably nothing as wrong with a photograph as sloping water. It is inexcusable and unusable. It's embarrassing but I still see full-on professionals peddling shots which abuse gravity. What are they thinking? Not even self-indulgent soppy snaps of former fairy-tale-land can be on the skew.

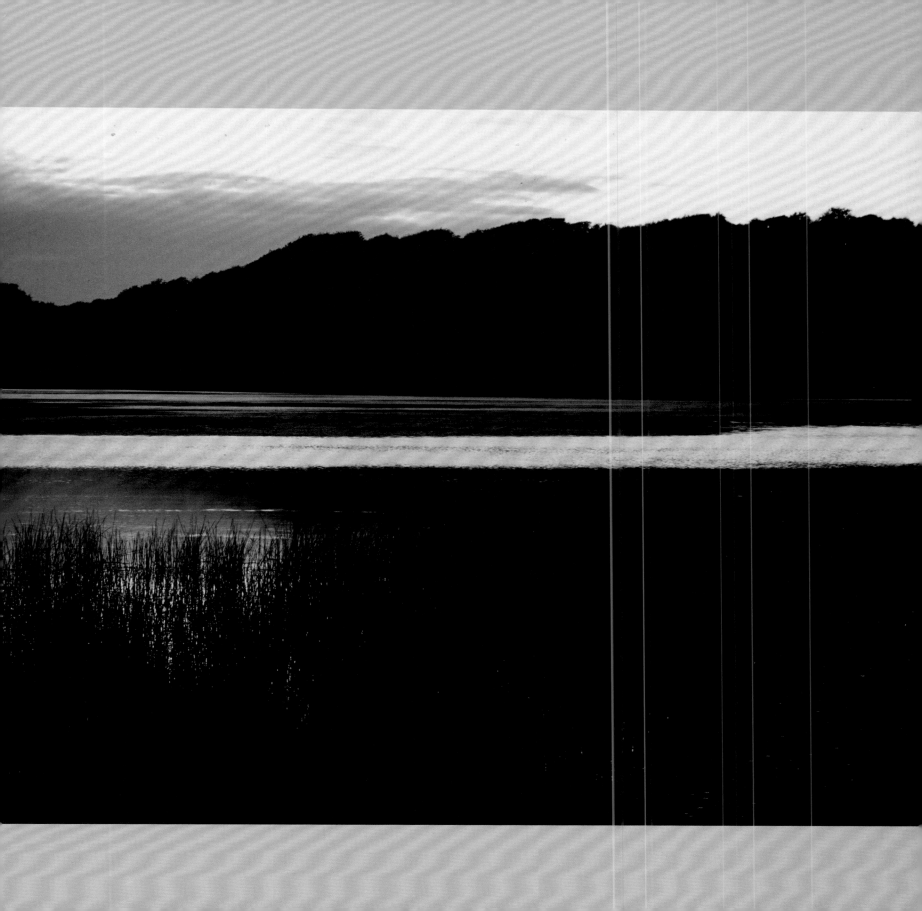

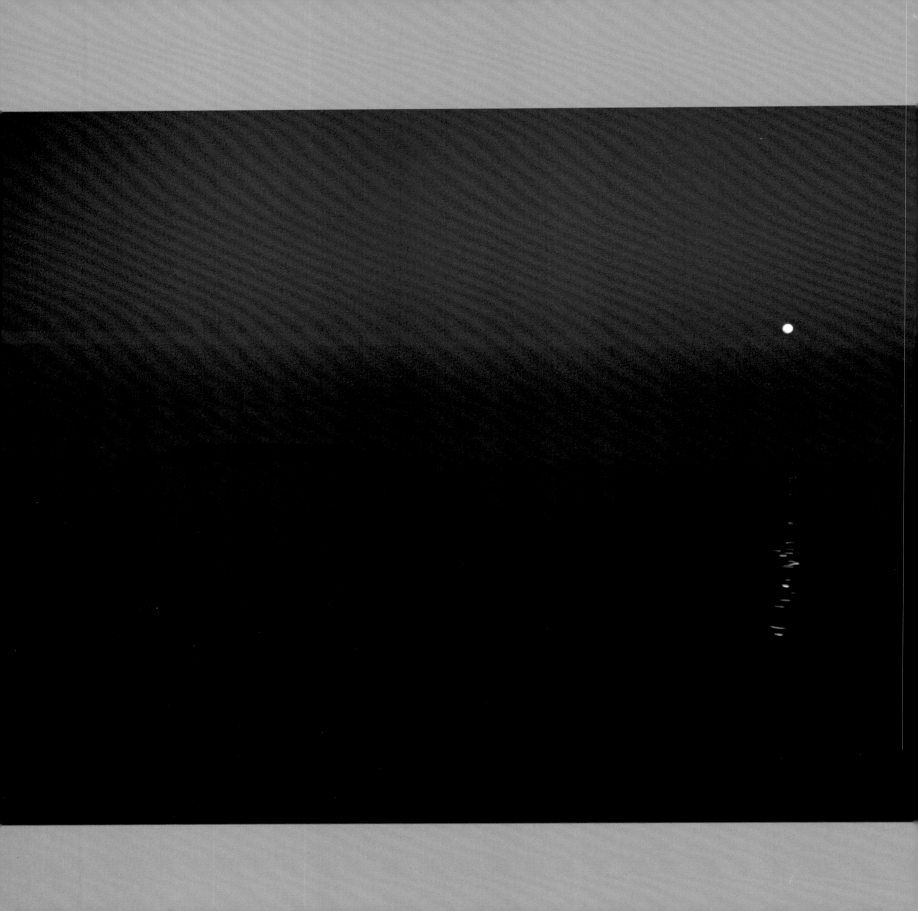

SEA OF CORTEZ
MEXICO, 1997

I know it's grainy and there's only a slip of an island and a pin-prick moon fizzing about in a big smudge of purpled-black but that's what it was like and it was wonderful. I don't like detail en masse; I don't mind isolating a bit of the world's filigree, but I can't control things if there are too many facets in my photographs. Imagine a sunset seascape with silhouetted palm trees in the foreground, a stereotypical idealised picture — think *Hawaii Five-O* and *Miami Vice* or the parting shot in many a Bond movie. But I can guarantee that if you gave me the greatest ever 'sun-sea-palm' photo I could find a flaw. One of those wind-tossed fronds will be a touch too thin, a trifle too dense, or have a few too few leaflets, a couple of the trunks will cross over at the wrong height, the wave will have broken just slightly too close to the edge... you get my point. The more you have, the more there is to go wrong, just like every overloaded piece of irreparable electronic technology that confounds us with its aptitude for disintegration through over complication. Just like that last sentence!

So I'm afraid that it's undeniable that my fuzzy photo of the sea, off the coast of Baja California, works. The composition is good, from island to moon; their relative positions balance in the frame; the simple gradation of tones from top and bottom to middle isolates these basic features and prevent them from getting lost despite their small size and lack of visual content. And the drizzle of the moon's reflection puts some tiny but essential life into an otherwise very morose and intense scene. It's not that I'm claiming any prizes here, merely saying that with so little, 'how could I mess it up?'

In Houston, Texas there is a chapel designed by the artist Mark Rothko. I visited there once and sat down for an hour while dusk was failing. It was one of the best hours of my life as it defined a new experience — one place, one hour — and yet a transformation of environment simply through a refined understanding of light and how to use it. As you might imagine it's rather spartan — about as far from the Sistine Chapel you could go in a house of God, but just as impressive. That night bobbing about on the Sea of Cortez I witnessed the same metamorphosis of mood; I discovered Rothko's inspiration and that's why I truly like this picture. A bit.

BEAUTIFUL NOTHING
NEW MEXICO, USA, 1997

White Sands National Monument was 'closed' due to high winds. That's what it said on a sign that blocked the road at the entrance. I got out. It was deathly still; there was no-one around. I looked at the map and it was clear that so long as I didn't leave the simple web of roads, or lose sight of the car, I couldn't get lost in 'dangerous drifting dunes'. The everyday visitor would turn back and go for a burger somewhere. They seem to do exactly as they are told, they have an unflagging respect for authority, they trust rather than suspect the faceless state. I nudged the cones to one side, drove in, reset the barrier and vanished into the void never to be seen again.

I'd spent my last night on earth in a motel in Alamogordo, been to the rocket museum, visited the place where science fiction was 'factualised'; I'd also read about the German geniuses that were kidnapped to man the space project that would get Armstrong onto that lump of cheese and leave us with missiles that can fly half way round the world and land in a living room carrying a warhead that can wipe out a nation. Yes, they built and tested those things out here too: Trinity Site is 'just up the road' and on 'special days' you can get in a bus and drive out to the original ground zero. Maybe you could piss in Oppenheimer's laboratory loo, although I doubt it. I would have like to have tried; this, after all, is where our civilisation took a major turn in a searing flash of irradiated evil.

Back in the sands I had a brush with this. I took my life in my legs and ambled 'off-piste' into oblivion and just as I crested a dune I had an urge to look up. A Stealth Fighter went right over my head, low, initially silent and then loud, a black arrowhead so unreal it looked computer-generated. I hoped Lara Croft might turn up later to escort me to safety. It was the weirdest moment. But then I was in an odd mood and I was aware that I felt more comfortable out here alone in this lovely desert than I had for some time. That's why I like this 'un-landscape' photograph. The tufts of vegetation give it some shabby scale and the distant mountains are spited by the vast spread of soft simplicity before them. There is a security in a vacuum, there can't be anything there to hurt you. Or over-complicate your pictures. In six hours of trespassing I saw not much and everything I needed to see.

26

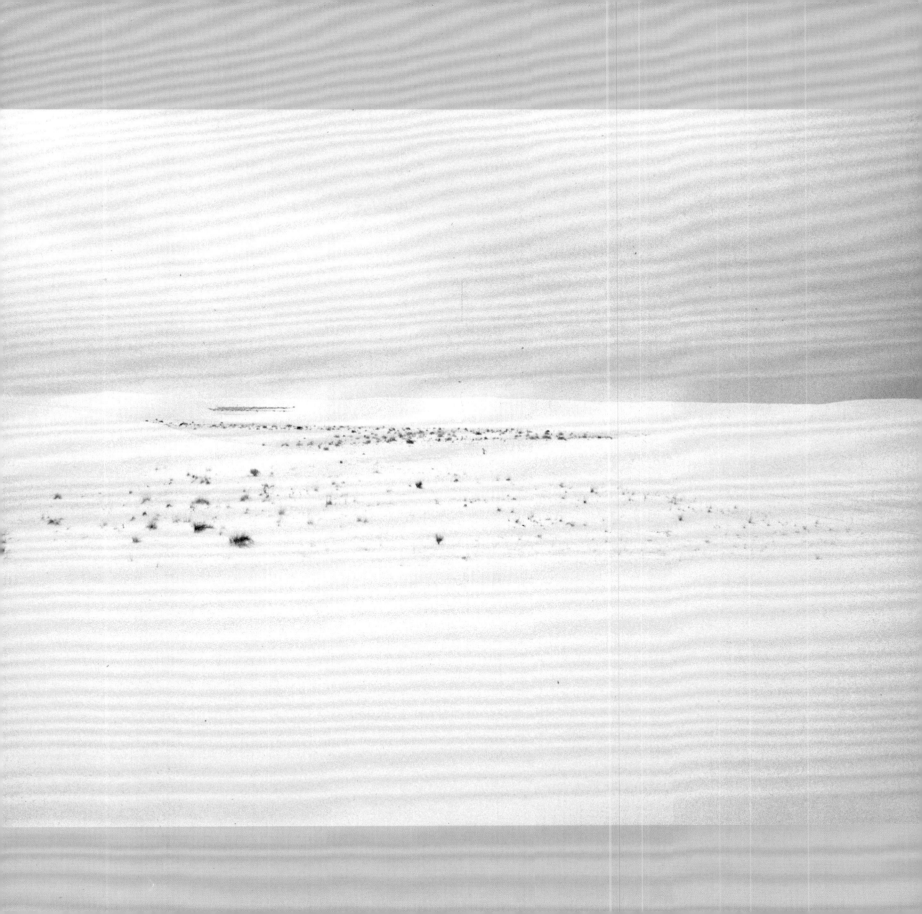

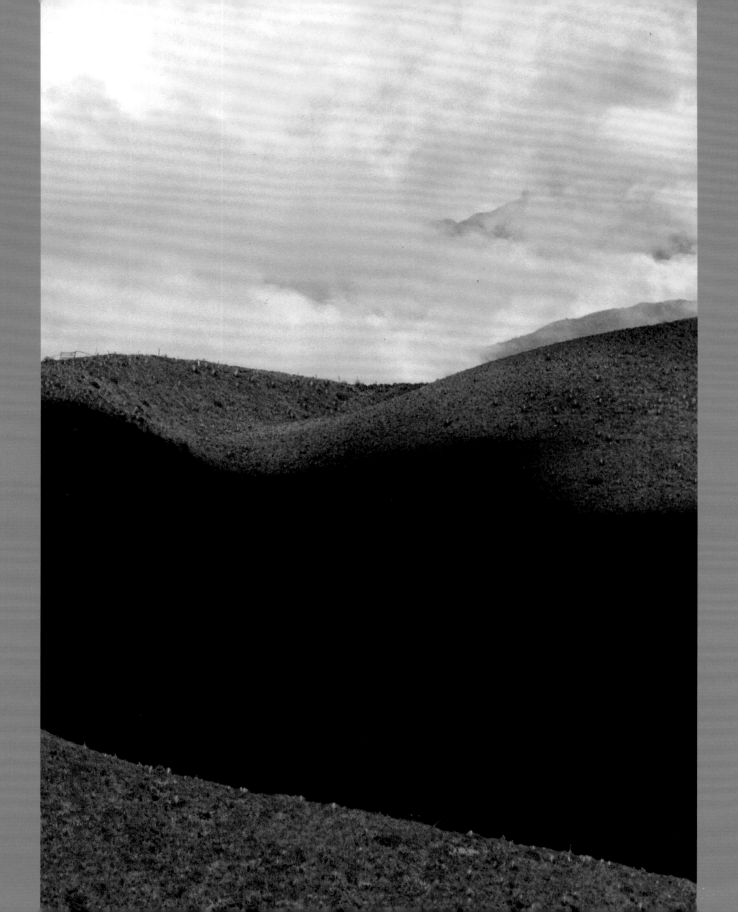

28

SHADOWLAND
ECUADOR, 1994

To follow the rules we divide our photographic frames into thirds, either horizontally or vertically. And if we take traditional landscapes we typically offer two-thirds as land and one-third as sky, or if there is more interest in the latter we switch it around: one-third land, two-thirds sky. For some reason we perceive this as balanced and therefore it looks stronger to us. It must be a human brain thing. Of course the brain likes a challenge so breaking this 'rule' can be effective; a tiny sliver of sky across the top or the merest slip of land lying across the bottom of the frame often make the spaces appear bigger, the dominance of either ruling in its favour. Choice of perspective as afforded by the characteristics of lenses also plays an important role. The feel of the image will be entirely different, even if its geometric composition is identical. Two-thirds of sky through a big wide angle with clouds reeling up and over the camera and chasing the distortion out of the corners can produce a more dramatic photo than two-thirds sky crushed together through a long telephoto. Both have their uses.

This picture of the high Andean grasslands was shot on a medium telephoto, maybe a 200mm, and it has squeezed the receding hills together and kept the detail in the distance while coincidentally stealing the depth from it – things faraway look closer and you can see them clearly, but it's difficult to judge just how far off they might be. I've gone for thirds but the reason I took the photograph was the powerful blackening cloud shadow which gave clear definition to the foreground hill and form to the second slope. Without it the rolling and rounded crests and valleys would have just been a dull green carpet of nothing. I included the 'sky' beyond as it allows the higher and darker mountains to peep through the wispy white froth which, in turn, offers a contrast to the heavy foreground shade. In truth I would have liked more peaks peeking and a little less brightness in the top-left. But the moment lasted seconds as the shadows raced across the highlands, dragging a miserable dose of cold rain behind them. So in principle the picture works; I find, however, the 'hairiness' of the hills annoying – that odd tuft on the top-left of the second rise particularly so, it makes them seem smaller than they were and spoils the simplicity of the comfortable curves. Llamas, you see, leave the long straggly bits un-munched.

SKELETON COAST
SCOTLAND, 1994

I remember the day: I saw an Osprey, which was still a big 'wow' at this time, but now the UK population has finally expanded to the extent that to see one in Scotland is 'merely' a thrill. Familiarity breeding contempt of something hard won and wonderful – terrible! They come to this little visited part of the coast just south west of Inverness to fish in the shallow sandy bays. The sea has clearly swallowed much of the shore here as these twisted tree wrecks testify and occasionally the fish eagles perch on them to peer for their prey. Sadly not in this image, which was a passing snap rather than a contrived objective. Indeed it's the only exposure that I made here on this roll of film. So what's the point of including this below-average, gaudy and forgettable photograph?

There are two things: firstly, landscape photography can be a difficult and desperately under-rated art, with many people believing that the world does all the work. That is to say that it shapes itself, through natural and man-made invention, into the pleasing views which we can all roll up and have, personally or photographically. But as this snap shows this idea is rubbish. This is one of those photographs of an opportunity; this is the sort of thing a landscape photographer would have taped to his or her wall as a reference shot, a prompt to remind them that there may be a picture in this area. Here we have these twisted and tangled skeletons of old pines sprouting from the sand like the bleached bones of dragons, with that great monster the sea behind them. It's just the three elements – trees, sand and sea – it's simple yet surreal, it's a great location but this was the wrong day, the wrong time, it's the wrong picture. It's a funny sunny shot that, while not quite a postcard, would not look out of place in a touristy brochure identifying this spot as one you might like to visit. No, on the right, thundery, storm-tossed day with a big sea, a damaged sky and a flash of hard winter light, this could be really nice and a proper landscape photographer would keep going back until they got it right.

Its one redeeming feature is the composition: traditional, pleasing, not exactly challenging; but the point is that it is always, always, always worth finding the best angle to dangle your camera. Never be lazy – look, think, explore, choose and shoot. If it's poorly composed then it's lost and it's your fault, not the weather's.

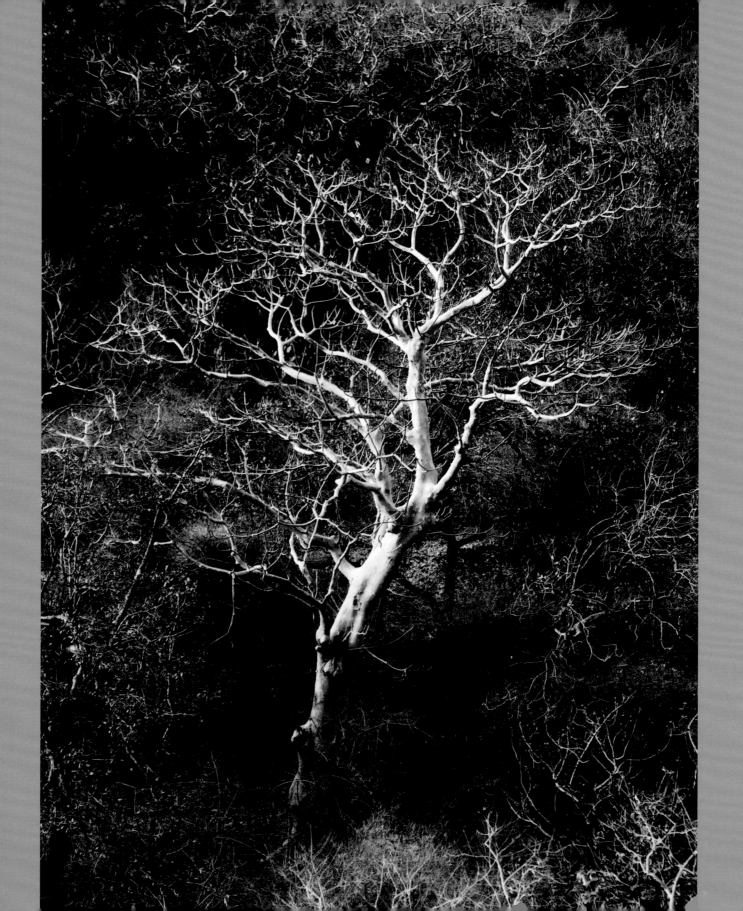

NAKED LADY OF THE FOREST
INDIA, 2006

Like a lightening fork she shoots up from the dry forest floor, bright and brilliant white, dividing, her diameters forever diminishing up to the tips of her silver fingers all spread skyward. But she's not struck, only striking amongst the tangle of trees that crowd together and conspire to hide tigers so they can continue to burn brightly in spite of our nefarious predations. The locals call her the 'Naked Lady of the Forest' on account of her stark and greyed bark, and we found this particular nudist growing on a hillside beneath the shrine on the hill in Bandhavgarh National Park in central India. Okay, I've upped the contrast a bit, but only in an attempt to try and represent the true impact this tree had when we spied her basking in the morning sun. She might be 'nude' but she stole the thunder from all the bashful latecomers that couldn't shroud her modesty. She glowed, radiated, a stunning specimen. The photo doesn't follow suit, I'm afraid, as that 'hole' in the canopy to the right isn't very nice and for some reason the photographs that Megan, my little girl, took look stronger than mine. Hers on the Nikon, mine on the Canon, but I think it was the exposure; she was on 'shutter priority', I expect, and I was trying to be clever on manual by deliberately underexposing in an attempt to crush all but the lady's charms. Auto beats brain? In this case of course, but an earlier or later light would have helped. We were busy chasing tigers when there was any chance of decent illumination.

In 12 days we failed in this respect. We were fortunate to have plenty of sightings and to see many different cats, and we made lots of exposures but it was all a big zero for me. The sun comes up, you are allowed into the park and if you don't find an animal in a decent location within an hour then the sky starts spewing vile high white light for the rest of the day until the evening. We found tigers during these periods but they were in useless spots, hiding in shade, twigs, or bamboo – it's not easy. And as this photo so pertinently shows, nothing is as important as light when it comes to a proper picture. On many days I won't even get my camera out of its bag, everyone's burning up their camera sensors with flashes of awful light, but what's the point – you will only get images of something that might have been okay if the light was nice. Like this one for instance.

33

FRANKENSTEIN'S GRAVE

SVALBARD, 1998

Grand arrivals by air are few and far between, normally a cold tube from the plane to a queue, to a line, to a fight for luggage, to a taxi... It's rubbish, it happens too quickly, and you only get to where you really want to be much later when the edge has been beaten from excitement or anticipation, dulled by the exhausting misery of modern air travel. By ship it can be different: there is scope to see a speck on the horizon gradually turn into a destination – somewhere new, somewhere you want to be. Land can also loom out of mist, appear suddenly, and all the while you can wonder if it really is the place and strain your eyes to see the port. It's one of the principal pleasures of boat journeys.

We had sailed from North Cape at the top of Norway across a great tract of the Arctic Ocean towards the Svalbard, ex-Spitzbergen, archipelago and this is what we found. We steamed slowly across a giant deep-blue mirror towards a sunlit fairy-tale landscape of iced peaks and puffy clouds. The clarity of the air in the cold or at altitude can be so good that it makes you feel as if you've been given new eyes; it also makes judging distances without any points of reference extremely difficult. You can be scanning a mountainside and suddenly find a minuscule deer or a giant bird, and here it was difficult to discern the size of the landscape itself.

When we eventually nudged into one of the fjords the summits towered over the deck and cast us into thick, blue shade, and we had to squint out at the snowfields rising steeply skyward. It was all a little unlikely and unreal; I felt a twinge of guilt thinking of all those who have reached here in the savage teeth of a freezing gale and photographically that would have been a lot more interesting. Light we like, but gleaming sunshine is very often a curse, especially with subjects which have extremes of contrast. Modern digital sensors are getting there fast, they try to get the best out of both the light and shade, but compromises have to be made and they show. I shot lots of frames of these impressive places but many of the pictures are either too 'Disney-clean' or too 'punchy' and super-sharp for me. Here the blue has almost gone to black but at least the wide angle has thrown the HD-reality into the distance and the symmetry becomes the principal point of a consequently very mundane picture of an amazing place.

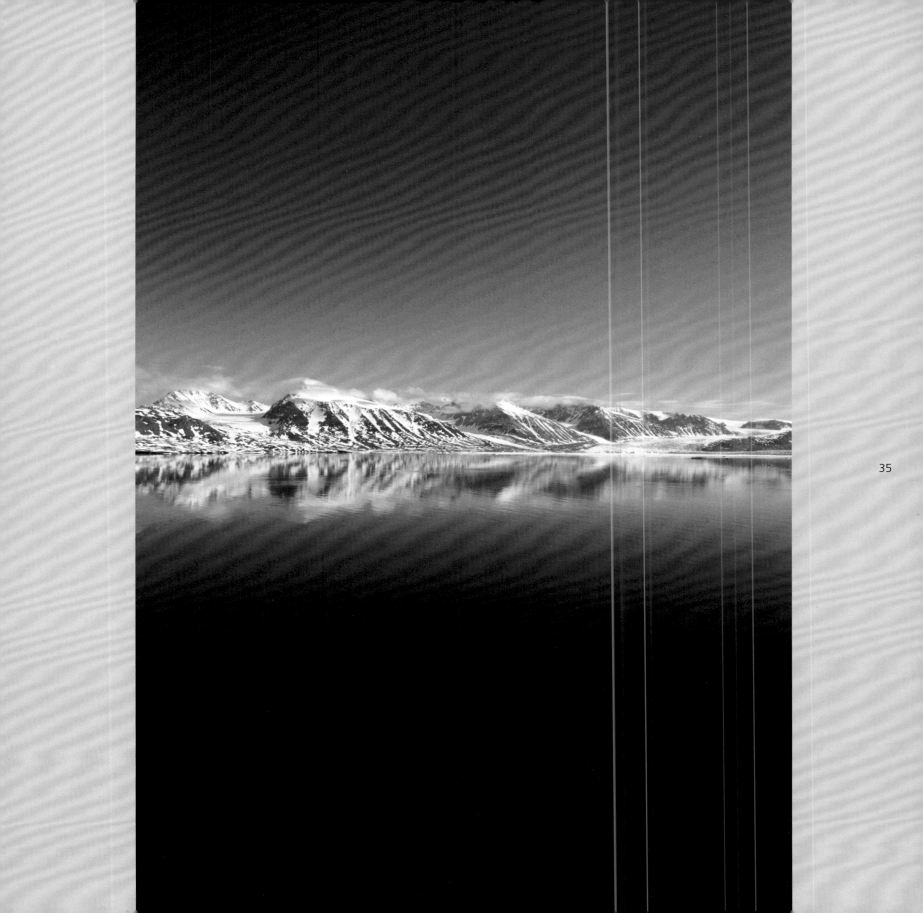

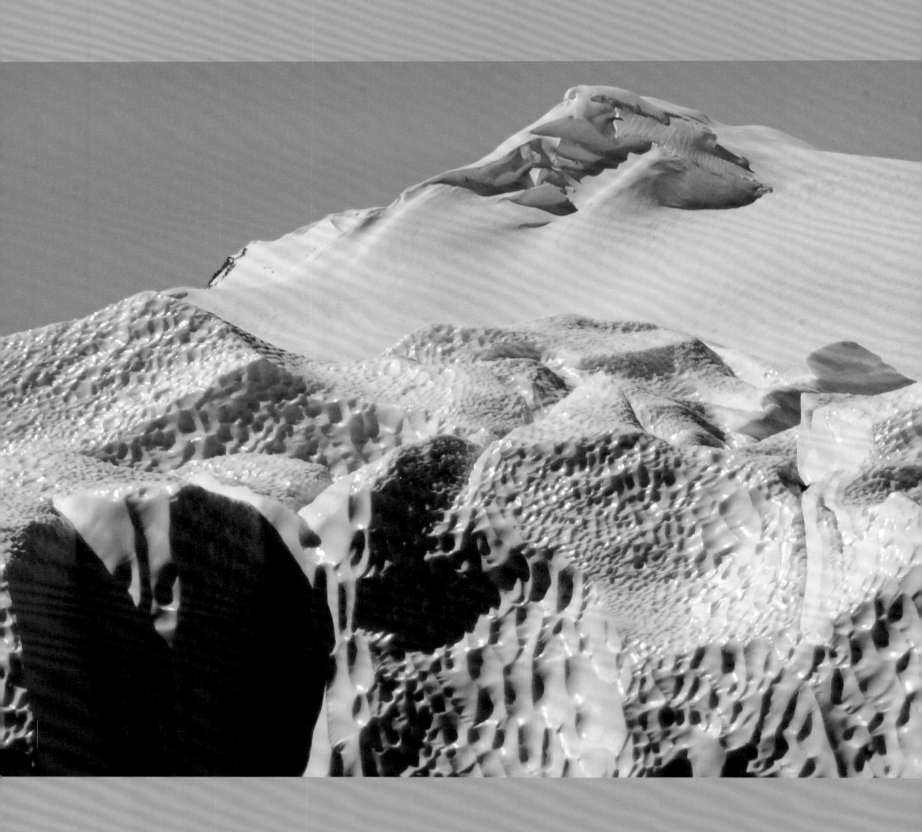

NICE ICE
ANTARCTICA, 2005

Icebergs are nearly waterfalls. In cynical mode I sometimes struggle to see the reason why they get quite such a 'wow'. Check your freezer – you'll find a few of these waiting to drown in your Martinis or Malibu. Yes, they're smaller chunks, but still no more than frozen water, and just like falling water, what's so special about frozen water? Well, it's rarer and a lot more inaccessible and to be fair one has to travel to the far north or south to see big chunks of it floating about. And it's dangerous, and uncontrollable, and perhaps it is the sheer simplicity of its physics and the occasional undeniable beauty of its form which gets the 'Ooohs!' going. Maybe also that these untamed and often antique giants have a primeval appeal given the desolate and hostile environments which spawn them; they are the mean, cold, hard stuff of real wilderness. They are ephemeral, destined to melt into the vast amorphous oceans, and they are all individuals each having a different character and appearance. So there, I've talked myself round and I'll stop being confrontational.

This photograph, taken from the deck of the Akademik Vavilov somewhere off the Antarctic Peninsula, has been cropped. In the full frame there is a navy blue strip of sea in front of the sculptured ice. But it was too hard, too rich a colour and it wasn't foaming or raging or doing anything interesting. This concentrates all the attention on the superb, unusual wind and wave-cut dimples in the foreground ice, which are actually enhanced by the rather harsh overhead sunlight, for a change. The snow-capped mountain beyond offers a contrasting softness and gives some essential depth to the composition, although I am pained by that small patch of exposed rock on the peak's left. It's the only 'black' in the frame and, although tiny, it is an unpleasant distraction. The wisps of cloud are a help though; without these it may have all been a bit sterile, too clinical.

Photographing 'bergscapes', however, is a hit or miss affair because few have the opportunity to return to the spot when the weather or light are more interesting; it's a case of a shoot and it's gone, probably forever, unlike many landscapes which can be considered and re-visited for years in pursuit of the perfect picture. Anyway, I'm very lucky to have had the opportunity and this is what I got.

COLD HEART –
SECOND CLASS
ANTARCTICA, 2005

I have a favourite line that I deliver to my step-daughter Megan when she is deliberating over which shot from a sequence is the 'best' one. 'There can only be one!' I announce in my best Highlander impersonation. It's no good taking 100 photos of a subject at a given time and place and weeding it down to three. Or two. You can only use one of those pictures and there is within them all the information you need to make the choice. So make it, and dump the rest onto your hard drive for a far off rainy day, or better still summon the strength to delete them and save cluttering up your life with the past imperfect.

Be diligent and deliberate; consider and reason, conclude, decide and delete. That's a workflow! When I shot slides I would sometimes rip open those annoying yellow boxes on the doormat and hold the 'trannies' up to the window, such was my impatience to see if I had got it. I very soon discovered that, despite the crude analysis, I would, with 90 per cent accuracy, identify there and then the 'best' ones. Hours later, after absurd pedantry bent over a light box with bleeding eyes, I would find myself all the way back to the original image. Thus I devised a harsh system: I placed a waste bin alongside the letterbox and as I withdrew each slide I would decide whether it lived or died. If it went into the bin it never came out – never – the bin was a photographic swamp from which there were no survivors. Occasionally tough calls were made with bleary-eyed hangovers, but in the main the process was cruelly efficient and it taught me to recognise that if an image is not good enough to grab you in the first few milliseconds that you lay eyes upon it, then it never will. I make the same calls now with my thumbnails and only a handful gets processed for a better look. When Megs and I go on a trip – an assignment, say, of two weeks photography – I tell her that she should be looking to come home with between three to five pictures. I aim for one or two. That's what I hope for: two pictures that are good.

This view into an ice-chasm was nice but entirely invalidated by the later picture of the icicle in the hole. How many icicles can you have? Answer: 'there can be only one!'

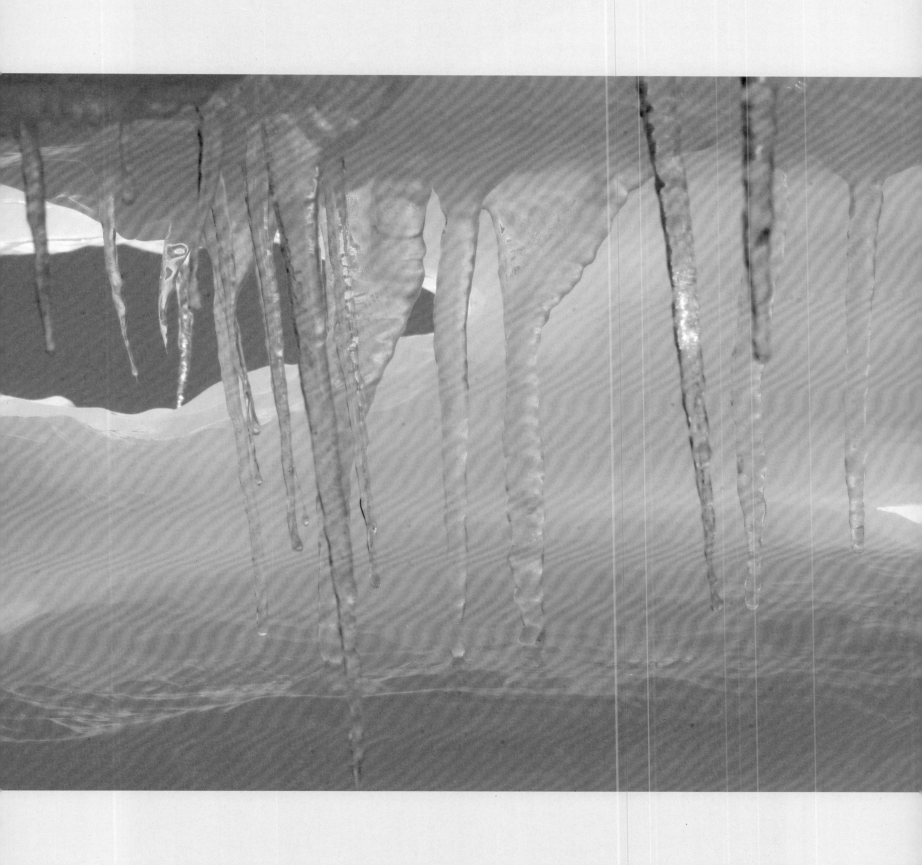

40

EYE OF AN ICEBERG
ANTARCTICA, 2006

I quite like this photo, which is pretty amazing for me! I like its simplicity, the tones of sunlight bleeding through the ice giving it such a range of cool glassy colours, the super-saturated blue of the sky, which is un-enhanced, and the fragile little icicle with its telling tear drop. But most of all I like the small degree of satisfaction I recall when I found the picture – this was very definitely finding more from so much less. The world beyond this window was spectacular, an awesome landscape of snow and ice stretched out in sunshine, pin sharp, potentially picturesque but oh so complicated. Icebergs of all hues of blue were beached and backed-up to the horizon, all glistening and scattering the brilliant sunshine across the flat ultramarine sea. I was with a tour and for many of us it was our first landing on the seventh continent. Cameras were snapping, pixels were exploding, blisters were forming on fingers, and we were in danger of turning Japanese! But for all the excitement there was actually nothing photographically new on view. It was, forgive me, all a bit of a mess; worse it was a horribly lit, characterless jumble that was only ever going to be photographically fit to show my mum! It was perhaps a bit like a moon landing for me: amazing to be there but when you pick up the camera there is bugger-all to make a picture. Why do you think Neil and Buzz photographed their footprints, each other and the earth? The rest was grey dust!

I waded between the great boulders of ice on the shore and found one berg with a great horizontal crevice filled with thick icicles and torn ice which had a lovely luminous light leaking through to the core of its frozen mass. I put my lens into it and shrunk the world by getting to the heart of its ethos – frozen water and air. But it was still too detailed so I moved on, looking for simpler shapes in these sculptures and this is what I found, a gift. I shot three pictures, this one, one a little looser and a close-up of the dripping finger. In a pretentious moment I might say that this diminishing shard symbolises the effects of global warming and the melting Polar regions. But I won't because I don't want to spoil one of the few photos of mine that I nearly like.

41

COLD GOLD
CANADA, 2008

I think I must be a photo-pervert. After spending two weeks prowling around the extraordinary picturesque high Arctic and bagging a polar bear swimming with a cub, a brace of walrus, lots of birds, ice and some lovely local colour, this is my favourite image. I'll tell you why I'm trying to like it.

It's abstract; you may not be able to discern that it is a large glacier winding down to the sea which I have excluded at the foot of the frame. I deliberately diminished it by using a telephoto to eliminate the coastal clutter and simplified it by exposing for the sunlit ice. Confusing scale is a ploy commonly employed to arouse a little curiosity in the viewer, so although I tried a couple with a slice of sky across the top, that arch of darkened blue alone gave it some perspective. I enjoy its apparent radiance but more so the texture implied by the creases and crinkles woven into its ancient form. Lines cross horizontally and wiggle vertically, lacing together like filigree on a melting tapestry. But maybe I like it more because as I glanced around the deck I could see lots of wide sea-ice mountainscapes illuminating my fellow passengers' sensors, but no one else peering deeper into the world searching for its smaller secrets – the jewels which were gilding its undeniable splendour. I'm not sure what manifests this desire to dissect the components, I did dismember everything from radios to roadkill when I was young, or a wholesale inability to deal with detail, I do live in a furniture-less ornament free white environment. Either way I recognise this attitude as both an asset and a real handicap when it comes to making pictures. I think it helps me to see, to look into reality or representations of it; it reveals the minutiae that make everything right or wrong. But such a compulsion for microscopic examination in the quest for pictorial perfection is equally a blight on any effort to expand my vision of the world. In its most severe form it physically stops me from pressing the button when the wider, bigger world is in fact the better picture.

I fear that in its terminal manifestation I will be unable to actually photograph anything because anything in itself will be too much! And how many people will appreciate 'pictures of nothing'? Sounds like a post-punk album title.

42

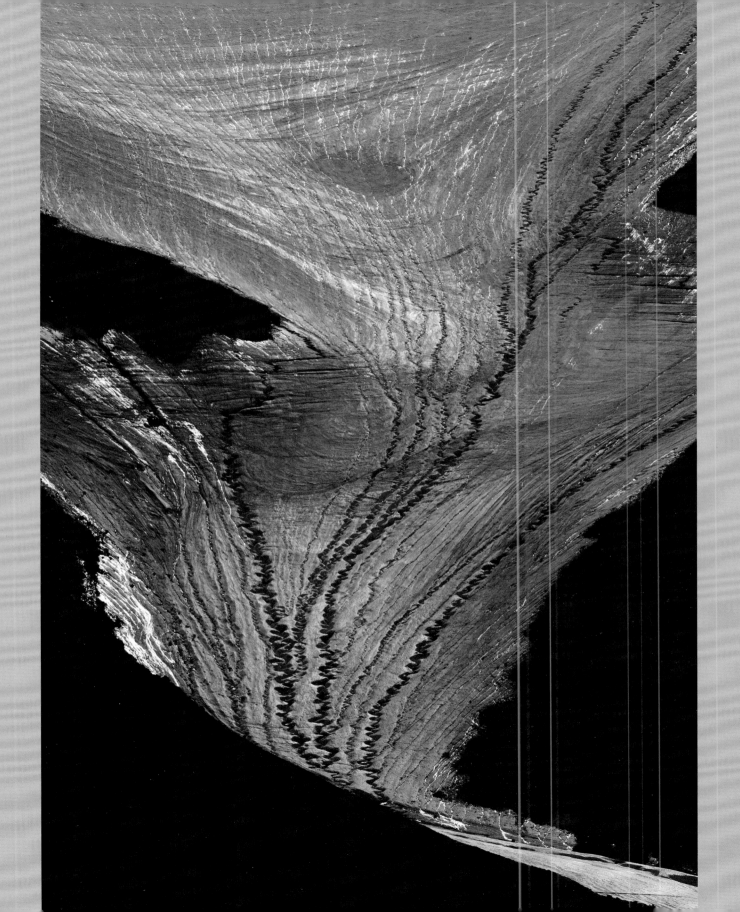

43

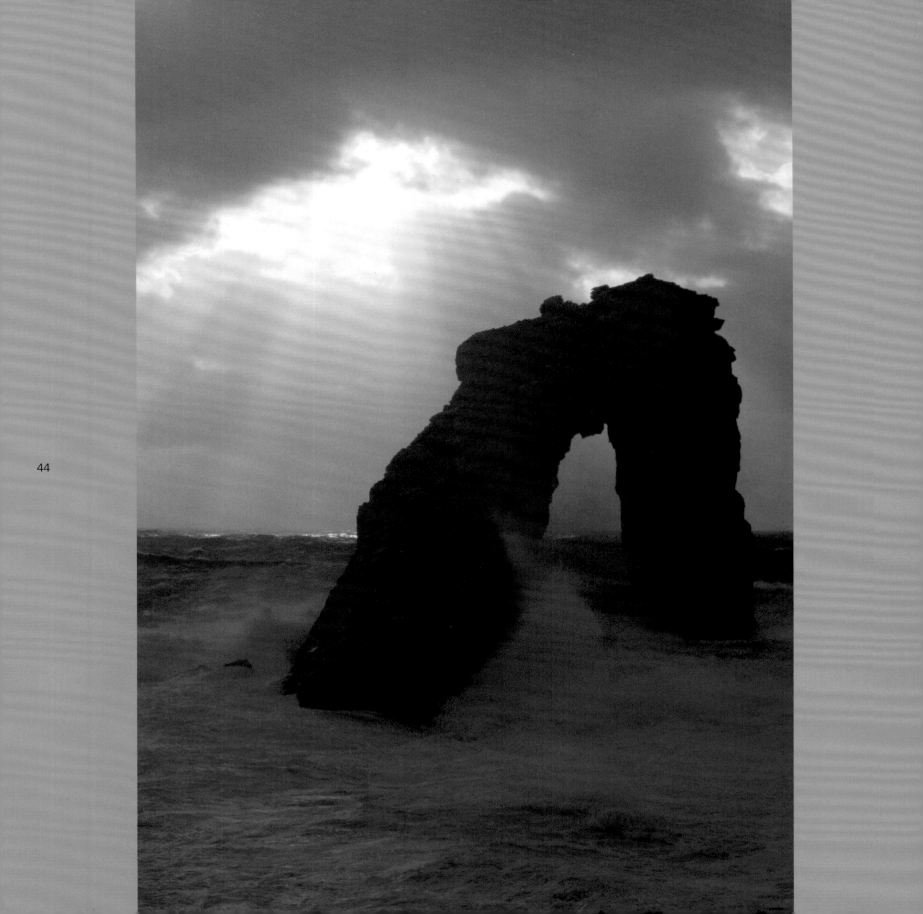

44

DOLMEN STORM
SCOTLAND, 1988

'Ultima Thule' is an old name for Foula, a tiny speck far to the west of the Shetland Isles. It means 'edge of the world' and for a long time I'm sure it was. When we visited in 1988 to annoy the local populations of Great and Arctic Skuas, bolshie seabirds who vigorously defend their nests by beating up any transgressors, we had to charter a little prop-plane from Lerwick and stay in the homes of the few local farmers. They seemed to be practicing the art of hospitality but any reticence might have been down to my appearance – bleached blonde, spikey hair was probably a first and things had been a touch conservative after the last Vikings left.

The airstrip was gravel and there were no hotels or Bed and Breakfasts because there were normally no visitors. The outgoing flight was on a sunny, breezy day and was a bit bumpy but otherwise fine apart from the landing. The shingle strip was thus functional, but it had also been identified as a beach by Arctic Terns and we had to land through an understandably angry colony that swirled into a snowstorm around us. The pilot was worrying about 'bird strike' while I was worried about the birds!

When it was time to leave we couldn't. The wind had got up and a telephone call revealed a two or three day gale had hit. It poured, we tried to work, film, but gave up and had to wait it out. I took this image one afternoon when the rain had relented and someone had reported seeing a pod of killer whales close to the shore. I sat shivering for a couple of hours trying to turn seals into Orcas but I've still to see these animals in UK waters. For a while the clouds cracked and silvered the sea, so I set up to get this arch being battered by the waves. The wind was pretty unruly and my attempt to combine a sunspot with crashing spume became quite a challenge. However, either side of the sea-cut dolmen were some other large rocks which competed with the star for attention so I also had to wait for them to be covered by water as well. I took six frames; this is the only one that nearly works.

Two days later I flew out on my own. Despite the storm's spiteful tail, the pilot reluctantly agreed to chance a touchdown but only if I was waiting to jump in and go. I did, he swung the plane round and we were off in less than 30 metres. This time I wasn't quite as worried about the birds.

FROZEN CLICHÉ
NETHERLANDS, 1988

What do you do? You're damned if you do and then you're sad too! Winter on the eastern flatlands of a country which without windmills would only have clogs and cheese and tulips and horrid blue and white crockery. Okay, and legal cannabis, and Van Gogh and Vermeer, and Marco Van Basten and huge wintering flocks of wildfowl. I like Holland a lot. But facing up to photographing subjects that appear on millions of postcards is a loser's game because they will have been defined and refined photographically. The world's best windmill shots will have been gathered, analysed, re-shot, re-touched and reproduced en masse. So everyone knows a good windmill shot when they see one... and this, as is apparent, is not one of those. Damned and sad!

When I skidded out and across the frozen ground on this December morning there were clearly some pictorial assets to hand, a pale sun trying to pierce the cloak of fog that cleaned the landscape by hiding all the distractions in the distance; the frosty crust that had bitten everything and sugared it white, and here, by the dyke, a nice old windmill. But sometimes, despite having all the ingredients, it just won't work, a bit like the Dutch in World Cup Finals! The little hut to the left spoils the uniformity of the screen of reeds, but not nearly as much as the line of canal water which bleeds a white line across the scene. I tried going lower but then the mill got lost in the fringe of reeds – too much mist. I tried moving the subject to the left to get rid of that shed but there was a gap in the vegetation which was ugly. Anymore excuses? It was about -20ºC, I had glandular fever and was riding a bicycle. And being an idiot I hadn't brought any gloves so I could barely push the button...

Actually I do sometimes trawl through the postcard racks just to see what has been photographed – from where and at which angle. It often helps to quickly find the best vantage point to film archetypal 'wides' for TV programs, but from a still photo point of view it will soon tell you what not to do because it has already been done. And if it's been done, and better, then what's the point?

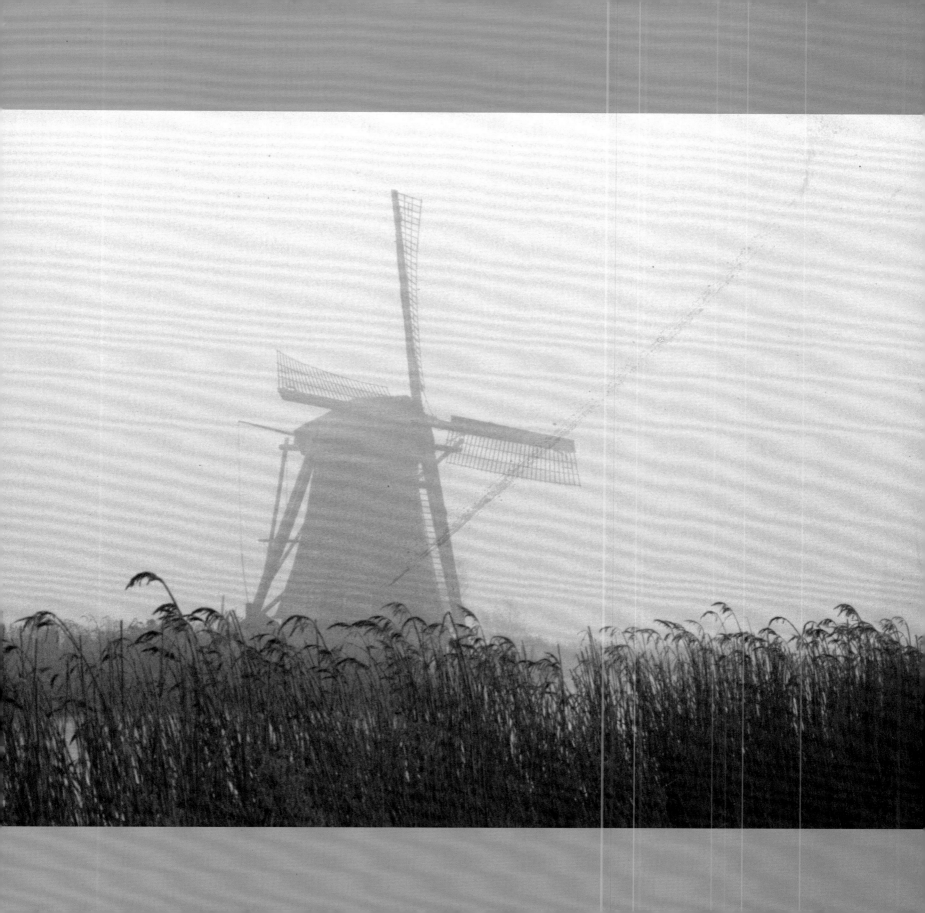

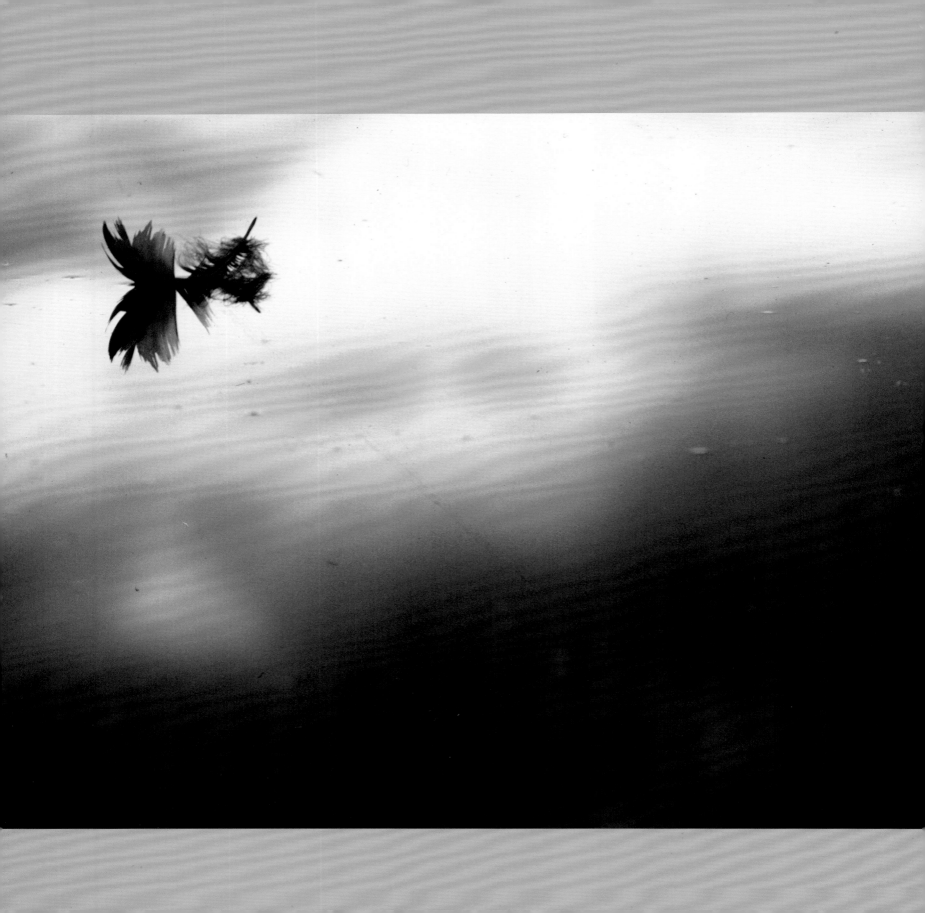

FEATHERLIGHT
ENGLAND, 1984

I plan a lot of my wildlife photographs. I have a sketch book in which I create fanciful designs for perfect images that I then sometimes go to energetically ridiculous lengths to attempt to realise. I often combine elements which I have observed in the world that work well together. So I manipulate a lot, always have, whether it's baiting wild animals into just the right spot, using tame animals or captive wildlife. So long as these creatures, which I consider sacred, are not harmed or disturbed then that's fine by me. I need to be in command of as many of the variables as I can because I feel that it is essential to manifest control over as much of the process as possible in order to tend to perfection.

And that's the game isn't it – we're all trying to get the perfect picture. I'm not really much interested in anything less. In the past the process stopped at the depression of the shutter button, that was the strict and ultimately supremely challenging discipline of shooting slide film. But not any longer; now we can all manipulate our images cheaply and cleanly using our Macs and PCs. And it won't surprise you that that's fine by me, it's the result that counts, the picture on the wall, not the story, the suffering, the cost, the technique or the subject. It's either a fair stab at artistic perfection or it's nothing. I won't lie though, I don't cheat, there's no point, if I've fiddled it I will tell you and if you don't like it you can enjoy another photographer's work. I know I'm not a proper wildlife photographer because the subject will only ever be secondary to the picture for me. An image of two snow leopards fighting in the shade of a total eclipse that took five years to get and cost me my marriage would be of zero interest to me if it wasn't a perfect picture. I'd rather have this photo of a feather on a puddle.

It was a cold winter's evening and I was walking home when I found the chain of pools filled with liquid sky in a potholed gravel track on a local estate. I set up the camera on a tripod and went to find a subject. At the river's edge I picked up a swan's plume which I then floated in the largest puddle. I blew it into the corner and took one exposure. I was poor, the film was expensive, I shot only what I needed to. It wasn't planned, pre-drawn or invented. Tell me if you think I, or anyone else, could have done it better. You see... nearly perfect.

PAINFUL CATCH
GAMBIA, 2008

Looks nice doesn't it, and this is 'unfiddled', just as it was on that cranky ferry which chugs across the mouth of the Gambia river, just waiting for the horrible disaster which is its inevitable destiny. A dawn sailing, a light mist trapping the glow of the risen sun behind a sumptuous veil which all but seamlessly blends sea to sky; the silhouette of the modern vessel rendered less bland in lavender grey and before it on the flat calm the traditional craft with its complement of busy fishermen. There is one standing proud, pole in hand, facing forward like a figurehead; there's the gang drawing the net, bent to the business in a painterly assemblage with minimal overlap or actual ugliness of composition; there's a wash of muted colours over them, gentle yellows and reds and oranges, and the rusty skiff's name… then there's that bloke at the back. The one whose crown is just clipping the bow of the big boat, the one whose head-butting the thing and joining the two together, the one who is ruining everything.

I know he needs to be there for the balance to work, given his mate at the prow; I like his stick and its angle, but the convergence of forms is an imperfection. And it's one that could have so, so easily been avoided, and

that has its roots in old habits still breathing. Firstly the flaw: you have to microscope your images and you need to savage them with relentless self-criticism. Only then will you generate the desire to keep on and on trying to improve your photographs, attempting to one day attain that purely mythical perfect picture. It's tough; it's a recipe for a life of brutal dissatisfaction; it makes what for some is a nice hobby or enjoyable profession a frustrating and even miserable arena for self-recrimination. But then think of the alternative – you like your work, think you've cracked it, get smug and cocky and then lazy. You may as well run a bath and dump all your gear in it. Nothing is as disappointing as the attainment of a dream.

The reason: I didn't push the button and fire off a sequence of frames, one of which would have provided that instant of separation. Why: because I still shoot as if I'm using film, a resource which I always had to conserve due to cost, so I still try to press at the critical moment and not before. The result: prior poverty prevents perfection. Fact.

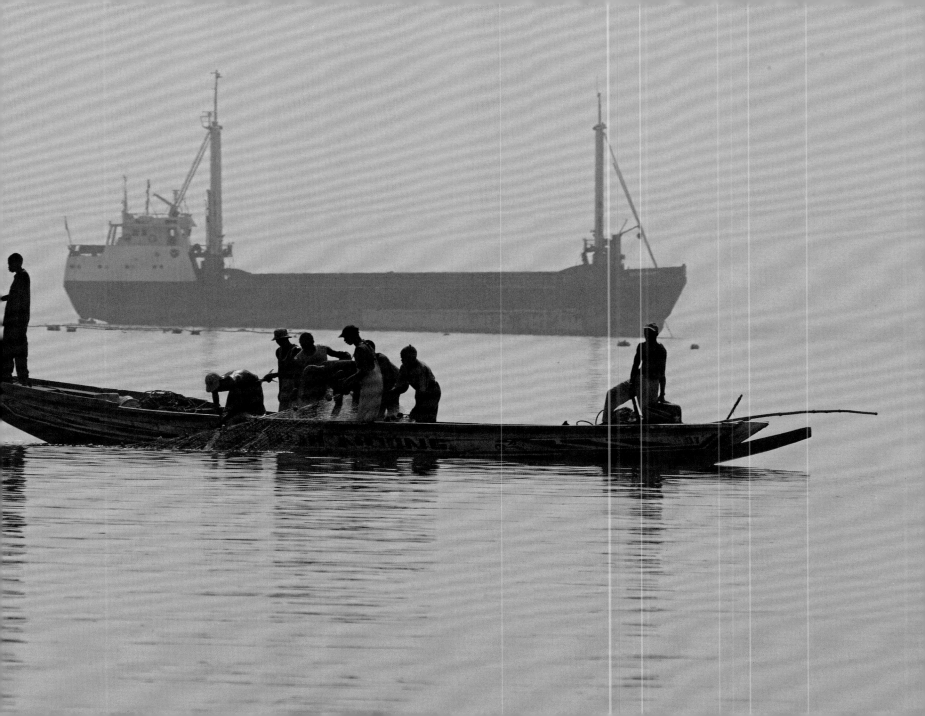

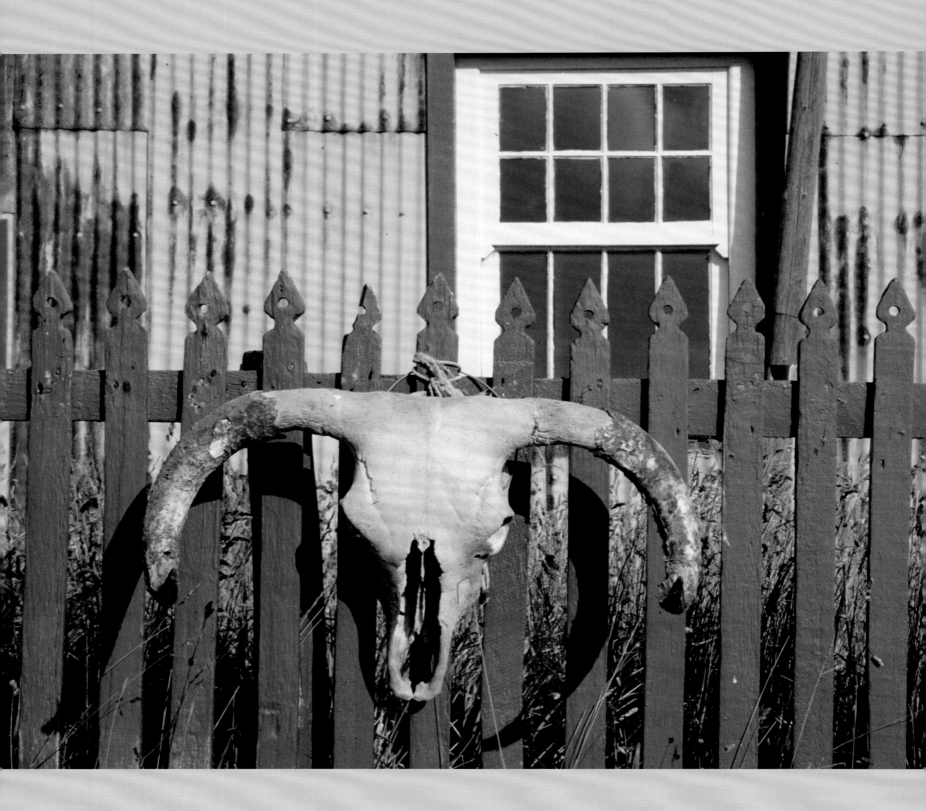

THE NOT SO OKAY CORRAL
FALKLAND ISLES, 1995

I took two photos of this subject. The other is much wider, shows the roof of the barn and its apex against a too-blue sky which looks polarised but wasn't. It has the same basic elements: green picket fence and matching window frames, rust-buffed corrugated iron front, unkempt grass in rich ochre and the core subject – the late Mr Cow. I wouldn't take that photo these days because it's ill-considered. It's okay but so much of the frame is utterly redundant. So much of so many frames are a waste of pixel space. If you don't need it, if it doesn't say anything or add anything to the image, if it isn't there to balance the subject, give context, give anything, then cut it out. And don't come to me with the ol' 'I shot it loose so I could crop in later' line. You should be making the choices at the point of image collection, not back home when all but a tiny fraction of those choices have gone forever. Stop and think about what you are looking at and what you have found; ask yourself why you are pointing your camera at what. Ask yourself what it is you really, really want. I look through my viewfinder and my eye races around the frame identifying all the crap that will add nothing and potentially steal something from the impact of the picture; I squirm and contort my camera eye so it can only see what I want it to.

You have to boss your gear otherwise it will show you what you later realise was a missed opportunity. Sometimes you have to do this extraordinarily quickly, in micro-seconds, as this is how long some of those chances last, and that's tough. So it's a good idea to practice when there is more time for consideration, like when you are working with long-dead cows.

I took this on the only occasion to date that I have had sunburned eyes. We had been chasing dolphins about on the sea the day before and gone to bed feeling fine. When we awoke all those previously 'sunglasses-less' were blinded by the tiniest amount of light. Luckily the cameraman was among the disabled so we all had a day off and I took this in the evening glow by which time I could just about squint through the camera. We tried to sleep in the barn but they were the coldest nights ever. No wonder the cow died.

OLD BONE
SOUTH GEORGIA, 2006

I wrestled with my wanting to take this away. For a naturalist collecting things is part of life, I've been putting bones in boxes under my bed all my life. I have a cabinet of curiosities overflowing with ragged and rotted remains, a skull collection second to none, a portfolio of owl pellets, dried insects, fruits and fossils. I've got two dead horseshoe crabs and a small tub of Ptarmigan poo. There are things in the freezer too. It's not weird, it's how we learn to uncover function from form and classify all life's diversity into the groups where they belong – because everything has its place. I'm not sure which comes first, a curiosity for the world's living and lived, or obsessive compulsive disorder. Either way the collecting gene is essential if one is destined to follow in the footsteps of Darwin. But this object is more than a dis-articulated vertebra from a seal backbone; this has also aged to have an artistic or historical covetousness. Imagine how it felt, rough, dry, and it had a baked, parched and old smell, like a tombstone. I was gentle with it though; to have dislodged any of the little lichens which were beginning to canker its surface would have broken the path plotted for its ultimate decay, maybe set the process back, interrupted its time line. And to remove it? Well, I decided that its context was a great part of its appeal; here at the blasted end of the earth, lost amongst a beachside boulder field, it had found its place. In a plastic box in a dark cupboard in a house in England? I've always felt sorry for those golf balls they left on the moon.

I know it might spoil it for you, but I'm honest so I have to tell you that I moved it from its resting place and placed it on top of this nearby boulder. I'm sorry if it destroys the authenticity or invalidates its archaeological providence, but I just couldn't get a photo without this contrivance. I used a tripod to get as much of the image in focus as possible, to flatten it, further squeeze it into the stone, to fossilise it. Luckily the overcast and soft light helped, a shadow would have given it a third dimension which would have spoiled it. When I finished I put it back into the crevice where it belonged. I like the fact that it's still there, so, so far away; perhaps this picture gives it some other value than romance, puts some beauty into a old bone. That's a job done for me.

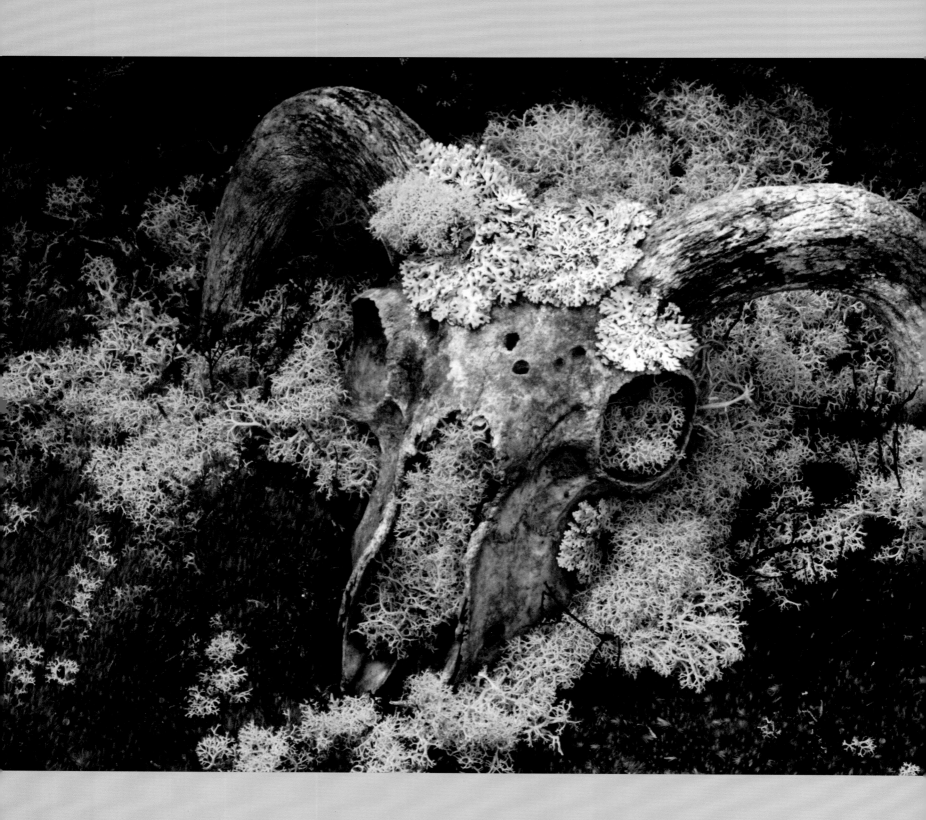

ANCIENT RAM SCAM
SCOTLAND, 1989

Submerged in a turf of wizened lichen, this pre-fossilised skull of a ram was a perfect, natural still life hidden deep in the great woods of Caledonia. While tripping over pillows of blueberry and the bleached bones of aged pines, sweating and filthy after a pounding of warm summer rain, all to find that ornithological icon the Capercailzie, I tumbled into a gully with a sodden thump, and when I sat up this eyeless fellow found me. It has all the resonance of a scene from Ryder Haggard or Conan Doyle except that it's all bullshit. I made it up, just as I did the photograph. Sorry... ish!

Here's how it really happened. I bought my father a book of paintings by the western artist Remington. Amongst his romanticised but talented depictions of Sioux, Blackfoot, Crow, Apache et al, in the throes of hunting buffalo, scouting for the cavalry and all things heroic there were a few still lifes, one of which illustrated an ancient buffalo's skull clad in the patina of years of harsh exposure out on the plain. It was greyed, pock-marked, chipped and supporting a flora of lichens and mosses. As there were no factual paintings of the tribes' vile slaughter, maltreatment and despicable exploitation, (I like the truth, at least when it comes to history), this was my favourite of the works included. So I copied it as best I could. I borrowed the old ram's skull from a friend who had got it from a farm in Northumberland, collected some crustose lichens, carefully scraping them off some asbestos shed roofs near where I lived, and glued them onto the skull using a water based adhesive — my friend wanted his trophy back intact. This is where a modicum of effort shifts from the sublime to the ridiculous. I boxed it up and drove to Culbin Sands just south of Inverness because I had previously been ogling the luxuriant carpet of lichen which prospers in the damp, sandy soils of the pine plantations there. Southampton to Inverness is 600 miles; eight hours there, eight hours back. An equation that equals determination, perfectionism or flagrant lunacy — you decide. Oh yeah, I also took a watering can and two big barrels of water because I knew that the soft colours of the lichens looked more saturated when they were wet. And it took me three trips to get it all down to my chosen location. That's an 'A' for autism if nothing else I suppose!

BLEACHED WHALE
CANADA, 2008

In summer the Canadian high Arctic islands are not a land of sweeping snow-scapes, soft rolling hills and iced mountain caps. They are a barren desert which can define what it is to be bleak. But it is far from boring: the raw geology is a wonder, a textbook example of the primal shaping of the earth; the specialist adaptations of the species which have evolved to thrive in this hostile environment are fascinating and these include the human inhabitants too. Here early man lived on the edge of his and her physiological tolerances and the desire to do so, to migrate here to avoid competition in the crowded south, is a marvel in itself. But it was about survival, that's where their ingenuities of technological advances were focused. That said, don't think that these people were primitive artless technophobes – bands of igloo bound grunting dullards; their culture survived in harmony with the environment where surely lots of others failed.

This whale's skull, probably from a Bowhead, is difficult to age. The Tuniit sites we were visiting nearby were around 1,000 years old and those that decorated their huts were weathered but still very much intact – the dry cold air had seen to that. But the locals have been harvesting whales continuously and on the beaches of the current settlements, fresh carcasses are abundant – something that worries me. The Inuit are justifiably proud of their culture and we all want to see it preserved at a time when it is imperilled by a meteoric move into the modern age. So traditions are important and this includes the hunting. But harpoons have been replaced by high-powered rifles, canoes by speed boats and dogs by snowmobiles. Thus the traditions have been perverted and the new technologies are no longer in tune with the sustainable past exploitation of a set of species that are under the threat of global warming, and not bearing up too well. When Narwhal were harpooned few were lost; when they are shot the recovery rate can be as low as 30 per cent. Their tusks are sold overseas and the cash supplements an already very heavily subsidised economy. It might not be politically correct to highlight this practice, but what the hell is going on here?

I took this photo to reflect these concerns. It was bitterly cold, colourless and harsh, and it felt pretty hopeless kneeling before this dead giant in a place that is out of sight and out of good minds.

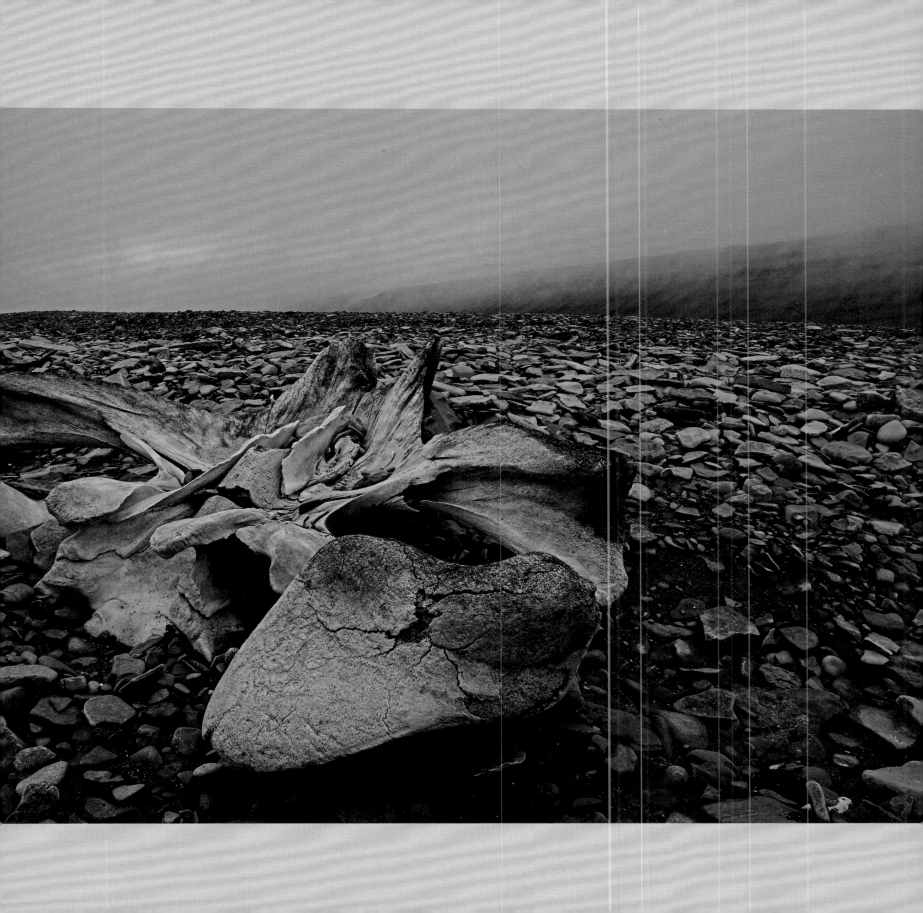

WHAT REMAINS

INDIA, 1993

Imagine if this is what remained of your late grandmother or a much-loved uncle or a son or daughter. A jumble of bones, many missing, spilling from a concrete cubbyhole in an old wall, open to the elements and the eyes of nosey-parkers like me, full of bugs and falling apart. It's unthinkable. But then the idea of carrying a dead relative onto a patch of wasteland behind a beach, scraping together a big enough pile of driftwood and setting fire to it is no more appealing. Or how about taking the body and laying it out on a platform where vultures and other scavenging birds are actively encouraged to come and feast, while you watch. For the Parsees, Hindus and some Indian Catholic sects this is the way they revere, honour and remember their dead. It's not disgusting or disrespectful, just different.

Incidentally, the 'sky burials' practised by the Parsees and others are no longer viable in many places due to the catastrophic demise of vultures across the sub-continent. A drug, Diclofenac, was given freely to cattle and for a long time not associated with the carcasses of poisoned vultures littering the land. 98 per cent of the vulture population died in just ten years, marking it as one of the fastest plummets towards extinction ever known. The few remaining birds are being quickly caught up and taken into captivity because, despite being banned, the material has been stockpiled and is still in widespread use. But vultures are long-lasting animals which are slow to mature and irregular breeders, so even a partial recovery is a tall order. What is encouraging is that the Parsee population are contributing significantly to the birds conservation – a cultural interest fuelling their valuable assistance.

The wall had about 50 such alcoves, each with a motley collection of bones; many had tumbled to the ground, but others had been recently tended, the red traces of incense running down like bloodstains. Some had more than one skull or several sets of femurs; it was all very Damien Hirst. The transparency that I took was very green, the cast reflected from sunlit trees into the shade of the wall, and was thus unusable until I scanned it and corrected the white balance digitally. Say what you like about the wonders and qualities of film, the digital sensor has it for me, far more flexible.

DROWNED MOTHS
SCOTLAND, 1984

The isle of South Uist in the Outer Hebrides has an otherworldly ambience. If you fly, before landing you look down on an unusual landscape of lakelets and lochans along a flat, sandy plain which stretches out to the Atlantic and is lined with long white sandy beaches. But like its larger mates, the islands of Lewis and Harris, it also has a backbone of hills, moorlands and the famous flower-filled machair meadows. Until recently it was remote and sparsely populated, as far off the British map as one might get, but those flights have opened this string of Gaelic gems to a wider world for good and bad. They remain unspoiled in large parts, an ornithologist's and botanist's paradise and one of my favourite destinations on the *right* day – because on the wrong day this can be a place where an entire ocean's fury can be spent.

Such a spat had just dampened our ardour as we were climbing around the western sea lochs looking for otters. We had seen some, far off and briefly, and then, despite the sunshine, it bucketed down in true tropical style and we were left soaked and cold. Time to slip and slide back to the comfort of a rusty Renault 16TL which was our 'home' on this three-week photographic pilgrimage to the Highlands and

its islands. The brooks were in spate and into one of them a confetti of these Magpie Moths had been washed, presumably from a resting site that had not survived the rain. Many were broken beyond 'use' but these two intact specimens lying in a mortal caress caught my eye.

The water doesn't quite work for me; it could be either blacker or whiter so as to hide the submerged detail of the pebbles. The wet stones are okay, I like their texture and vibrancy, they look freshened and the composition works with the rather bland big stone in the bottom left balanced by the moths in the top right. I got a twig and tweaked the corpses so they fitted together better and then shot the cameo with the camera on a tripod to get plenty of depth of field. You don't often see dead butterflies and moths, outside of spiders webs in garden shed windows or welded onto car number plates, because they are so fragile they decompose almost instantly, having perished in the secret spots where they have been avoiding predators. So this rather sad still life, very much of the 'something from nothing' school, has endured for me.

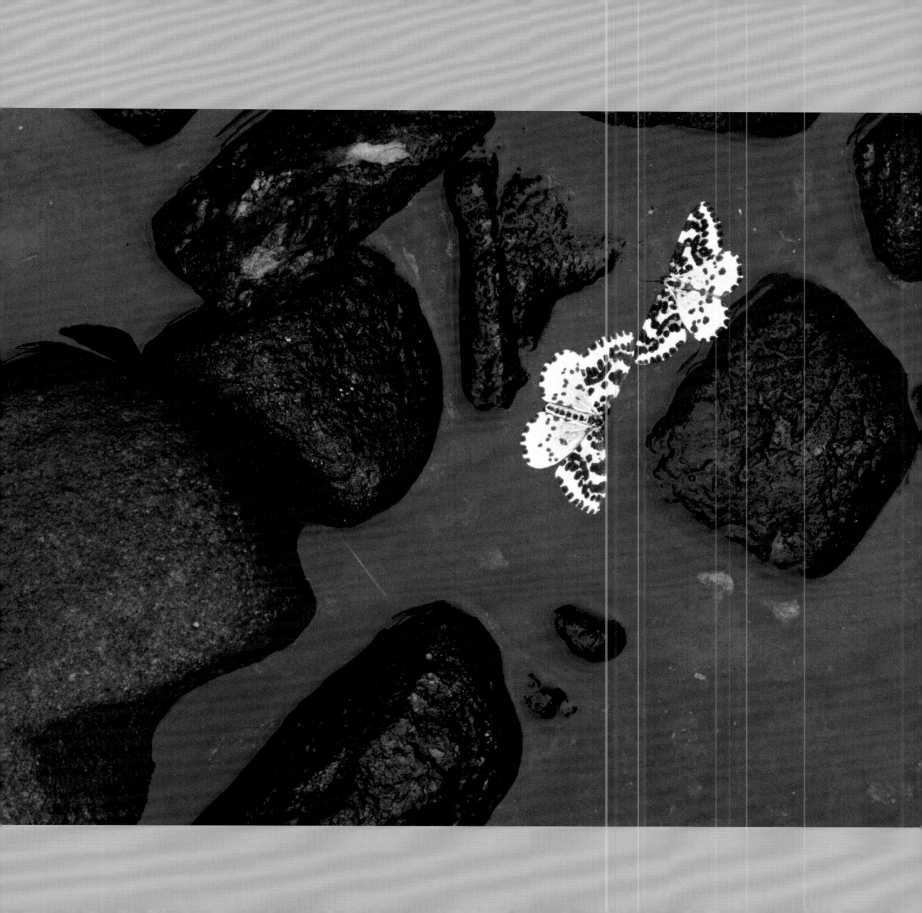

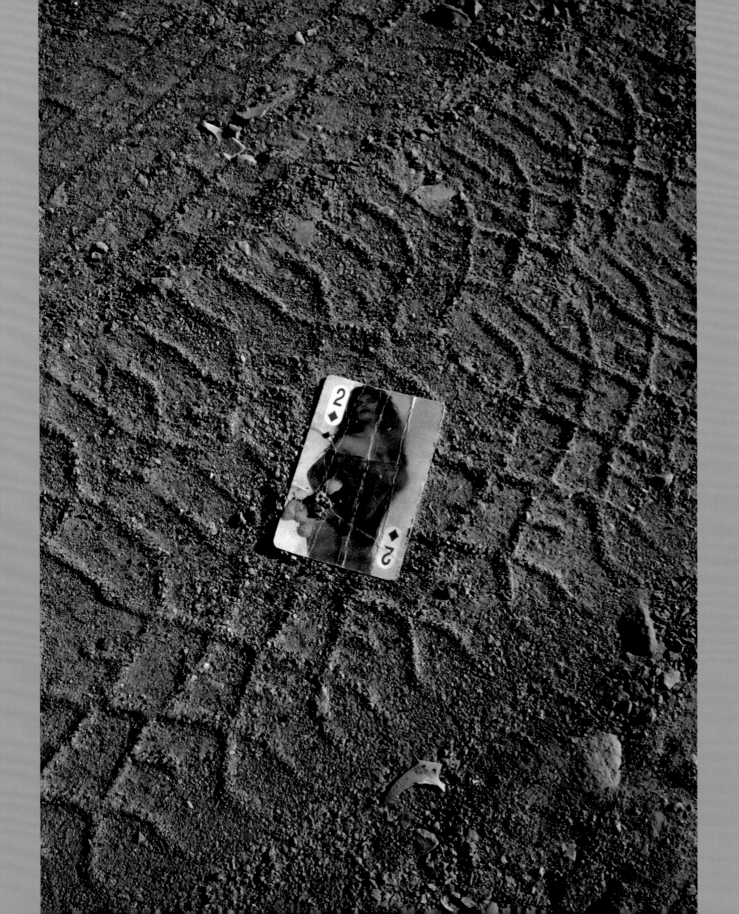

LUST IN THE DUST
MEXICO, 1996

She was hot and so was I. We met on a sultry Mexican roadside and there was an instant chemistry. She was laid out so provocatively, oozing sexual abandon, just waiting for me to find her, all undressed and going nowhere. I was sweating, tired and heading for the nearest cerveza but now I wanted her in the dirt, and within minutes I had her, and here is the proof!

Yeah, sorry, as you can see it was pure fantasy, and as usual the picture is an indecent exposure too! Still, after a few weeks chasing hundreds of millions of butterflies around the deserted Highlands, a man's eye can be easily caught by a stray female. Looking down is a naturalist's habit: lots of things creep, crawl, slither and slime across the ground, so scouring the path underfoot can pay dividends – I even found a £20 note once! I've found lots more that have teased my camera out of its bag and this saucy playing card lying in a dirty truck stop was another. I liked the tread marks and the low evening light lifted them nicely; it also struck me as particularly 'Latin' that this lady should be bedded here. Clearly not part of a winning hand and, although I'm not a connoisseur, I feel not a western style of playing card pin-up, a bit too big, brazen and, dare I say it intimidating – she's no demure 'Page Three'

babe. So had you asked me to play photo detective, to identify the location of the scene based on the scantily clad evidence, I would have gone for South America, and Mexico is therefore close-ish. Oh yes, and the tyre prints belong to an old Firestone tyre product now only sold in Mexico, so I would have got it exactly... well, in my Jack Bauer dreams.

Trying to get more into less is a constant objective of mine. It's what I call the 'F. Scott Fitzgerald technique'. This author continually pared down his prose but took nothing of the substance out, he could say more with less, the antithesis of the verbose Thomas Hardy, or that maestro of excruciating wordiness Herman Melville. Therefore if I can sometimes fill a frame with 20 square centimetres of a place, rather than the obvious sweeping panorama, and if that place can still be seen or reflected in the shot, then the flavour is intact and I'm going to be closer to being satisfied. Thus, although our affair was over in less than a second, this wanton woman put a smile on my face.

CLINT'S WASHING LINE
PERU, 1995

The páramo is a high grassland which flanks the Andes above the tree line. It is coarse, tussocky, off the beaten-track and difficult to walk or ride over. On the day that I put my arse in a saddle for 14 hours to explore it, the sun shone, and despite a nip of breeze the air was thin but kind. It was brutally obvious, however, that this was probably 'the day' of climatic kindness and that a bad one up here would hurt. Soft, rolling hills ruffled up to the rocky slopes of the volcanoes whose black silhouettes cast a backdrop of raw danger over the highlands. At times they were cloaked in twisting cloud, but it was never long before the jagged peaks cut through to intimidate all that dared to survive here in spite of the pervasive hostility.

Our destination was a small farmstead where alpacas provided sufficient income for its proprietors to able to cling on to their extremely remote and traditional lifestyle. The corrugated steel roofs shimmered as we nudged our nags up the muddy path and into the grassy yard. The corral of windowless barns held some rough dogs, thin fowls, thinner mules and a family whose smiles could crack diamonds. They were squat, robust, and weather beaten, a beautiful tobacco-skinned people whose hair shone glossy black and

were dressed in a rag bag of cloths of various colours and patterns (I did photograph them, but soon after we arrived they went indoors and donned all their 'best clothes' which ruined the pictures for me). As I staggered about cursing my cowboy aspirations and nursing bruised buttocks and knackered knees, I spotted this poncho hanging beneath the eaves to dry.

I framed it tight to get rid of the roof line, but ideally I would have liked a little more of that wonderful cracked mud wall to hold it in place. But the patina of age and hard use stained and ingrained into the fabric is what makes the picture work. This is so very clearly the real thing; this is a working poncho, not some cheesy tourist take-home or catwalk homage to the garment's authenticity. This battered square has been there through thick and thin – it's bloody marvellous! As for the photo, well, aside from the lack of a bit more sun-baked brickwork, it is quite good; but if you look closely you'll see it's hung on a green nylon cord... I don't like the green, as it spoils the earthy hues of the thing, so that's bad and the plastic rope, that's downright ugly!

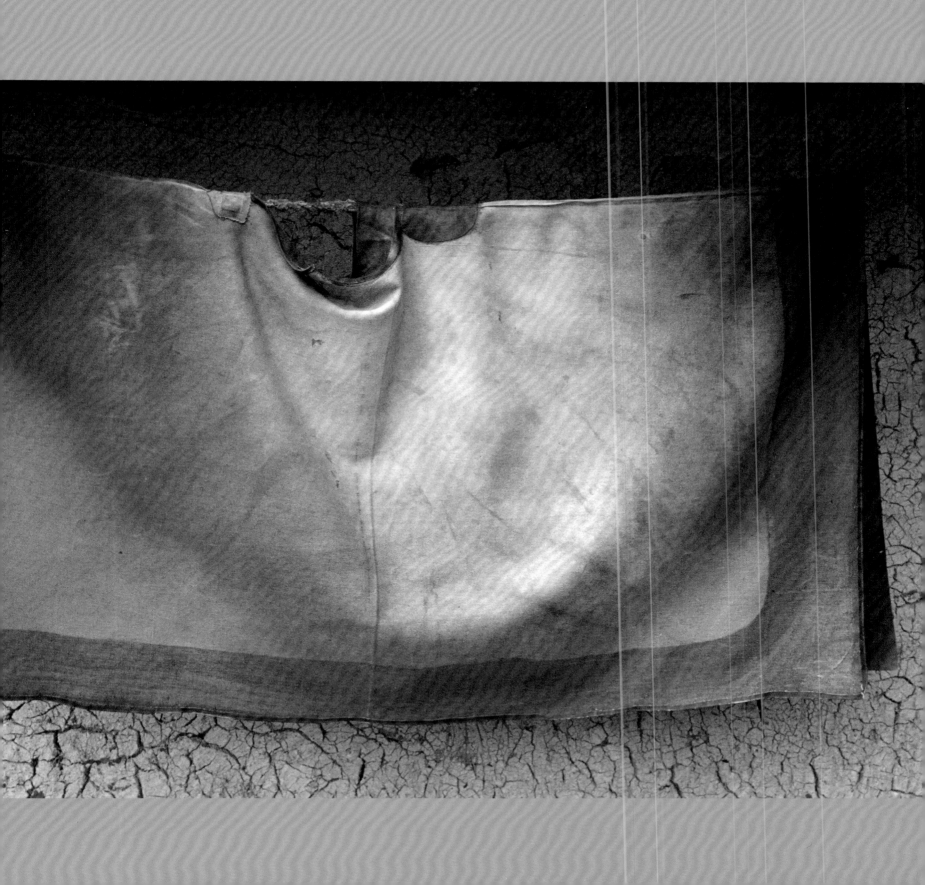

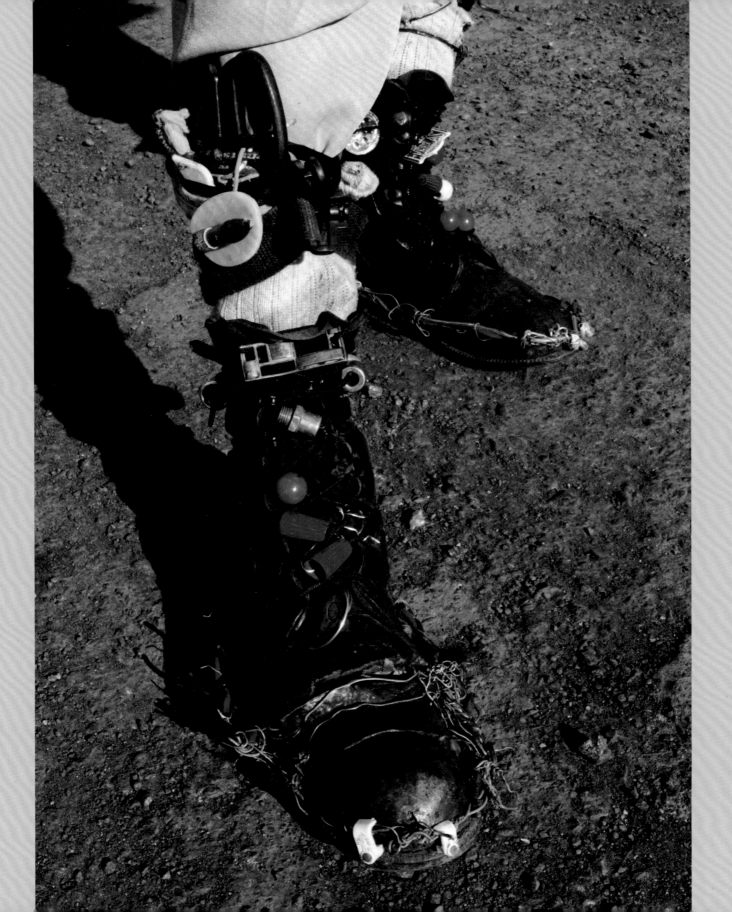

MAD MAX SIZE 10½

ST VINCENT, 2008

I like the transference of everyday objects into art or jewellery. For me, the defining example was punk rock's safety pin. I wore them along with lots of other little things which I tied and stapled onto my black leather biker's jacket. I got one of my girlfriends to sew fox teeth, key rings, bottle tops and pull rings into my hair, along with strips of rag, coloured cord and buttons. I thought it looked great and since then it has been much copied. I can't claim to have been the originator, but my generation of bright young rebels were those which scoured other 'primitive' cultures and brought parts of their ideas into an urban fashion. If I had owned these boots circa 1977 I would have had the coolest treads in town!

I had been out snapping in the town, which like so many of the less developed Caribbean settlements has great photographic potential. The gaily painted clapboard shacks can be tempting and the local people effuse plenty of colour themselves; it's also true that the locals are so friendly that you can get away with murder without abusing their privacy, especially if you take the time to say hello and have a chat. To my mind there are two techniques when it comes to 'stealing souls': 'Sneaky' and 'Upfront'. For 'Sneaky' I employ two modes of collecting pictures. Firstly I use a telephoto, typically a 400mm, maybe with a 1.4 x lens converter. Obviously this means you can be some distance from your subject and fire off without being noticed. To try and not look like a photographer I dress down and just have the one camera and lens, no big bag of kit. I sit in a chosen spot with my camera wrapped in a plastic carrier bag as a bit of camouflage and wait. I drink lemonade, pretend to read a newspaper and watch. When something nice happens I pick up the 'bag' and shoot; it's all auto, and if I get spotted I might move on. In a crowded place where hiding won't work then I use the same 'bagged' camera with a big wide angle and I shoot from waist height while looking away from the subject and pretending to speak loudly on a mobile. Any dodgy horizons and exposures can be rectified later on the laptop.

For this picture I used the 'Upfront' approach: I said 'I love your boots man, can I get a picture?' I don't know what he said but here it is.

SOMETHING BORROWED
TANZANIA, 1994

I haven't a single picture of the lady around whose neck these trinkets hung. I can remember her face, which was interesting, very black and extremely shiny. Her head was clean-shaven, a froth of grey stubble and plenty of bumps and scars, her eyes small but bright, her arms thin. She had good teeth though and was a grandmother with a baby in her lap. I sat 'talking' with her for some time in the sparse shade of an acacia that had endured an equally hard life. Some small boys arrived on the edge of the boma with a herd of goats, I raised my lens and wasted a shot. I've got it and it is horrible; the harsh light was the culprit and the reason why the old woman was also not a potential subject. But I had already been looking at the way the Maasai in this remote tourist-free corner of the country had found alternative uses for various scavenged or traded items.

Several younger women had used the spool centres from music cassettes as earrings, their specifically expanded lobes holding them, and when I remarked upon this, they giggled and were very coy. They were obviously 'cool'. Elsewhere bottle tops shone from doorframes where they were pinned, and drinks cans had been cut and flattened to display their vibrant, shiny colours. This woman had four Yale keys, their rings, some chain and some tape centres on her necklace of which she was very proud. I tried to uncover how long she had owned the keys and in the process of our mimed conversation got my keys out of my pocket. This was a mistake because I was directly lobbied to exchange them for all and sundry. But they were the only keys to my door, I had no spares, and I felt so bad that I couldn't satisfy their desire for something so materially inconsequential that I searched for substitutes. I cut off all the buttons I could spare without compromising my dignity, gave them some coins and my stash of cosmetics. Whenever I visit a hotel I take all the complimentary shampoos, conditioners, hand creams, whatever's available. I use my own, I don't need them, but I meet plenty of women who do! So without feeling like a cheapskate I fill my bag and then fill a bigger one whenever I head somewhere where I know these little pots will be priceless and very gratefully received. I take the trouble to explain their use; I'd hate to think of beautiful African women rubbing shampoo into their skins – spotty tribes, not my fault guv'!

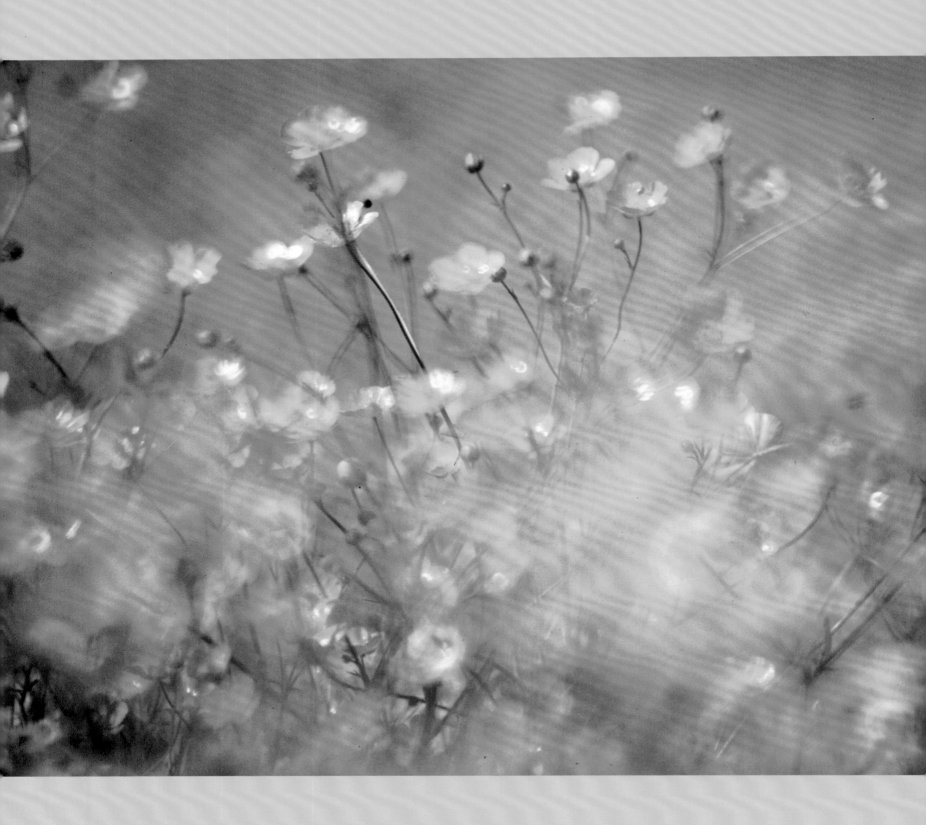

FIELD OF TRUTH
ENGLAND, 1989

I now live about two miles from where I took this photo and it's a gravel car park for an adjacent restaurant. In 1989 it was a field of gold, it glowed, it sang 'Yellow' years before that atrocious band did. I drove by and then watched the weather until the following Saturday afternoon when I returned and uncharacteristically expended a whole roll of Kodachrome 64 on this buttercup bonanza. You can say 'I've seen fields like that' and you may be right, but this particular patch of wet meadow was stuffed, rammed, crammed, smothered with more of these fragile blooms than any other I've ever seen. And for once the weather worked for it too. Buttercups, dandelion heads and cherry blossom, even autumn birch leaves and hawthorn flowers, have two deadly enemies from a photographic perspective: heavy rain and wind. So many times I've watched potential shows building only to see them washed and blown away before their prime. 'Another time' I've thought, but it seems everything becomes a car park eventually so seizing life's simple spectacles is essential.

I wanted everything to be yellow so I shot low, on a tripod, through the flowers. I used the densest bouquets I could find as close to the lens as possible, touching it even, to produce an out of focus veil to diffuse that hue over the frame, as well as soften up the sticky and spikiness of the buttercups' stalks. I chose a telephoto, an old 500mm mirror lens, to compress the perspective and thus intensify the colour and made full use of the stop down button to check to see what I was actually getting. All too often lazy photographers brought up on 'auto everything' don't flick this switch before they shoot and then wonder why their subject is lost in the background or why there is some horribly distracting element in the frame. The camera is not the human eye – you have to learn how to look to see with it and that button needs to be one of your best friends. Clearly I didn't want a single point of focus here, I took some pictures of individual plants but felt that it detracted from the fact that this was a spectacle en masse. And I like the fact that, for myself at least, this acre of Hampshire was, for a few days, just that – a simple yet stunning spectacle. The restaurant is okay, but for me the menu is a bit jaundiced. Ha, ha, ha!

73

GARDEN STAR
ENGLAND, 1986

Familiarity breeds the most contemptible laziness when it comes to making pictures. Our taste for novelty and the exotic gets us into all sorts of trouble and wastes so much of the available pleasures in life. Read into that what you will, but we are all guilty of this, and should be tried for treason when it comes to photography. Whenever we step off a boat or plane we open our eyes and find things to focus upon; we take a significantly greater number of snaps than we do at home because we have long ago stopped looking at what's around us. It's terrible; the subjects that are most accessible to us, those which we should know best – both tangible advantages when it comes to using them as photographic subjects – are adamantly ignored. That's why I'm so pleased to include this picture of a dandelion on my front 'lawn'. For me it's a study of a beautiful underdog, an unsung hero; it's a little triumph of making something out of nothing. I've got some nice pictures of orchids, and weird and wacky tropical blooms, but you're not having them – here's a dandelion!

I looked down at the spattering of bright-yellow circles spread over the tatty rug of grass and thought there's a picture there somewhere. The crux of the image, I decided, was the rich and pure colour, so I planned to get rid of as much else as I could. Thus, I got a sheet of black card, cut a 10-pence-sized hole in it and propped it up so the sunbeam it projected struck the subject on the head. I then put a black drape over a chair to cut out all background detail, used some scissors to trim away a fringe of grass, put the camera with a macro lens on a bean-bag, and gave it a long enough exposure to keep as much of the flower in focus as possible. All told it took about 30 minutes – 40 by the time I'd packed up. Being mean I shot three exposures on what was, for me, very expensive Kodachrome. At the time I'd not seen another dandelion portrait like it, so that was worth a point, and I quite like the way that the florets swirl like tentacles in the infinite black. Maybe it reminds me of those deep space photographs of distant galaxies twisting so far beyond our comprehension. But maybe now I'm polluting a rather ordinary picture of a very ordinary subject with a hint of pretension. So I'll shut up before I spoil it!

KOI POLLOI
HAWAII, 1992

It wasn't the Waikiki babes, it was the honeycreepers; it wasn't the idealised atoll, it was the World Surfing Championships; it wasn't Magnum, it was the fine snorkelling that made us slog all the way to this stupid place. But I was bankrupt, had no credit cards, had no money so why, why, why Hawaii? I'd read Walking on Water by Andy Martin, a well written sort of history of surfing, and although I had no intention of getting wet, I think this sealed it. Plus it had I'iwi, a brilliant orange bird that had exploded from the pages of my childhood bird books, and whales, coral reefs, volcanoes, observatories...

The hurricane hit after we had booked. It all but destroyed the island of Kauai where most of the good birds are so they closed it to visitors. The bad weather continued so they cancelled the surfing. The reefs that we visited were all long dead so they lied in the brochures. The whales were there but they said there were no boats going out because everyone would be seasick. We eventually went out and 20 Japanese re-enacted the World Vomiting Championship – which was nice. It totally pissed down – which wasn't. We went up to the summit of Haelekala to photograph the remarkable Silversword plant but a fat ranger told me I couldn't so I waited until I thought he had gone but he wobbled out of a truck and shouted at me. I lost count of last straws, there were enough to weave into a grass skirt. We finally washed up in Waikiki and found the whole of Tokyo buying Chanel in the American version of Blackpool.

So before you skip past this picture of Koi Carp swishing on the surface of a hotel pond realise that it is the only saving grace from a journey into the true hell on earth. That's not an excuse; the previous anecdote is only for your amusement and a bit of context, pictures must work without stories to bolster them up. Nevertheless I've got a soft spot for it, I like the fact that these fish have been successfully reduced to their most important feature, their vibrant colours, and I like the tissue-esque texture on the surface and the composition of their shoal. The fish's fins are still visible for those who need them, but for me it's a picture that I can still live with, I can't think of how I could take a blurry photo of overblown goldfish and make it any better, and guess what... I won't be going back to try!

MOONDANCE IV
ATLANTIC OCEAN, 2008

Here's a thing: I was sat on the balcony of a luxurious cruise ship cabin thinkin' about this 'n' that and looking at the moon which had risen as fast as the sun had set. I had to get tuxedo'd, which when I'm on my lonesome always seems a bit of a waste of time, so I was putting this off with the help of a generous glass of wine. And I just thought why don't I take some really slow exposures of that moon whist zooming out and panning about. So I did: I took 147 photos over the course of an hour and a half, was late for dinner, but cheered myself up considerably. Simply because to the best of my knowledge I've never seen any other pictures of the moon like these. Yet everyone has a blurry phase when they try two or three or five second exposures of things, and everyone points a lens at the moon, and everyone zooms and pans. But just imagine if no one had ever done this before; it's difficult to actually believe, it's so simple. Wow! That would be so exciting; that would be what it's all about – seeing something familiar in an entirely new way – that's my driving ambition, my photographic Holy Grail. And if it were a simple idea too, well, that's nirvana in a can!

The majority of the frames were no good, it was difficult to moderate the degree of jiggle and pan when I couldn't see the subject, so although it was where I wanted it at the start of the exposure it wasn't at the end and thus the composition didn't work. But five or six were beautiful, like shoals of weird luminous jellyfish in the deep black of the sea or bizarre auroras fleetingly formed in far northern skies or those patterns you burned onto your eyelids as a child by staring at a bright light and then plunging your face into your pillow, those rainbow shapes that raced back and forth each time you blinked. In some of the images the merest traces of craters are visible so the subject is not entirely rendered abstract; it's a stuttering moon, caught in a rear-view mirror on a bumpy road, an astronaut's last vision before re-entry.

As you can tell I rather like them. You do or you don't with these type of photographs, they are either art, pathetic and pretentious (I hope you like my title and numeral!), or mistakes. But if I were ever tempted to put one of my own pictures on one of my walls it would be one of these, and that's what it's all about I suppose.

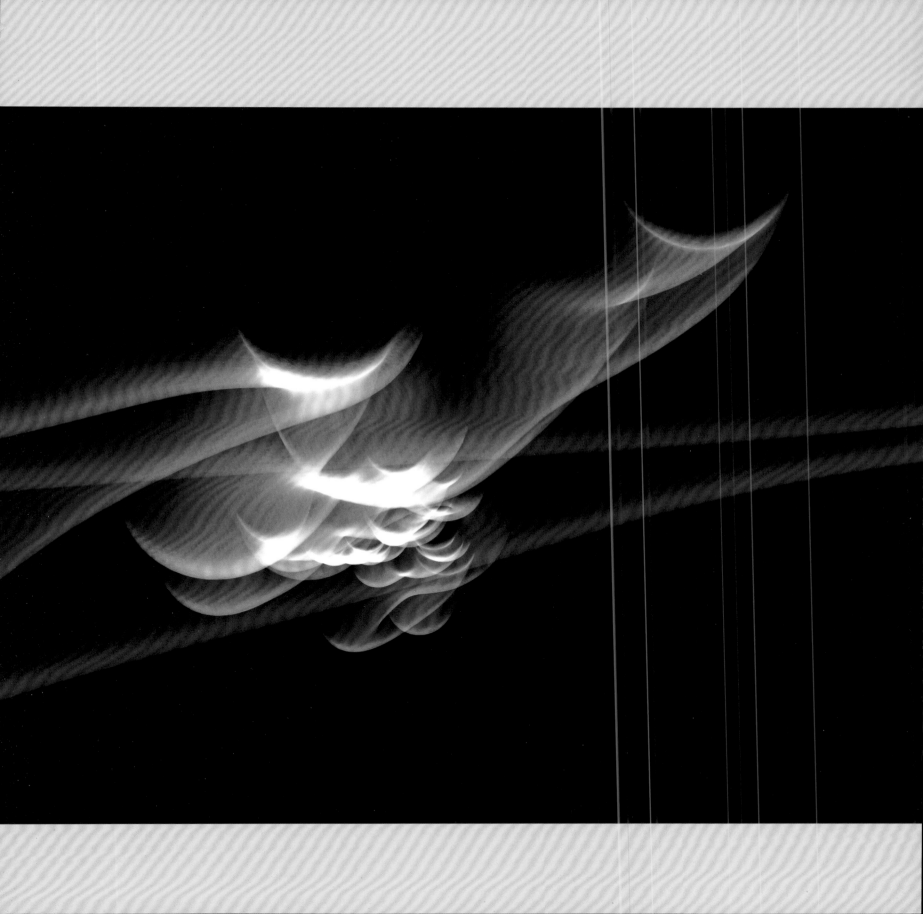

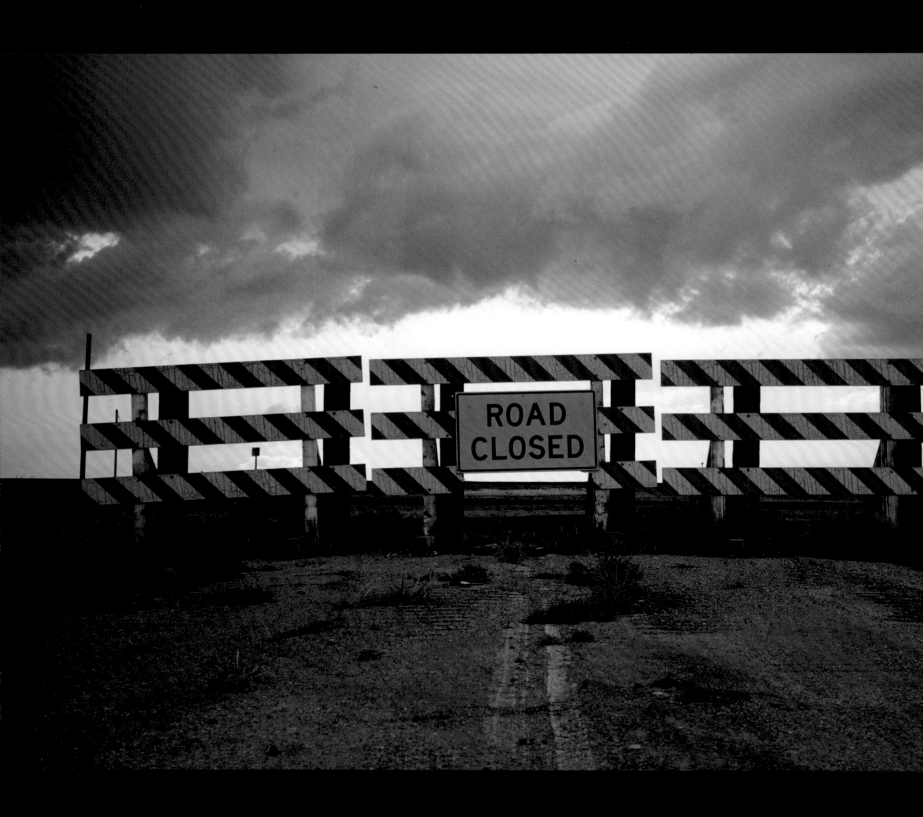

DEAD END
WYOMING, USA, 1997

I'm not sure but isn't this another of those superfluous signs which now blight our every view and jostle for prominence in our motorised landscape? The road didn't appear to have ever gone anywhere anyway, up and over a rail track that split the earth from the sky in a straight metal meridian, and then off to another part of the wretched horizon where only bluebirds would fly if they could ever find a rainbow. This rain-soaked prairie defined 'bleak'; no wonder parts of it are unsentimental called the 'Badlands' – it didn't feel like anything good ever happened here. And when Dave the soundman thought better than to control his competitive zeal whilst crucifying the local opposition at pool in a very 'local' bar the previous evening, things turned a little worse still. Was it common sense or a cowardly streak that had me offering scant encouragement from very near the exit throughout the final tense frame?

The image oozes apocalypse, the bruising sky is coming down, squeezing that pale stripe of rainless prospect away and the thirds divided between this, the battered barrier and the dead wrinkled tarmac unite to present an outlook of hopeless misery and finality. Great! All it needs is for an army of bloodthirsty zombies to be ambling up behind you and you've got despair incarnate. I know, I've seen too many movies but then living in the real world can be tedious at times for all of us can't it?

I have to say that it could have been taken almost anywhere on earth; despair in the landscape, after all, isn't the sole preserve of Wyoming, but often the photographs we see are found as a result of the moods we find ourselves in. If I had been singing 'Zippedy-do-dah' on cloud nine then 'Road Closed' would probably not have caught my eye. From my experience it's much easier to find happiness when you are at least a little happy yourself. Makes you realise how hard it must be for portraitists who work diligently not to corrupt their subjects with their own moods. It's always easier to project misery onto a moment than energise it with optimism – well for me, at least. Still, turning varying degrees of pain into something permanent is a great part of the human adventure; just ask Charles Baudelaire, Edvard Munch or Leonard Cohen, all men who had closed roads.

SAD EYED CAR
WYOMING, USA, 1997

This crashed, smashed and crumbling wreck is probably now gleaming in someone's garage waiting for its dry Sunday drive where it will draw admiring stares from those it passes. I wonder if it's black, or perhaps a deep midnight blue, and how much conflicting joy and frustration its owner juggles while maintaining its splendour. Of course it could have fallen into three buckets of rust by now, left as I found it on a roadside in the middle of this great big nowhere. It had a few mates to rot in harmony with, and a collapsed barn with some more mechanically redundant machinery which meant less to me than the sad look on this car's face. But this is a state where people come to find old things and nurture them back to as much life as they can. This is 'dinosaur country' and we had come to see an even more decayed lump of wreckage get heaved out of the mud, an Apatosaurus, formerly Brontosaurus – he got re-named. It was the tornado season, although we weren't lucky enough to get twisted, and this is what gave the extraordinary light in the image. It's flat and so crisp, each blade of grass pin sharp; you can see that it's just about to chuck it down, which it did. The downpour almost washed the old bones away actually.

I don't like to talk much about equipment – no camera ever took a great picture – but I shot this Kodachrome transparency on a Leica M6, with a 35mm Summicro lens. There is no doubt that these lenses have a very distinct look, they are simply sharper, but that isn't all of it, they have an essence like nothing else. I can tell which slides were shot using the Leica in the hand, without magnification. They are often divine and the camera transcends its practical purpose too, itself a piece of art that I am very lucky to own. I tried very hard for a while to only travel with this kit; I bought 14, 90 and 135 lenses, but I found the latter two difficult to use as the area in the viewfinder they cover is too small to focus or frame easily, particularly in low light (remember it's a reflex camera, you are not looking through the lens). In the end I gave up as it was not a flexible enough tool kit and I started to miss shots. Nevertheless, as an everyday snappy, which it couldn't get further from, it has no equal and if I could afford it I'd love to give the digital version a go. That said, I think perhaps this may be the one system I might dig out some of that old film stuff for!

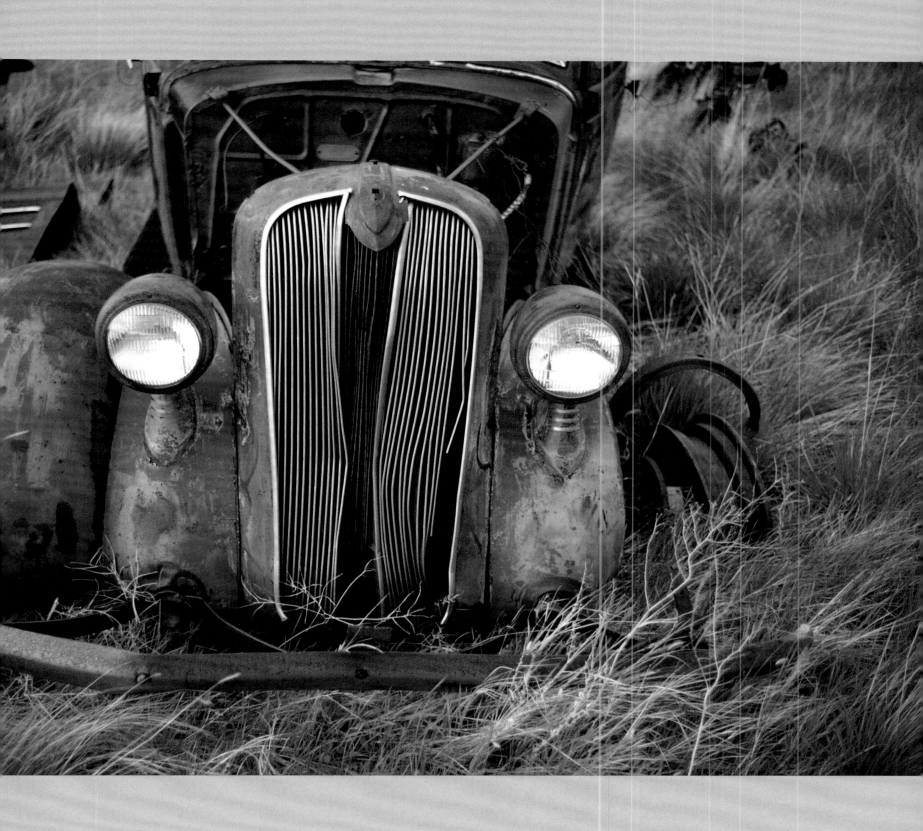

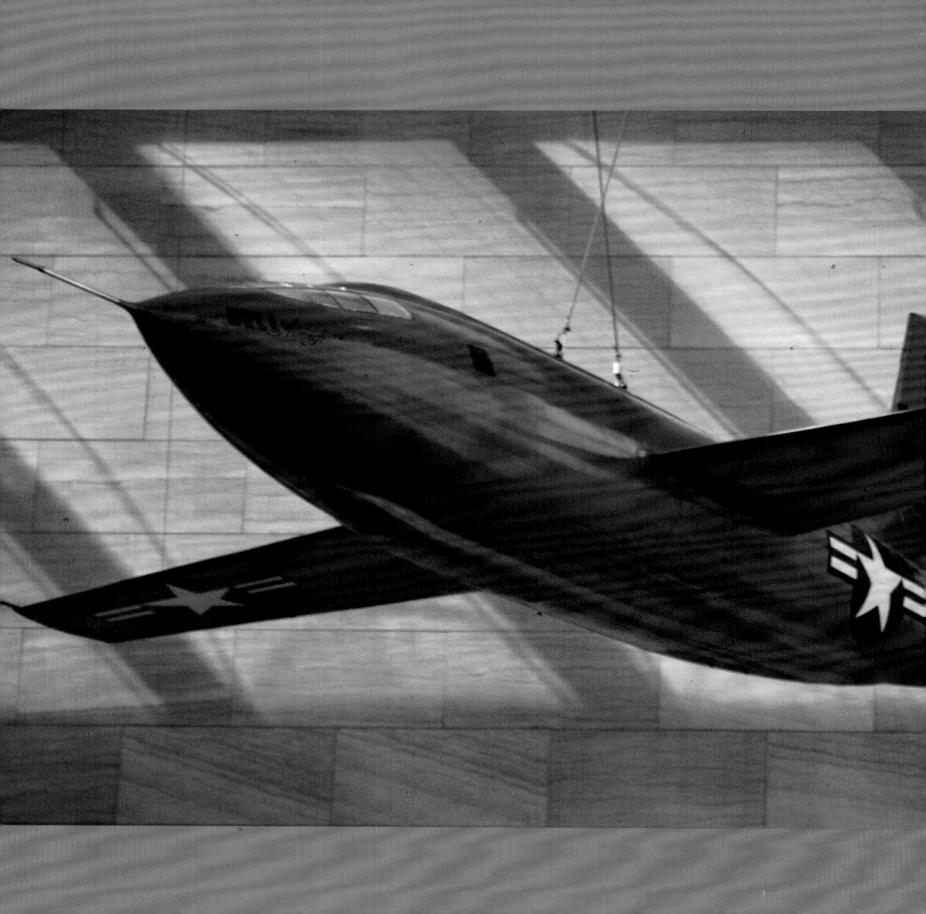

SUPERHERO SOUVENIR
WASHINGTON, USA, 1985

I'll be honest, this is a souvenir snap. It's one of those personal 'postcards' I hate to see so much. It encapsulates a wholly individual tale of expectation, great fortune, revelation, realisation, elation and then dismal tragedy. And this uninspiring photo is all there is to show for so much. For me its story is formative, the object is beautiful, its history is glorious, and my lesson is salutatory, but to you it's merely a snap from the wonderful Air and Space Museum in Washington D.C and, I must admit, little more than that. So let me try to inadequately exaggerate its few virtues before I go on. Umm, well, I feel with no degree of commitment that the architectural shadows on the complementary coloured wall add to the composition; that I like the idea of a plane flying indoors; that it's an icon, so, well, anyone who recognises it will have a point of reference and will realise that to have actually seen it is pretty special... oh forget it... it's one for me, okay! And other than that I've given it to you, what is wrong with that?

Pictures that mean something to each of us are always going to be the most valuable of all, whatever their technical or artistic quality. My need for justification only arises from the fact that you are now judging it, and thus if you don't pimp your pictures, then you won't ever need to squirm. So moving swiftly on, the story...

Glorious Glennis, Chuck Yeager, Tom Wolfe, *The Right Stuff*, Sam Shepard, Mach One... if you are not with me maybe you should skip to the next picture, because this is probably a macho speed-machine-hero-worship zone. This is the tiny orange rocket plane that fell from the belly of a B29 in 1947 and put the first sonic boom into the earth's air; it shook, rattled and rolled in the mood of the age and then got lost behind the space race, forgotten, hung up to dry until the book and movies set things straight for all us history boys. Chuck Yeager, the pilot, became a hero for me and my visit to the museum a pilgrimage. I saw his G-suit and read his flight report, awestruck by its matter-of-fact honesty. Then I went back to the hotel and turned on the TV to see him, Chuck, endorsing air-conditioning in a naff advert. In life nothing is sacred.

NO EARTHLY EQUAL
ENGLAND, 2006

Some things we have created are just righter. They have rightness in every molecule of their form or fabric or it has flowed in a moment of revelation from the fingers of those who made them real. They somehow exist on a different plane from 'normal' beauty, they are just better, and as much as we could murder to dissect them and discover why, taking them apart doesn't help because it is their completeness which effuses a synergy of perfection which has and will exist for as long as human eyes can gaze upon them.

The bust of Nefertiti or maybe Donatello's *David* is the sculpture, the *Mona Lisa's* smile or *Girl with the Pearl Earring* define the portrait face, the Guggenheim spiral or the Acropolis epitomise architecture... I could go on, make a list of man-made things which have irrefutable beauty, but I would beg to suggest the 'best of the best' of these icons might be those which also needed to have a purpose, whose design included art as an artefact of function. Thus the Supermarine Spitfire appears as my icon beyond compare. Balanced, proportioned, shaped and sculpted, it's one of our greatest ever designs, but it also had to fly fast and it needed to be able to kill people.

Due to my father's obsession, I have been looking at Spitfires all my life – Airfix and air shows. From ages four to 15 I remember running into our garden to watch the occasional plane return to the place of its birth – Eastleigh airport, near Southampton. I've read the books and re-read them again. Needless to say I and many other photographers have snapped a few, but it's a luckless task. I'm afraid Spitfires compel me to believe that old maxim that some things just don't look as good in pictures.

But when you love them, you've got to try. This isn't my best Spitfire photograph, I have another black and white taken in misty rain in March of 1986 which is better, (no black and whites here), and one of my father sat in a cockpit just after a flight (personal and therefore invalid), but it contains most of the delicious shapes seen while the aircraft is at rest. The cocked tail rudder doesn't help though, the livery is a bit gaudy and the weak sky ruins it all.

THE TROUBLE WITH TOURISTS...
THAILAND, 1990

Is that they get in the way. I don't mean the endless queues but the fact that all the world's wonders are populated with far from picturesque people who make photography impossible. They are not the stereotyped family from the holiday brochures – well-dressed, smiling and most importantly lined up nicely to admire the spectacle. They are a shabby rag-bag of scruffy ruck-sacked folk, the fat, thin, tall and short in uncoordinated attire, with bags, cameras and kids, and they mill, boy how they mill. I want signs up at the planet's major attractions that read in every language 'NO MILLING'. Because occasionally in a moment of lunacy you might think you could get a clean shot, of say, the pyramids, so you wait for that one person, the one in the ridiculously distracting red raincoat (think Egypt, think desert), to disappear but they never do. They mill about until someone else in a puffa-jacket wanders into your prospective picture. The most awful are probably those groups of students all with matching gaudy cagoules; there are hundreds of them and they really mill badly. Then one always loiters, and there are signs about that. And please don't say 'get up early

before they all arrive' because if I do you will be there and we'll get in each other's shots. So I'm afraid all that stuff in conventional photography manuals about 'How to Photograph Temples' or 'Getting the most out of Ruins' is utter tosh – you've two choices: a massive Photoshop exercise or trigger the fire alarm.

Or you can point your camera over that sea of heads which is why this is the only snap I have from the Golden Temple complex in Bangkok. Okay I didn't really want to photograph it all, I didn't want the 'postcard shot', but I just felt itchy, I had a camera and... you know. It was hot and heaving, a hopeless case, so I used my wide angle to produce this pointless picture of six converging 'spires'. Paradoxically it needs a subject – a flock of birds or a UFO would have been nice. A red balloon in the shape of Jesus – something really incongruous. I do actually have one photo of Machu Picchu in Peru with only one tiny, blue person in it. I fell asleep on a terrace there around midday and when I woke up at 2:30pm everyone was gone. It was a miracle, but the light was useless.

89

LOVE OF LIFE
NEPAL, 1994

I once travelled through southern India with a marvellous man of God who introduced us to the region's religions and gave us exceptional tours of places of worship past and present. As the archetypal atheist but ultimately tolerant of others' beliefs, this was a challenging and enlightening journey. We went to an ancient Jainist temple, largely abandoned but tended by a few contemporary followers of the sect. They kill nothing, they were digging with small trowels to reduce the danger of bisecting worms, they dissuade pests peacefully and they honour all life. As someone who gently pushes mosquitoes away, releases ticks and leeches unharmed and happily shares his home with hornets most summers, I was close to signing up. You probably think that they are extreme and I'm mad, but I just like life, in all its guises and in its very essence. I sometimes imagine that one day I might be so desperate to stay alive that I'd welcome a minute more as a fly, or a worm.

When I first went to Kathmandu in the early 1980s I endured a severe culture shock. A combination of horrible overnight flight delays, a consequent rush from the airport to an audience with a living goddess, no food, or sleep, and having been left alone in a

tiny temple in the suburbs of the crowded capital, all the while very ill, set my senses in a frenzy for an extraordinary scene. I was in a small courtyard with three tight tiers of balconies; there were shrines full of oil lamps and strange icons, a heady perfume, the smell of ages, rice had been scattered everywhere, saffron splattered orange on the ancient stone floor, prayer wheels turned, tinkled, a covey of red cloaked monks were whispering and giggling. Then all of a sudden hundreds of pigeons spooked and exploded with a great ripping of wings. I gazed up as they spiralled into the sky, turning in tight circles to climb out of the chamber and I felt dizzy. When I looked down there was a large tortoise wobbling towards me, brass cups had been attached to its carapace and they were ablaze, it had been painted, anointed, it was a sacred reptile. It struck me as utterly bizarre but in the weeks and visits that followed I have come to enjoy the strange harmony that all life shares here. There are no 'Please do not feed the birds' signs. It's wonderful. Look at them here. Bollocks to Ken Livingstone and Health and Safety – we want our pigeons back!

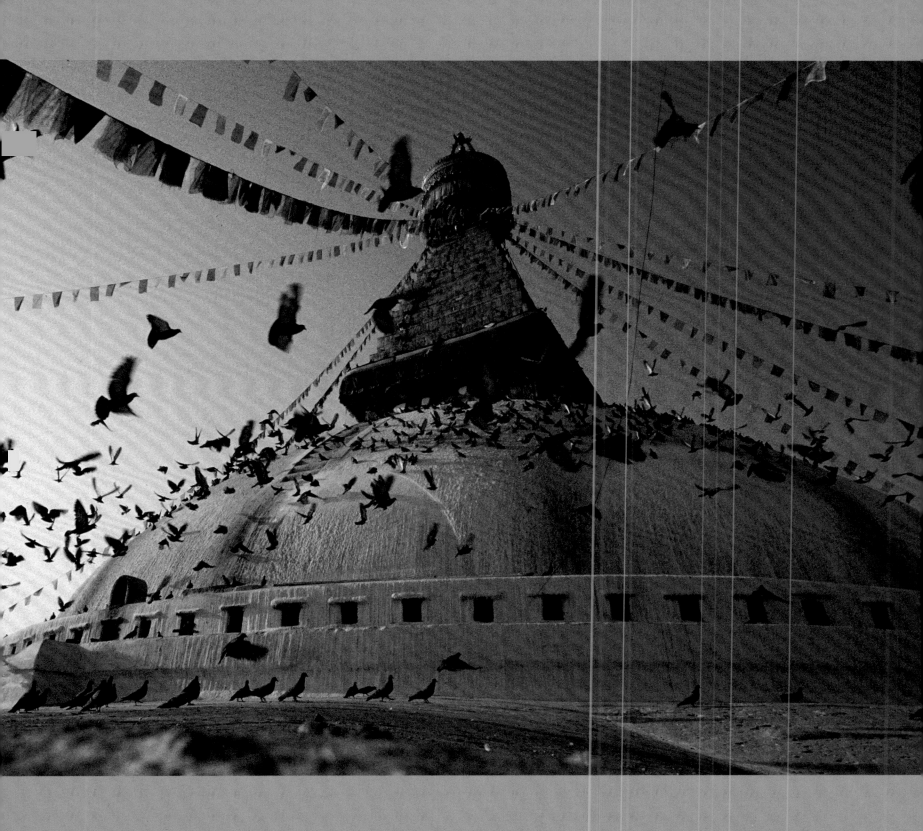

THE SUNNY DAY IN HELL
GREENLAND, 2008

Look at it. It doesn't make sense, it's pure surrealism. I was lying in a t-shirt at the top of the planet, gluing massive chunks of ice into a scene of flower-filled sunshine which glistened with all the zip of springtime. But look again: the ground is bare and broken, hard and earthless; the flowers are all plastic because nothing like that could bloom here, because today is the day, the day in the year when any semblance of joy might briefly bathe this scene, when this cemetery can look like a nice place to lie or to say goodbye.

We put our cameras down and mooched around reading the inscriptions on the crosses. Young deaths, twins only days old, children and teenagers and then graves of 60, 70 and 80-year-olds. The drowned. Beyond them lies the town, which I deliberately excluded, with satellite dishes and giant 4X4 cars, the last few dogs lying in the shade of gleaming snowmobiles, all the tech' of the 21st century. But this place is still out there, no longer beyond modern medicine, but beyond its reach when it's really needed. And the teenagers hadn't fallen off motorcycles, they had crashed into ice crevasses, and here babies still died in labour. But worse was the vision of this graveyard in winter. Eternal dark is lived here then,

and those stones which made me wince are welded to the rock where graves are hewn by torchlight in freezing storms. What kind of funeral can be held in that kind of hell?

Photographing cemeteries is not morbid, they are a specialised distillation of some very important cultural values and reveal a lot about their location and their incumbents. Here I was obviously determined to juxtapose the colourful foreground with the inherently hostile background of the relics of icebergs jamming the bay on this summer's afternoon. I struggled for ages with the composition, walking up and down the rows, bending and bowing to try to find a line that worked. Paradoxically I was sweating; we had raced out here so that our scene was not polluted by our fellow passengers, and thus I was also in a rush. Do you sense an excuse looming? Is one necessary? Look at that wreath on the cross on the right. It's tipped back, it thus looks odd, and... I saw it at the time. Why didn't I get up and set it right? Was it reverence or laziness? Perhaps a wish for reality? Over my dead body.

93

DAY OF MY DEATH

TEXAS, USA, 1998

'Howdy,' he said, with huge mirror shades, chewing a toothpick, bare-armed and crisply dressed in highway patrol-blue complete with the cap, which he later tipped back in a gesture of camp incredulity. This was the stereotypical country cop, straight out of a Springsteen song or an Eastwood movie; he even swaggered and sweated right on cue. But he wasn't very happy. 'You lookin' to be in a whole stack of trouble being round here,' he said (it may not be verbatim but the gist of the dialogue is 100 per cent). He stubbed his shiny toe into the base of a tombstone and looked down. Saving some dumb English guy was exhausting work.

When I parked the car I had more than a sense that this was not a popular picnic spot but I have this policy of going everywhere or anywhere I want. My thinking is that if you can live long enough to read the signs then you can always leave in good time. Nearly always, anyway. On this account I have walked in and straight out of plenty of nasty spots. Only twice have I crossed a line and been lucky to have got back still breathing. This cemetery, which I'd seen from the main highway, took a bit of finding, driving round dusty rutted streets in a shit-hole south of El Paso.

The cars ditched there were missing wheels, hoods or doors, the kids all stopped to stare and quite a gang gathered when I bailed out, camera in hand. Curiously no one followed me into the dead zone with all its pastel graves and flamboyant icons. My plan was to 'snap'n'go' as soon as possible, but as usual I started hunting for the shot that was just that little bit better and time went on. I'd just taken this pic when Duane the policeman arrived to rescue me. A local had tipped him off that a gringo was in a 'no-go'. I tried to buy more time but I was literally and honestly escorted to the city line!

The photo: I like the bleached out and wasted feel which is as it was; I don't like the clipped tomb in the bottom left, it's careless, and I'm sure there was a better angle there somewhere. Still I suppose I was lucky to have been a visitor and not a resident!

GOD'S LIGHT
INDIA, 1993

On a sticky night in Goa I set up my tripod in front of this quintessentially quaint church, and fought the very real need to dive into the nearest potential toilet for the few minutes it took to take the picture. The result was this curry of colour thanks to good ol' reciprocality failure, a facet of photographic film behaviour now long forgotten. Basically as I understood it, when you made abnormally long exposures in very low lights the various layers of light-sensitive dyes in the emulsion became saturated at different rates and thus the overall colour cast became perverted. Thus the scene I saw looked nothing like this but the resulting Kodachrome transparency does. Obviously digital sensors operate entirely differently so the 'stand there and wait to see what comes back from the lab' game has died out. These days a few mouse moves is all we need to simulate the effects. Or remove them!

The purples and mauves are delicious and the brick-coloured sandy forecourt which matches the door sets them off a treat – if only Gauguin had seen this! There is even a star in the top-right. But while this is a classic dolls house church, a triumph of over-design whose modesty is only preserved by its plain white painted curves, it's spoiled by an abhorrent corrugated iron skew-whiffy awning which casts a nasty shadow over the whole gloriously camp face of it. I so, so wanted to go and tear it down. What was the priest in residence thinking? My God, or rather his!

The coast of Goa was largely unspoiled when we visited but I'm given to understand that unregulated development has blighted much of it, which is a shame. There were so many crumbling Portuguese villas in grounds gone to jungle to explore and the people are in the premiership of the world's most friendly. So despite the most vicious attack on my bowels, my visit remains a favourite trip. Being chased by water buffaloes after being snapped at by a large crocodile, but still trying to correctly identify a species of cuckoo shrike while wearing a makeshift nappy will never slip my mind. Maybe I should have prayed instead of making this picture.

MONET'S CROFT
SCOTLAND, 1984

The machair of Scotland's Outer Hebrides can be described as a botanist's dream. This late-flowering unspoiled grassland has a tremendous diversity of species, including a few local specialities, but you don't need to know the scientific name of the Western Marsh Orchid to appreciate the astonishing spreads of colour that drench these sandy coastal flatlands. The yellow of buttercups, dandelions, corn marigolds and flag Irises, the blue of vetches and harebells and the candy-pink of ragged robin washes over the fields like nowhere else in the UK thanks to the relaxed, old-fashioned style of herbicide-free farming. From a distance the smudged palette is a spectacle but its impact is weakened by the photographic lens which never 'sees' as the human eye does. So to try to better represent this I strolled out into the meadow, lay down and peered through the flowers. By focusing on the distance and keeping the foreground blooms un-sharp, I increased their ability to saturate the frame and regenerate the actual impression which I perceived. It's a technique that often works but you have to be careful with the blurs because if they're in the wrong place they can be intensely distracting (like that mauve blob in the bottom right) so a fair bit of wet-elbowed fidgeting is required (or a pair of scissors); also sometimes a little re-planting can help too and taping leaves and flowers to the front of the lens is something I often do. Only not with rarities.

I wanted the floral richness to dominate so I used a wide angle and kept the croft small and in the corner, and the mountains to a minimum with just a sliver of sky to give them some shape. Retrospectively, though, I'd go for more clouds and rid the frame of the 'mauve blob'; I would also try using a massive telephoto, with the building the same size, but to squeeze a lot more flowers and colour between it and the lens. But then the date on the aged slide tells me that I'd only had my first 'proper' SLR a few months so this was taken at a time when I was still learning to look with a camera – discovering how it sees so differently than we do. That was a fundamental lesson and sadly one that's never grasped by so many photographers. They thus fail to recognise those aspects of the world which can look ordinary to us but shine through a lens, and continue to try and bully the beauty they see into their pictures through the eye of a camera.

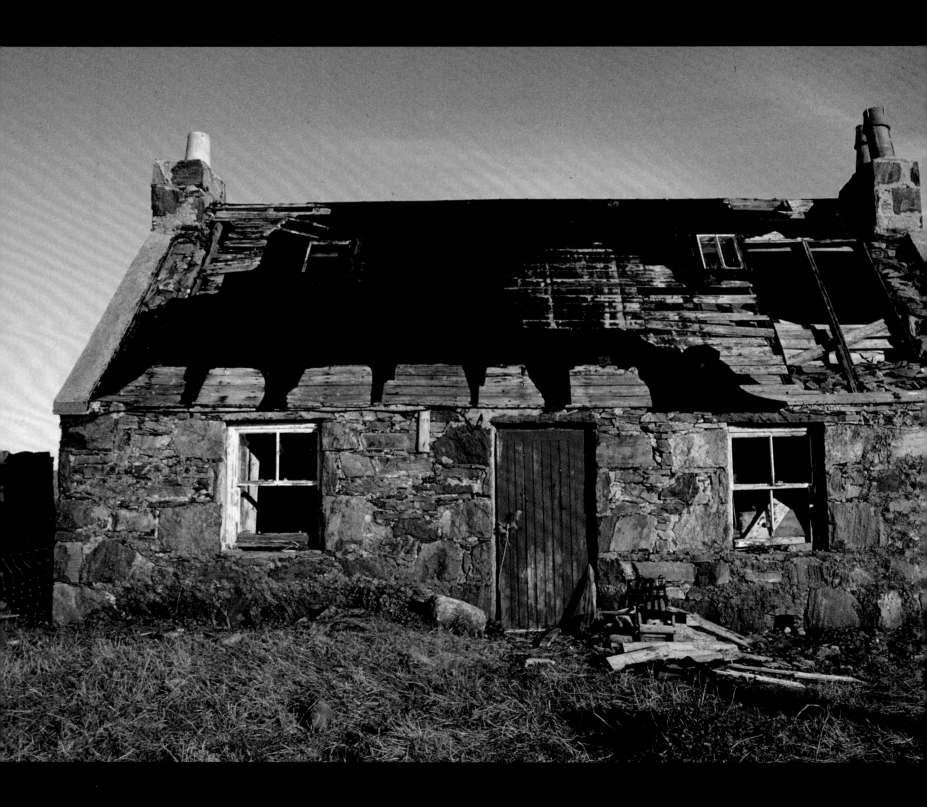

THE LAST OF THE CLAN
SCOTLAND, 1996

Am I perverse? It's just that if this little croft was lived in and loved I would have driven straight by and never given it a second look. I like things a lot more when they are falling apart. Ruins – the more crumbling the better; overgrown graveyards, old cars, rust, rust, rust! I have mixed ideas about restoration, often essential but frequently abused, because to my mind not everything ancient or old is great or important. Some of it can and should just be allowed to go the way of entropy. This is probably what I subconsciously enjoy, that our arrogance, that aspect which tempts us to try to create permanent things is, and will ultimately be, confounded by nature's natural tendency towards chaos. I like the idea that one day this planet will be purged of everything we've tried to leave behind. It will be cleansed and there's nothing we can do about it. Yes, okay – perverse.

I've always crept about in old buildings, initially looking for birds' nests, latterly because I like moving about spaces where invisible things have happened. I behave reverentially; I don't pick up or touch anything and I much prefer to be alone so I can concentrate on rebuilding the stories that the scant remaining evidence betrays. It can be humbling, pointing sharply to the ephemeral nature of our lives, and it's a romantic's treasure trove – all those lives, the pains, happiness, joys and sorrows sown into those volumes, there to be played with. Yes, okay – I'll shut up!

This croft, on the Isle of Harris in the Outer Hebrides, has an obvious childish simplicity in its construction: symmetrical, with two windows, and one door, fortuitously painted red for the future photographer, and a great patina of decay. The peeling roof, lovely texture of the stone work and rank grasses all add to the definitive 'abandoned' cachet. It was very late in the day, the sun nice and warm but also very low. Worse it was right over my shoulder and thus spilling my shadow down the garden path; I had to get to ground level to crop myself out and this unfortunately meant that I couldn't give the building anymore space in the frame. I went sideways but these attempts wasted the symmetry which is certainly part or the picture's modest strength. Not that it's much good – I wish I'd had an hour inside!

LAST STAND
TEXAS, USA, 1998

The way they tell it round here the ginger Jackson boy never made it a halfway from the rail stop where they trashed their truck. He'd taken a gut shot back in town and lost a load of blood bumping down the track in the back of the Chevy and the others were too strung out to get to helping him. It's likely he just got round to bleeding death or lay in the dirt screaming and moaning till they found him and ended it. So only the three of them got to the old liquor store, though in what state is anyone's guess. They was damned for sure but together enough to make some sort of stand of it. They were just dumb teeners with Hollywood heads on them and ideas too big for the cut of their senses and they were well high on their own supply. Two 38s and an antique magnum from God knows where versus some serious Mexican pro's loaded to the sparkling sky. Whatever, by the time McCain and the troopers closed in the dust was down and they were stone cold in plenty of pieces. No cash, no narc's, just three sets of tyre tracks going south and a whole lot of crying to be done. The kids came out and cleared up all the souvenirs pretty quick but no one wanted a shrine here so they closed it up with a view to pulling it down. That was 12 years back and now it's mostly forgotten. No one ever got a sniff of

nothing. Dwight Governors' father hanged himself in the Methodist Chapel seven months after they put his boy in the ground, the other folks are still around. Or maybe it's just a story...

Blown out and away, this shack somewhere in the nowhere that is so much of the lone star state caught my eye on account of its patches on patches. For some time they tried to stop this going beyond repair, someone must have turned up and scavenged whatever was to hand and nailed it up over the door and windows. But they lost because it's beaten now, down and out and heading to dust. The tatty trees and sparse clumps of golden grasses, the dumped rail trucks, parched ground and scattered litter mean that it's not a tidy composition but they add to the feeling of disarray and the bleached light so typified my days out here under shelter-less skies struggling to find things to connect with.

Without that star parts of this are surely a lonely state and I remember thinking as I pressed the shutter that this smashed up shell was not a place I'd choose to die.

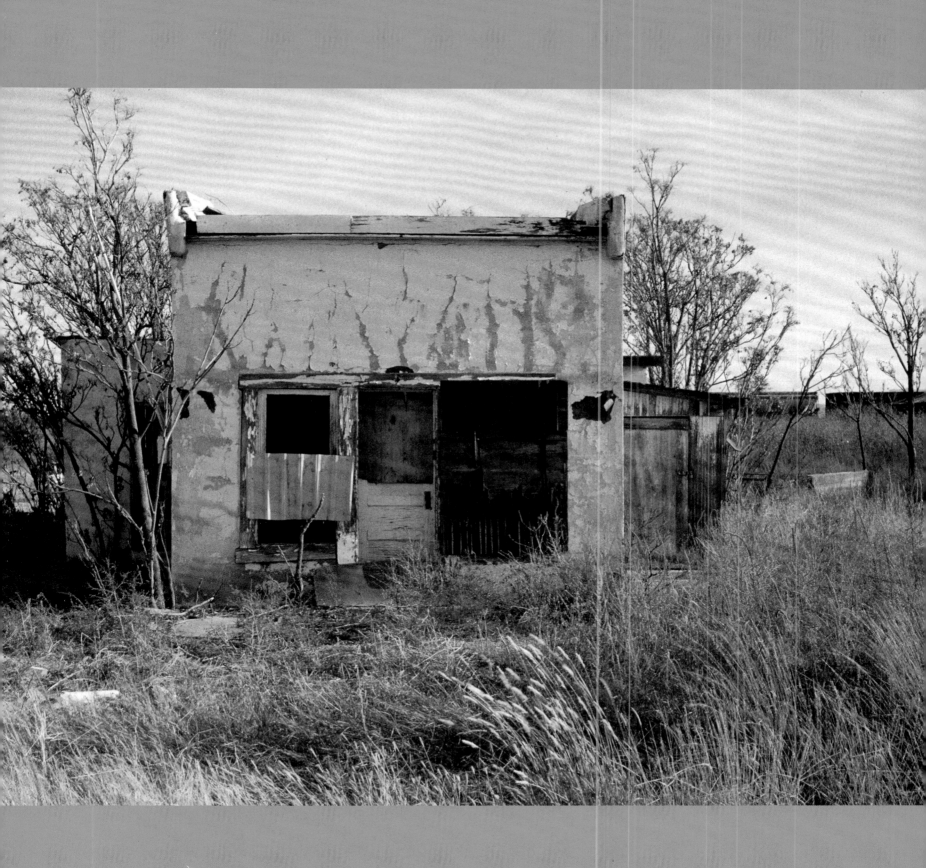

104

UNWELCOME SHADE
SOMEWHERE, 1995

Okay, one out of 100 is not so bad is it? At the moment I cannot remember where I took this photograph. The original Kodachrome mount tells me it was processed in June, 1995. I think it was taken in Scotland in May when I went to chase Corncrakes, those enigmatic hay meadow relics that managed to hang on here after we had mown them down everywhere else. I've an idea it was on the south side of Lewis in a seaside ruin. At least I can still see why I took it!

It's a view through a frameless window of the door behind it, but I like the way this is quite difficult to discern because the concrete textures and the harsh light have conspired to compress and flatten it all together into a series of rectangles – in fact this study is all about its geometry and its surfaces. I also like the monochrome and I've no doubt that this image would look better in black and white. However, there is a significant fault and the 'Squint Test' reveals it. The 'Squint Test' is a method I have devised to identify distractions in photographs and paintings which otherwise might give my conscious and subconscious examinations the slip. It's not a high science, you just put the image in a place where it is evenly lit, or turn off the lights if it's displayed on the

computer screen, and then you screw your eyes up and squint at it. Needless to say this destroys your ability to see it clearly but it also strips out all of the detail, so the fundamental shapes and forms of the picture are much clearer. If it has a bias in the frame or has facets which are out of kilter in the composition they will jump out at you, not least highlights and ugly shadows. Try it with this image and you will see that huge wedge of shadow beneath the lintel plays far more of a role in the picture than you may have thought. It tries to hide in all the other outlines which conspire to compete for attention. But now you've seen it I'm sure you'll agree that it isn't good. In reality a lower sun may have helped but to the detriment of the oblique light which enhances the texture, so its hope is virtual – a Photoshop fix.

So why didn't I just not tell you and improve the picture? Simple and self-evident really – this shot isn't worth it. It's just part of my vast catalogue that did its job by not working.

VOTA DOOR

ECUADOR, 1992

As I type this I can look up and across my house to see a 280-year-old door which I 'Indiana Jones-ed' from Stone Town on Zanzibar off the coast of Tanzania. This ancient port has architecturally prospered through its exposure to so many different cultural influences, African, Arab, Indian, European and the sub-divisions, and is a hybrid of them all. Consequently it is a World Heritage Site. Its alleys and streets were laid out by Escher, a maze of sunlit splendours and shady secrets, through which a cocktail of exotic perfumes waft, cats creep and life bustles. And its doors... well, it's a januaphiles' paradise. I got up at dawn every day and prowled until I had the labyrinth mapped and my reference points were those doors – carved, coloured, spiked and studded with a multitude of designs. I love mine; I sit here dreaming about what has happened behind it and enjoying it as a piece of practical art. Looking at this picture of the Latin lovely I wish I'd put in an offer and had it pinned to another wall.

I like the passion of someone who paints political slogans to their front door, it shows a deal more commitment to the cause than to stick a pathetic mass produced red, orange or blue square in the front window behind the nets. When I was a kid in the early 1970s, a bloke daubed 'NO IN 40, NO NOW' on his house in letters about a metre high. He used creosote. My parents said he was mad; the general consensus was that it 'lowered the tone of the whole neighbourhood', but at least I found out about the prospect of us entering the European Union. Another wall had 'LONG LIVE DUBCEK' on it, and I know who he was too. So 'VOTA POR EL CAMBIO' gets my vote, candidate 6, possibly a Senor Nebot. The colours are great, the green, red, black all work and would confirm to me at least that this is a door somewhere in central or South America, actually Guayaquil on the Ecuadorian coast, so it has a global identity outside of its pictorial attractions. The whole town was buzzing in the final surge of election fever and there were posters and slogans everywhere, a van with three massive loud speakers rattled by emitting a political polemic, the orator of which must have been roasting inside. People were banging drums and you knew there was going to be one hell of a victory party, firecrackers, flamenco, and another corrupt politician in place to profit from poverty. Great!

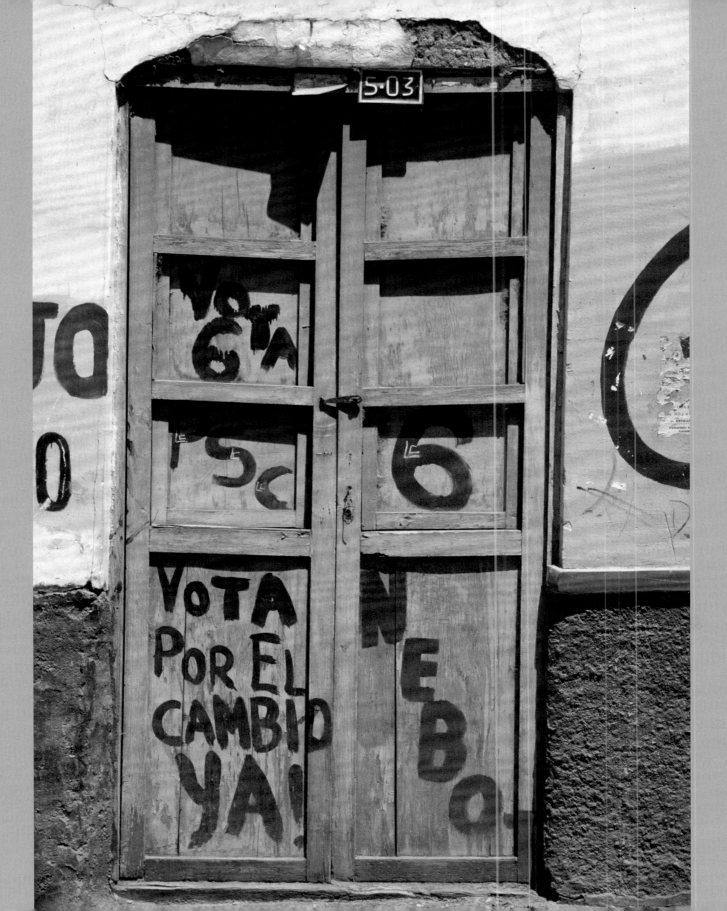

SORRY NO GOAT TODAY
TANZANIA, 1995

When I was fortunate enough to start travelling regularly I was a bit like a pit bull in a sweet shop, not knowing what to focus on next, dizzied by the riches which revealed themselves every day. So, in a moment of creative sobriety on an uninspiring Mauritius beach, I formulated a plan to ensure my photographic sanity remained intact. I devised three projects which would have a globally inexhaustible supply of accessible opportunities and that at that time were novel-ish. I chose Coca Cola, that celebrated symbol of globalisation, windows and doors (four of which are reproduced in this book) and corrugated iron. I soon kicked the coke habit through lack of variety, but the other two assignments still reduce distraction.

Corrugated iron is totally ubiquitous, it's been around for ever, or at least often looks as if it has, and is used for everything. It also photographs well, chiefly because the light that falls on its folds gives it form. Also everyone seems to like painting it in garish colour schemes, partly to stop it from rusting, so it's a win/win, colour/rich texture of decay situation. I've photographed hangers, pigsties, halls, homes, bomb and bus shelters, fences, trucks... I've got them from inside and out, raw and decorated, painted, papered, trashed and smashed and gleaming pristine. From Svalbard to South Georgia, from Canada to Chile, from Sutherland to South Devon. It's a life's work of the metal and this was butchery on a sandy Tanzanian highway.

It caused a bit of friction as I insisted going back for the shot when the crew were beat after a long day getting hassled and harangued by irate tribesmen (consolidated by all the joys of Africa like delays, flies and suicidal journeys over cow-covered, pot-holed roads in decrepit hire vehicles). Plus no one wants to drive after nightfall because that's what we call 'Safari Roulette' -- a game that makes the Soviet version look appealing. So it was a quick snap'n'go and the late light is more pleasant than the atmosphere in the back of the safari Landcruiser for the trek home.

SCRAP HAPPY HOME
KENYA, 2001

At one point, I think after the embassy bombing, Kenya's Nairobi was classified as being as dangerous a place to visit as Bogotá, kidnap capital of the world and of Columbia. I suppose it's true that a tiny minority of people do get held up and mugged here, some killed in the process, but it's a city whose underbelly I have greatly enjoyed exploring for years without anything other than a few minor scares. And I'm not a lucky person: if there's a banana skin out there it's waiting for me. I have learned how to stay sharp and escape trouble. It's 99 per cent common sense and without developing this 'skill' a vast proportion of the world will be too easily categorised as 'dangerous' and you will never see it. Also, for the economies of many countries such lunatic scaremongery is damaging in the extreme. It's shameful but I didn't see too many western visitors on the streets of Nairobi for years and yet many parts of those nations' cities could be classified as 'random death central'. So they keep their much-needed cash with them at home. Great, that will help make everything worse. Why is it that tourists want to be able to travel to countries where poverty-driven crime is more frequent than they normally experience and not have to deal with it themselves? They expect to be protected from this

reality, to be cosseted, to not have to look at or see the reasons for it! Listen, you can fall off a ladder or choke on a fish bone and it won't give you any reward, but a walk through Kibera shanty town will change your life.

Sprawled out and stinking sewerless and shitty and 'dysentery hot' or 'cholera muddy', this crust of below breadline humanity has accreted and expanded alarmingly as many millions of Kenyans urbanise in the hope of hope. This picture is of a home. This is the window. I presume that the iron has been de-corrugated to increase its surface area. It is not gaily painted, it has something wiped over part of it. The rest is wired together, not nailed. The wire has been purloined from the telephone lines running into the city. I hope a tourist in a five star hotel bedroom can't phone home.

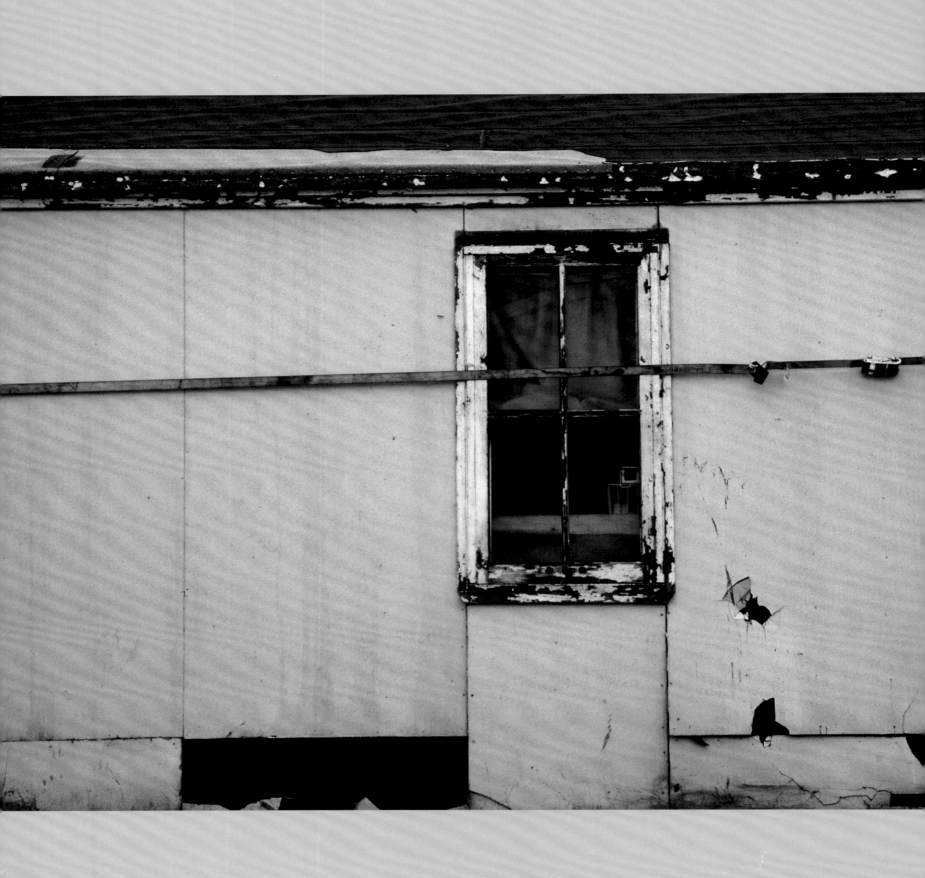

BROKENDOWN BLUE
CANADA, 1994

'FOR SALE, Portacabin, in need of restoration/ incineration'. It's huffed and puffed and the house is being held together by this webbing strap. Dorothy has packed and left the wicked witch buried beneath it. Toto is in the pound and the happy trio are in the yellow-brick nick on charges of abducting a minor. In Churchill, Manitoba, no one hears you scream because they're screaming too. If you want to shack-attack come here; it's ripe with ruins and rundown rotting and smashed shanties. Whoops, there go my keys to the city! But seriously, I have enough photos to put together a booklet for visitors entitled 'A Full Colour Guide to The Crap Cabins and Shit-hole Hovels of Churchill'. I might publish anonymously and donate the royalties to the local charity for the homeless. There must be loads of them here!

Part of my 'windows of the world project' ethos is that I hoped to invite the viewers of the photographs to imagine what is going/has gone on inside each of the buildings – behind the curtains so to speak. Welcome in! This place doesn't exactly radiate an aura of love and happiness; it seems to be shouting about domestic abuse and drunken brawling, about neglect and sloth, about never needing to keep up with the Joneses. But that's good because it's a feeling which can be generated just by looking at this destitute shed. In truth this may, in its fresh blue days, have been a very pleasant place to spend time, full of laughter and kindness. This photograph may be lying, something they do all the time; this may be the sad end of a glorious tale. But the fact that this window is more of a wound, gaping in the side of the slashed and scalded skin of a decaying shell, seals its fate as a portrait of pain.

I like the contrast of the jolly blue and the near total collapse, I loved the single thread holding it all together, and the symmetry gives the hole no chance to hide. The rest is just contextual dressing, and the overcast sky meant that the colours would saturate and effuse the damp which dominated this bleak day. I'm not so fond of the metal trays visible in the lower right of the portal, I tried to get rid of them, but I couldn't reach or find anything that I could use to dislodge them. Must try harder.

THUMS-UP
INDIA, 1994

I've included this window principally because you need a house-full to make a project. Don't worry, we won't be going upstairs, out to the extension or into the conservatory of this idea. But I could; I found about 70 exterior face-on symmetrical images of windows that I have taken all over the planet. Each window was selected for a certain reason at a certain moment. While few could be described as 'desperate for any old hole in the wall', some photographs clearly better define their location than others. I have some shots of highly decorated frames which typify a local or national style, nicely carved and/or painted, and in designs which are decorative or eminently practical. Thus the 'H'-shaped lintels and sills I found in Nepal, some brightly painted, or the fretwork rosewood grilles from Morocco and Muscat, or the Tuscan shutters and elaborate Thai temple stonework – all exemplify traditional architecture. The tiny portholes in the sides of research bases on Antarctica are artless but airtight. There are quite a few ruined windows too!

There are two ways one can approach windows; you can look out or you can look in. Most of mine are from the latter perspective for two reasons: firstly, because it's easier to walk down a street and snap away from outside the houses. This alleviates the need for breaking and entering, or begging an entrance with a bizarre request – not that this puts me off too much, but this is a project which merely needs eye-work, not lots of blagging. Secondly, looking in is very distinctly different than looking out. 'Out' exposes a piece of the world from that limited viewpoint and if that's what's wanted you could just spin round, lean against the window and make a picture. Of course from inside you would have the inhabitants' true perspective, but exposure would often be tricky or impossible. 'In' is inviting your imagination to become voyeuristic, it's asking to wonder what is happening behind the 'curtains', or what once happened in that invisible volume. What love or what cruelty, what life or death, what laughter or how many tears? It's also easier to keep the photograph simple too.

Why the hole in the red wall of the Indian kiosk? I liked the dyslexic sign writing, wanted some colour and the painting links neatly to the next idea.

TRADEMARK REGD

TRADEMARK REGD

CINDERELLA'S SHOE

CUBA, 1999

I waited and waited but it just didn't happen, so I took this to act as a painful reminder of an opportunity that couldn't be realised. We were birding in Cuba and had returned to Havana to chill for a day, before we continued our sweaty searching for feathered comrades. This simple stained glass window was in a building open to the public and I liked the way its round shape had been reordered on the floor in the form of a vibrant spiral. The veined marble was nice, the staircase also added to the jigsaw of geometry, and despite all these potentially confusing elements by exposing for the sunlit colours, the overall scene was simple. All it needed was a subject. I wandered about looking for something, thinking 'old key', something 'dropped', a slipper, a mouse... any stairway favourite, but there was nothing. Then I thought 'legs' – someone walking through – but the place was deserted and I didn't have all day. I'd given up and was just leaving when I noticed a pigeon had flown in and was gently flapping in another of the windows. Now all I needed was some crumbs! I returned to the street and walked for ages in search of biscuits or bread. Peanuts were all I could muster – not exactly a pigeon staple and not the number one choice of the Cuban stray birds either, as I found out,

after spending 20-odd minutes of whispering 'here Castro, come on Che, Buena, Buena vista... come on.' Havana is one of the most wonderful cities on earth; I know, because I spent my time there talking to a depressed pigeon. And not getting a picture.

One way you can avoid this 'subjectless-ness' is to always have something in your bag to use. I know this might sound absurd but with some planning it's a top tip. Once, when I was off to the Skomer Island group off the west Wales coast and knowing I would need to bank some wide landscapes, I borrowed a weathered and tightly coiled ram's horn which I carried with me and placed strategically in the foreground amongst some fluffy Thrift. It looked a trifle contrived but was better than a banana skin or my left foot. I occasionally sniff about in antiques markets or through my mate's knick-knacks for things. Sometimes all you need is a feather, a bone, a playing card, and if I ever return to Cuba rest assured that Cinderella's slipper will be in my bag.

STREET ART
NEPAL, 1997

You may be thinking 'you've got to be joking' or 'that's rubbish', or maybe you have already turned the page, in which case I can say 'philistine' as I won't run the risk of offending my reader! But look at the design, accomplished with a swift brush; it's perfectly balanced and proportioned. The choice of colour for the masterful daubing complements the hue of the original wall and the texture is delicious, granular, rough, raw. You see, as soon as you start to dress it up with a bit of pretentious 'art-speak' it begins to transform into something which has a greater value than the sum of its very basic parts. We know the likelihood that the 'artist' chose the colour is almost certainly nil; nor that he or she had projected an artistic response after a period of considered creativity. For some wholly inexplicable reason a person painted a star or a sun on a back street wall in Kathmandu where I found it while searching for a traditional pharmacist to purchase some aphrodisiac. Don't ask.

The thing is that by photographing it I've made it into art; it is my selection that has transformed or imparted a different value to it. Think of Marcel Duchamp's urinal or bicycle wheel, or Tracey Emin's 'un-made bed', or the even more infamous slab of bricks that so upset visitors to the Tate in the 1970s. By placing these things in a gallery, in a new context, they all became art and were justifiably afforded an entirely different value. If I could I would have collected this 'piece', had the wall torn down, cut out the sun, and shipped it home. It's not so ridiculous – people do the same thing with pieces of graffiti artist Banksy's work. And they are worth hundreds of thousands of pounds, often more. I'm sorry but I truly like this particular abstract symbol; look at some of Miro's paintings, there are parallels, and the hues are pretty Rothko too.

All that said I think the photograph fails in one sense. Unless this sun has some defined representational identity, unless it means something to any Nepalese who see it, then my photo lacks the ability to provide any context itself. It could have been taken anywhere on earth. The photograph becomes abstract in itself. Still nice though!

118

120

THE NATURAL PORTRAIT GALLERY

ST KITTS, 2008

It's no accident, surely the curator of this Caribbean street has hung this Pop Art portrait after care and consideration. Just look at it, the vertical shadow-stripes on the funky corrugated iron paintwork stop and then re-emerge from an epicentre of radiating vegetation courtesy of the palm. The colours on the caricature are taken from those around it, or complement them, and it is placed symmetrically where the eyes are naturally drawn to it. I asked him, the 'gallery owner', and he said it looked nice there, that it fitted, that a local artist had copied the image from a photograph, so while I'm not convinced he contemplated it for too long, his instinct wasn't a freak of chance.

The human 'eye' finds ease and comfort, maybe even pleasure from balance. We relate immediately to symmetry, we see it in the mirror and in so much of our lives, in everything we observe, so to disrupt it can be a challenge even if it would make sense to do so. Have you ever wondered why cars are symmetrical on the outside given that we drive on one side of the road? Surely there must be reasons to re-shape them, but then would you be the first to buy one, to challenge that ingrained convention? Pattern is also prevalent in nature – whether regular or complicated – and we surround ourselves with it, from pin stripes to wallpaper to pavements. We like order, subconsciously choose it or consciously design it, or sadly inflict it on the natural world – think gardens or parks – and we shy from its antithesis – chaos. So this picture is a 'no brainer', a gift. It's bright and colourful; I can even imagine it on the front of the *Discover the Streets of St Kitts* guide. How boring.

Isn't it better to squirm a little, feel pricked, to stop and have to think 'oh, that's not right', to feel edgy rather than cosy, to feel different, to see that some of the world is not lined up and all sorted out? Contentment is never grand, it's a depressant that promotes complacency and laziness; it sucks the shine out of the soul and stops everything that can make a difference. If that's not a life philosophy for you that's fine, but when it comes to scouring the world for photographs it should be – it has to be. You have got to get outside the box, push the outside of the envelope, go too far. I've got a shot of a burning cow's head on a Mexican roadside – would you like to see it? I know it would make you think more than this photograph, make more of an impact?

GRAPHIC GENIUS
ST KITTS, 2008

For me it's perfect. It's a Hans Arp with a slogan; it's a five-colour masterpiece; it's an ice-cream design icon. Can you imagine the people, the teams, the consultants, the committees, the cost incurred by the likes of Walls, Ben & Jerry's or Häagen-Dazs with coming up with the artwork to promote a new flavour or lolly? Millions of dollars, pounds or litres of micro-managed hyperbole – enough to melt every ice-cream on earth – and yet here, on a Caribbean side street, a local lad has produced this beauty for the price of a few pineapples. The real world is always better, sometimes its flavours are an acquired taste, some are difficult to swallow but the ingredients are always pure and ultimately that's good for you.

So, in my opinion this is a lovely piece of commercial art but it's not a great photograph – it is only a document of the former. Can documentation sometimes be acceptable though, if it can communicate the time or the place or the moment? Can it be allowed to bypass art and work on this different level? As when the subject becomes all important and photographically the need is only for technical competence. The result can only be sterile from this perspective but can it be brilliant from a content point of view? I think not: it always strikes me as a little parasitic and in this case the artist has done all the work, all I did was line it up and expose it properly. I could argue my mission was to save you travelling to St Kitts and looking for it. But I'm only giving you a basic taste of the local flavour without taxing my imagination in the slightest. It's a very lazy picture but does that still mean it can't be successful, or even a good one? I hope that while I can appreciate the inherent value of such photos, they don't much appeal to me. I'm afraid that I still want art from news, even if it's an assassination, or a train wreck, or a goal or a try or a starving baby, however repugnant or horrific or impossible to control; if it's being photographed, fixed, and given away there is still a need to invest the result with a personal translation of the moment. You need to take something, feel it and put something unique back in with enough skill to communicate to the viewer some originality and wonder. It should not be shocking that there are better pictures of starving children. This shot has little scope to expand into but, all said, I still wouldn't mind a lithograph of the artwork on my wall.

DEFACED

INDIA, 1994

I can wonder who he was, or is. Would his family recognise him; are his nose and moustache enough to give a positive identification? Why was he glued to a garage door in Goa, why was he picked apart – did people turn on him, was he despised, or deposed? He doesn't look like a film star from a Bollywood epic because it's a mug-shot photograph. Nor a musician. So maybe he was a politician or a wanted criminal – little difference there perhaps? Yes, that's it: I think what's left of this badly mutilated head is the remains of a failed attempt to govern some small part of this region of India. His ambitions were savaged and peeled apart and then left to disintegrate in the sun and rain. I hope to God that it's not a part of a famous portrait of a young Ghandi – then I'll get some letters!

It caught my eye because the colours and torn textures of this collage appeal to my sense of the abstract and my perverse attraction to damaged things. It needs the partial face though, to put some point of focus on this map of paper wreckage. Of course it's nothing much really, but that's the point I suppose: I'm trying to find things to foist some ulterior value upon, the things that most sane souls with lenses wouldn't see, either because they are lazy or because they are looking for the bigger picture. Anyone who tries to find something new in something established will know it's bloody difficult. Without the mind of a genius, a big budget or unlimited time to invent or wait it may be impossible. So I'm saying 'avoid competition you can't often beat', find a new angle, a new niche. It's what drives the evolution of new species in nature and generates entrepreneurs in business, the basic need to avoid competition and do something new. So for me it's novelty or nothing. And failure is part of the process and I'm not too proud to admit mine – maybe this defaced bloke is one of them. I'm just offering you honest views into the evolution of my ability to find pictures.

That said, in meaner moments I fantasise about getting a 5,000-piece jigsaw made from this image for my father's birthday present. Should keep him off my case for a few months! Maybe you know someone who you would like to have a copy?

125

ALL OF THIS AND NOTHING
ARIZONA, USA, 1994

Junk is dictionarily described as 'discarded, scrapped or second-hand objects', but for me it could be defined by the contents of this 'Antiques' emporium somewhere in the outback of Arizona. Look into the matrix of chaos in this yard and try to positively identify anything and then find something you might want. I know the picture is 'contrasty' and it's difficult to discern much except a sort of hospital cot and what seems to be a homemade Ferris wheel and a few chairs. But let me save you some time because I trawled through this wreckage for an hour and didn't discover a single thing which should have been saved. Normally antique or bric-a-brac stalls, boot sales or even trestle tables at church bazaars eventually throw up an item which you have to buy if only to justify the time you're squandering searching through it all. But no, most of this stuff was unrecognisable, just haphazardly piled in mountainous tangles preparing to rot. It was the life's work of a madman who never appeared or answered the continually ringing telephone.

Pictorially I like the mess, the harsh late low light exacerbating the puzzle, and the saturated sky. I also like the humorous idea that this stuff might be classified as 'antiques'. I picked my way through it, finding details: a half-headed mannequin with a blonde afro wig, a giant plaster hand minus one finger, some destroyed cars and a 1950s fire engine; but for once I felt that this muddle worked better photographically together rather than isolated fragments of its collective insanity. Of course trying to then find a frame which could be controlled, which could be enclosed without distractions to rip any composition apart wasn't easy. Photographing crowds or jumbles never is – whether it's a herd of fallow deer or a stage with ballet dancers – if you are not meticulous there's always a stray antler or tutu poking in and drawing the eye off target. The temptation is to keep going tighter, reducing the availability of material that could be a nuisance, but then you will always end up with a portrait and never any sense of event or the broader view. You could go wider and wider so that your mess gets so small in the frame that it might become invisible or irrelevant. I think there's an equation which predicts a pictorial point where the density of disorder determines which way to go. There's another point where the climax of chaos is reached and then you just deal with it.

128

GOOD OLD ENGLAND

ENGLAND, 1994

Dungeness is a wonderful place that clings on to the south coast of Kent. It is a geographical marvel, the largest series of shingle ridges anywhere in Europe; it also supports a unique flora and fauna, and attracts a surreal flotsam of folk and their things. It's also a pain in the arse to get to, so it's still got a semblance of that charm that is virtually extinct elsewhere in the overcrowded south of England. The landscape is pure 'Car Boot Sale', a mishmash of disconnected artefacts thrown together in no artistic order. For a start there is the nuclear power station – the imposing granddaddy of the place, with its web of pylons and constant ominous hum. At night it's just like *Blade Runner*, all flickering lights and Vernian technology that was not even futuristic in the past. There are two lighthouses, the newer a giant banded phallus that adds a monotonous dimension to the disco show in the dark, and is just rude in the daytime. Then there's lots of broken stuff; in fact, this place is so far from everywhere that taking anything back is unthinkable – boats, trains, old wartime junk by the tonne – it's simply a fascinating scrapheap spread out on a wide flat plain. Derek Jarman's garden is, in summer, just the best in Britain and his black and yellow house clashes with every other clashing home here. Some of those made from old railway carriages are sadly falling apart when they should be listed. There's a top RSPB reserve too, and a mad as hell pub, and a superb chippie. So you can keep your Lake District, your Lost Gardens of Heligan, your English Heritage and National Trust stately homes – this is my kind of England and it's got five flashing stars!

I found these wrecks somewhere behind the Britannia Pub; they had been banger-raced and accordingly tarted-up with some nasty paint jobs. I'm sure they'll still be there and 'Mad Max', the mechanic who invented them, is probably still in a wheelchair. You can see what it's about – two offset circles, wheel and the satellite dish, but the rest hasn't really come off mainly because of the wicked white sky and weakness in the subject material. There was a loose bonnet that had a Union Jack carelessly painted on it that I was going to shift into the frame but with that sky I couldn't be bothered. That said 'Dunge' is a photo goldmine so I'm sure there's better out there.

KHARMA FM
NEPAL, 1997

These long lines of flapping flags are each printed with prayers, mantras and symbols, and when hoisted aloft the currents of wind are said to pluck the texts and carry them around the world. The airwaves activate a spiritual vibration and the blessings are spoken on the breath of nature, dissolved on the gusts that unwrap over the land. I know this because a monk told me. Sat on some rather grubby part of the Swayambunath Temple in Kathmandu he gave me a spontaneous and enthusiastic précis of the practice in perfect English. I gave him a small donation in return. He told me that hanging them has a long history, way back to pre-Buddhist Tibet when they were used to appease the spirits of the mountains. They were originally hand-painted, whereas now they are wood-blocked onto the gauzy fabric. Not so natural, he said frowning, and the colours are not as bright either. I concurred and he went on to point out that they come in five colours, each representing one of the elements, and are hung sequentially... the rest I forget. I was trying to get a picture.

I love the romance of this whole concept and the tatty bunting that bedecks the temples and shrines of the region; whether blowing colourfully, flapping frenetically or frozen solid, they give the sites a sense of being a shared place, sacred but not sanctimonious, very much used. No one seems to tread in fear here, the flock don't shuffle and whisper or cower in the corners, but then I suppose they are not subjugated by the constant threat of their sinning either. The respect seems more practical than pious and it's a real pleasure to tread these ancient and unusual sites. No need for guides either; enthusiastic, young and well-mannered maroon-clothed monks fill you in at will!

Photographically, however, it's a bit of a boring shot. It would make a nice jigsaw puzzle for someone, but other than that it's a bit lost between the 'bigger picture' with some essential context and the personally identified detail which reveals that same context more imaginatively. And the real world elements are not great enough to boost its status either. Still, I was distracted!

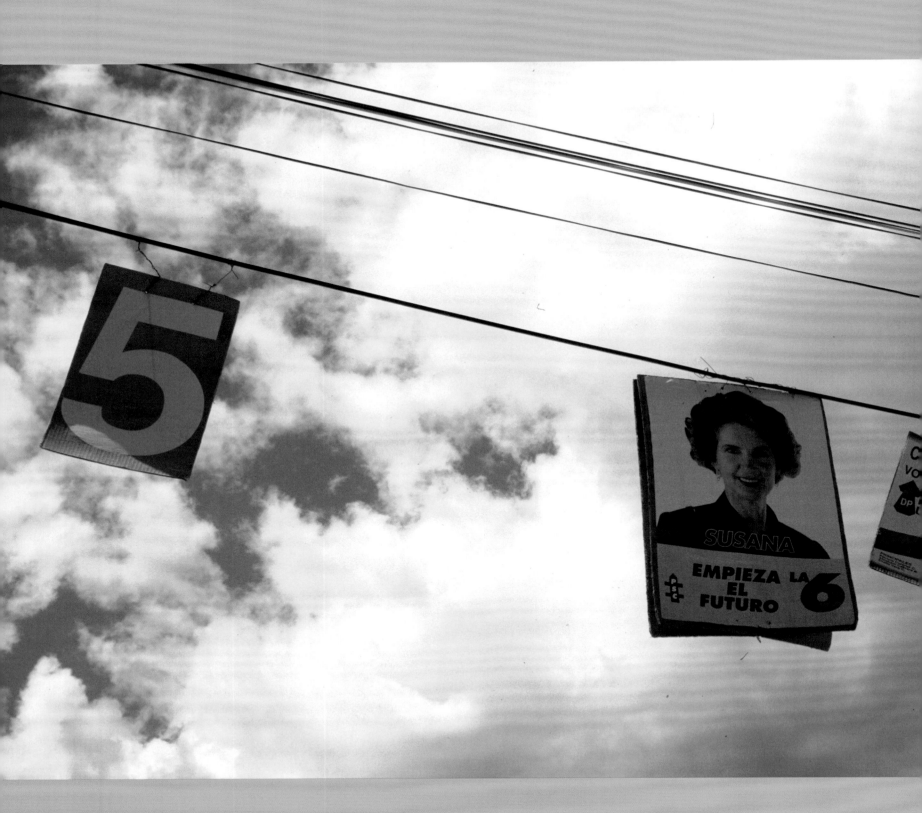

HIGH-FLYING SUSANA
ECUADOR, 1994

I don't want to cast any aspersions or betray any political convictions, but I'm not sure I like the look of her. She's not oozing warmth and sincerity for me; she looks like she's trying hard to look younger than she might be, she gives me the impression that she's got a turn of temper and that maybe 'numero uno' is her prime concern. I'd rather a vampire kissed my baby. But then she is a woman standing for office in a nation not renowned for its equal rights so she probably needs to have a diamond-tipped nose to try and level the field. And of course she's a politician of some measure so that's enough to germinate enough mistrust to ask the fundamental, but rarely satisfactorily answered, question – why? Still, her rival, Patricia, looks like a 'readers wife' from the early 1980s, not that I'm an aficionado, but I don't expect that photo did her too many favours. I'm sorry to be so caustic but when I took this I'd just had first-hand exposure to Ecuadorian political veracity and found very little to feel good about.

We had been given a brief audience with the fisheries minister to try and uncover why a single gunboat was rarely ever in attendance in the Galapagos archipelago while the 'protected' seas were being summarily raped by illegal fishing. He spent more time talking about his opulent office trinkets than he did deflecting our simple questions. He didn't stop smiling, invited us all to his hacienda, and showed us his saddle collection and new cowboy boots. As I recall he had recently married some head honcho's daughter and asked me if I liked polo. He didn't get my vote either.

Still, heralding from a nation where a 'good turn-out' for any election is around 35 per cent, I'd better get off my pony because at least in Ecuador the right to vote is still vociferously and enthusiastically appreciated. In many states it is still fought for, people die to be able to contribute an X to their country's destiny, we should be ashamed to elect a government when less than half of us bother to do so. And I like the way they hang things on telephone wires whenever it suits – flags, bunting, firecrackers, politicians (although sadly only their photographs). The portraits blowin' in the wind appealed to me as I wondered if the times were actually a changin'. Perhaps they both ended up rainy day women.

WING WITHOUT A PRAYER
ARIZONA, USA, 1994

The sickness, moral inadequacy, the stupidity, the shame, the shocking wastage. When it comes to things or places which portray the decadence and decay of civilisation, then few can compete with a chunk of the Arizona desert not far outside Tucson. Here, in searing sun or blazing electrical storms, you can witness hundreds, maybe thousands, of aircraft lined up to disintegrate. It's a horror show of our most advanced technology turned into tombstones. Millions of billions of dollars on parade to celebrate inhumanity. You can walk the chain-link line till you're too thirsty to go on, all the while passing rank after rank of jets. Fighters, bombers, burners, shooters, killers; I'm afraid I cannot differentiate between an F-111, a Tomcat, the B-29 or 42, but they are all dumped out here. Some have been sprayed with latex to protect them from the ravages of exposure, presumably on the pretext that they might be brought back into service. But would any sane pilot want to get into a complex modern aircraft that had been sunbathing in the wasteland for years? How much could it cost to refurbish them? We don't even want last month's mobile phones, let alone last year's computer, who will ever want yesteryear's aeroplane? Museum collectors, perhaps? But these

are not victorious Hellcats, Typhoons or Mustangs, they don't even look nice, so the former will not queue up and a few very rich enthusiasts can summon the infrastructure to keep Spitfires airborne let alone maintain a modern jet fighter... Plus who is going to sell them in these days of global paranoia – when there are more rogue states than united states. No, this is a frank display of our evil desire to damage each other and its insidious cost. Plane freaks charter light aircraft from a local strip to fly over and marvel at these 'treasures'; I'd fly as many children as I could cram into Jumbos so they could witness our ethical poverty.

I took lots of photographs but it's not easy, I arrived too late for the light to be much good, you have to shoot through the fence and ground level does not offer the best perspective. I found this mouldering insignia on the underside of one of the closer aircraft and it seemed to entirely encapsulate the whole sorry show.

ACES LOW
ARIZONA, USA, 1994

This is here for one reason alone, to exemplify the disappointing art of photographing an opportunity, not actually finding the real picture *within* that opportunity. This row of retired jet fighters lined up in the dry Arizona desert are a potentially poignant subject, given the unsavoury waste of technology and dollar value they represent, but here they are merely... lined up. They are layered, grass/ground, nose cone/cockpit, tail planes and mountains, but in fact the tatty base is annoying – a mess of wheels and weeds which conflicts with the smooth and geometrical man-made elements and the simplicity of the distant landscape. I can see that I made some paltry effort to place the 'Black Aces' insignia in the centre but there is no saving this ugliness. Maybe with a longer telephoto, in exciting light or with some foreground subject 'there is a picture in there somewhere'. That is a proclamation that I frequently turn on others so it's only fair to illustrate that I am a just recipient of the same curse.

I'll tell you why I took it. I marched up and down the chain-link fence, on a baking hot day between filming jobs, collecting a portfolio of such shots because I had the idea that I would have some pioneering wizard in the formative days of Photoshop scan my mess of transparencies and weld them together in a series of aeronautic tiers which would serve as a background on which to mount a cut and stuck picture of a Turkey vulture. This unpopular symbol of scavenging, an all-American citizen, stands with the 'Angel of (not death, because they don't kill much) Decay' written all over its macabre, drooping plumes. When I got home I made colour photocopies of the chosen junked-jet shots. I Pritt'ed them together and gave all the originals to a man with a computer the size of a fridge. Unfortunately I was ahead of time – the results could be used on page one of a history of composited images. I wasn't looking to pull the feathers over anyone's eyes but I did need it to look real-ish, which it didn't. Disconsolate, I then went back to my resource material to try and scavenge something from my sweaty stroll. All I could come up with was the preceding air force star logo and this. Maybe it's time to resurrect the vulture and dust down the disgraceful ranks of rotting weaponry and try again. Nah, no point, the idea died long ago.

A LONG WAY TO ALMOST THERE

FALKLAND ISLES, 1994

Look at it and start counting. See how long it takes before you spot it. Them. The two predominant elements which spoil this photograph which I have tried so hard to like. In the meantime I'll explain the picture's content.

This is the view from a barn window out to the little house where our hosts lived on a remote Falkland isle. The other building is a meat safe/larder, probably mostly freezer, which they still used. The house is tiny, a necessity for two reasons: firstly because construction materials were always in short supply here. There were no trees so all the timber had to be imported, no doubt putting a premium on its price. So many of the buildings are built from wood scavenged from the many ships that were tragically and frequently wrecked around this archipelago. This accounts for some of the more unusual architecture – what you had beachcombed determined the scale of your scheme and how it would shape up. Only a modicum of detective work reveals that some projects obviously went up piecemeal over years: planks and panels of all species, sizes and ages have been jig-sawed together into all the shacks and shanties. Secondly, when it comes to living accommodation in cold places, building big is not a brilliant idea heating-wise, it wasn't the bill, it was staying alive with enough coal, firewood, oil or dung to cook meals over. Hence the outdoor larder; the relatively hotter house would have been comfortable but not helped food preservation, so this was stored outside in pest proofed, well ventilated sheds. We slept in this barn and at night I went into a cryogenic torpor.

Well, as you will have no doubt discerned by now, that small length of bright green hose on the right isn't very nice and I should have removed it. And that pale 'stripe' of timber which arcs up from the 'gate' on the left is pretty distracting too. More difficult to fix in vivo but both would be a Photoshop cinch. The sky's a bit hot too but I like the idea of the photograph: the classical 'Dutch' still life is in here – the dead Prion, a seabird that nests in burrows on the hillsides, nods towards this but also adds a surreal touch. It's fairly painterly except there aren't any stray pipes in the corners of Vermeer's work. I should have blocked it out with an old lace-maker.

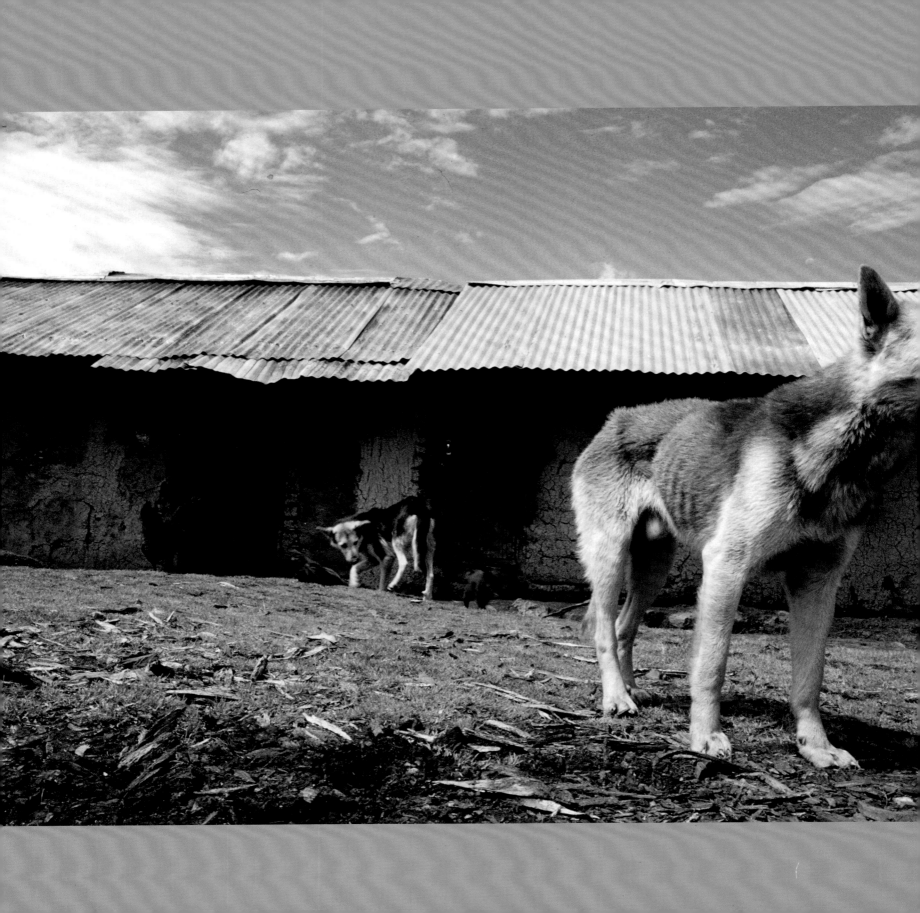

DOG'S DINNER
ECUADOR, 1996

From my experience pets or domestics are a lot harder work than wild animals. We've ruined their natural predictability and manners and as photographers we mistakenly presume they will be 'easier' because they are not frightened of us and we can 'tell them what to do'. But I'll tell you the worst job in the world... cat snapper. Imagine trying to photograph strange moggies on demand, not candid stray shots around the Coliseum, but someone else's pet, on a velvet cushion, in a studio, on a Friday afternoon. I know, people do it, and I take my hat off to them because I would rather lick the floor of a bus for a living. I've got dogs – I love them – but I haven't got a single decent picture of them. No, I'll take rabid Malayan Death Rats mating underwater as a commission over pussies or poodles.

These unruly and initially unfriendly mutts were hanging around this farmyard and, as I was too, I tried to make something out of it. I thought I liked the anonymous long mud brick barn with its corrugated iron roof, the verdant grass lawn, and the mixed herd/flock of occupants. The light was a bit ordinary but I got off my horse, literally, and began stalking for a shot. Now, in such situations you may only have a

few seconds or minutes to get a good snap, when the animals are curious about you. These dogs would obviously not be afraid of humans, and you cannot be afraid of them. The way I look at it is this... if this creature attacked me, could it kill me or ruin my trip because I'd be so badly injured? If the answer is 'no', I go for it; if it's 'yes', I think twice. I'm not afraid of other animals, I've learned to respect them, if you don't you are likely to get stung in the chest. But domestic animals will not give you long before they 'sniff'n'go' and get bored with you (wild animals are different but that is another story). So I dismounted, got down to their level, which is essential, and they ran up to check me out, milled about, fast, and I tried to get a decent composition, my eyes ricocheting around the frame, chasing them and all the elements, waiting for the moment when they fused and looked good. I was shooting film so my motor-drive wasn't overheating. If it ever happened I missed it. Nice perspective – blue sky, ribs, chickens – but a shame that the other dog looks like he's just trodden in something nasty!

141

IMPERFECT PEDIGREE
FALKLAND ISLES, 1992

Not the dog, the picture! Let's be honest this is a photograph of a photographic opportunity not the actual photo itself. And it's here to prove this point. Whenever I have the privilege to be asked to act as a judge for photo competitions, a duty I take seriously but accept cautiously (who am I to assess the merits of others' endeavours?), I unfortunately see a large number of these photographs which illustrate the unique circumstances of getting a good picture. I can see how fate has conspired to bring the elements together, or worse I can actually see the picture itself within the frame of the image that I'm looking at. It can produce a head-in-hands-screaming-disbelief reaction which I'm sure perturbs some of my colleagues. And more often than not it is simply that the photographer has not switched format, not twisted the camera from horizontal to vertical to better compose the image. Honestly, this murders more pictures than anything else – not technical ability, overexposure, or softness, just the wrong way the camera was oriented at the big moment. It's a killer and it comes principally from laziness, not thinking, not learning that everything counts at the initiation of that fraction of a second when we decide to stop time forever.

Well, here is one of my own missed moments immortalised on the Falkland Islands on a fair January morning. It's not the shoddiest example I've got – I can't even bear to look at that one, it's tattooed indelibly on my soul and will punish me to the grave – but this is bad enough. The dog is too far to the right, the hut, actually a meat safe, is too far to the left, meaning the gap between them is too great. This would have been quickly fixed with a shift to the right by about 20 centimetres or less. The depth of field is too shallow, there's not enough in focus, and given the sunshine this is inexcusable as I clearly could have lowered the shutter speed – the dog is stationary after all. The pooches' paw is too close to the bottom of the frame – it should be back about another 20 centimetres. I like the idea, the 'half a dog half creaky old shack' composition would have worked. I had one chance and I blew it. I call such shots 'Waddles' in unloving memory of that missed penalty in the 1990 World Cup Finals.

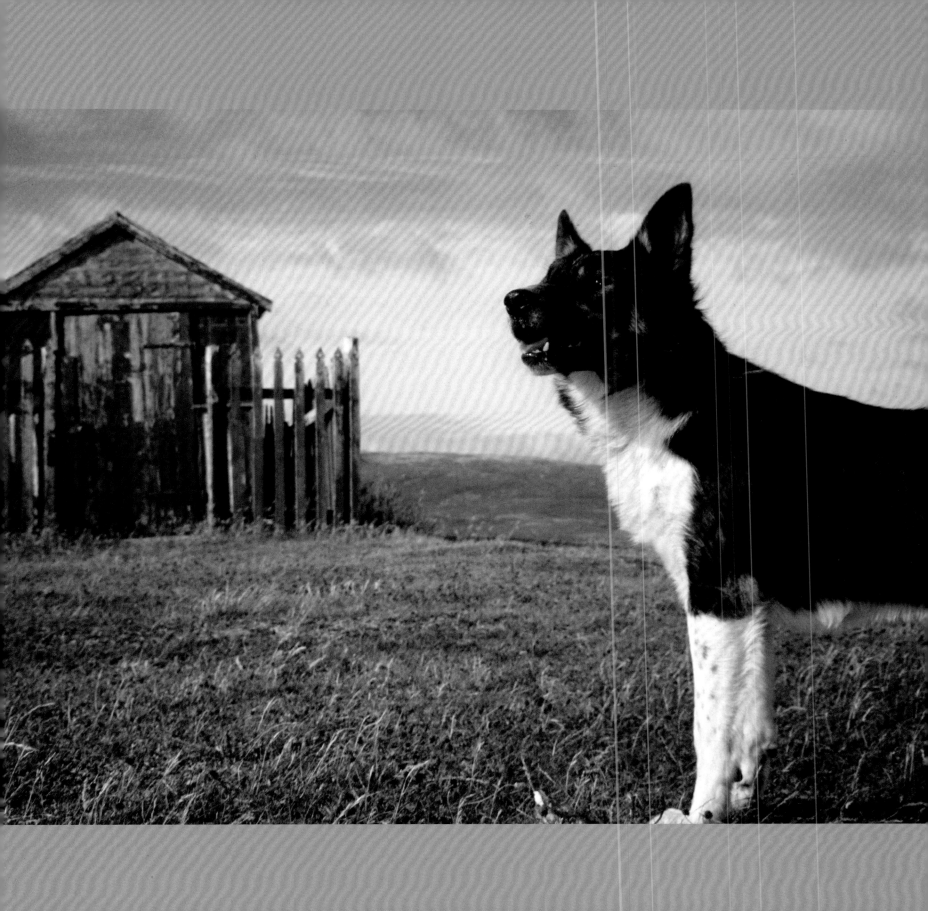

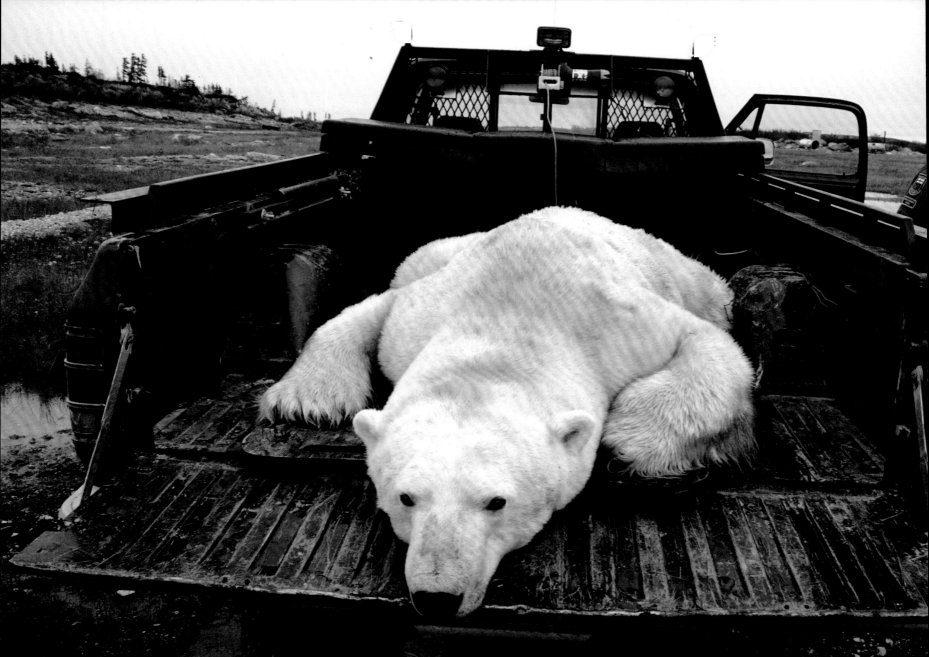

BEAR TO GO
CHURCHILL, CANADA, 1994

It's alive! Don't worry, it's drugged and on its way out of trouble. But look at the size of it! This, remember, is a Canadian pick-up, a monster among trucks, and this animal is spilling out of the tailgate. That's what struck me hardest when I knelt down beside the toppled beast – its sheer and horrible size and all the unreasonable power and danger that comes with it. Polar bears are the world's largest land carnivores and the only species which will actively, deliberately and regularly hunt humans. Taking the photo, leaning over it with my wide-angle, was like grabbing a quick shot of an unexploded atomic bomb – its fuse might have been temporarily stupefied but it radiated death. Wow!

Churchill is a wind-smashed shanty town at the end of a railway line clinging to the chapped southern lip of the Hudson Bay. Its heart is beaten and mostly everything there is broken. When I went there in 1994 it enjoyed a brief boom as the polar bear capital of the world, and for a short period in autumn eco-tourists braved the rough and ready local flavour to bounce about in 'tundra buggies' and meet the big white ones. They in turn had arrived at the shoreline to await the impending freeze so they could get out onto the ice and sate their summer fast by terminating a few seals. However, in the un-frozen hiatus the increasingly hungry animals made a right nuisance of themselves by wandering into town on the sniff for garbage, or dogs, or people. Deemed unacceptable, a squad of burly bear police patrolled the environs searching for the rogues and carted them off by helicopter a few miles up the coast and out of harm's way. It's not a job for the faint-hearted, nor one where complacency would be any sort of vocational asset. Accidents were still happening; it was a classic case of living with a species being a very different reality than loving it from a safe distance. Polar bear skins were sold in the small gift shop in the town and while some scowled I wasn't surprised at all. Churchill wasn't the sort of place for happy bear-huggers.

BUTTERFLIES WITH GUNS
MEXICO, 1995

It has come to this. We're guarding butterflies with guns. Not in the UK of course, not yet anyway, but in the mountains four or five hours drive north of Mexico City. Here each winter 500 million Monarch butterflies arrive after migrating southwards from as far north as Canada. They hang up in select and traditional parts of the pine forest and chill out for the winter. Then they head back, breeding and dying in a series of 'generation waves' until their progeny reach those prairies at the other end of this continent. They've been doing it for millennia; the Aztecs believed the butterflies were the returned spirits of their dead and venerated them, but now we are putting an end to one of the greatest natural spectacles left on earth. Hence the guns – it is Mexico after all.

The choice of hibernating sites was never random. These fragile insects need to get through a winter without feeding so energy conservation is a critical factor. Thus their metabolism defines exactly what is required in terms of shelter, the precise temperature range which is tolerable, the humidity, the amount of light and wind and snow and rain. The areas they choose are very special, cloaking the trees in vast cloths and the trunks in a skin of weird scales. So we should

look after them right? Well, no, we're cutting the trees down, or at least felling the surrounding forest and changing their perfect micro-climate. The result is a genocide. I've seen a photograph of an American scientist wading knee-deep through dead butterflies, killed by a frost that penetrated their sanctuary for the first time ever.

When I first visited in 1995 we were the only ones there. When I returned in 2002 it had gone all touristy but even this was not going to save the butterflies. The people here are poor, the officials corrupt from local to government level, and the World Wildlife Fund (WWF), who seemed to be leading the conservation efforts, had employed a naïve Californian lad in his early 20s to be their force on the ground. The chainsaw-wielding honchos had him wrapped around their blistered little fingers. As I interviewed them, we were serenaded by the continual crashing of falling trees which they tragically claimed not to hear. Maybe we need butterflies with nukes not machine guns.

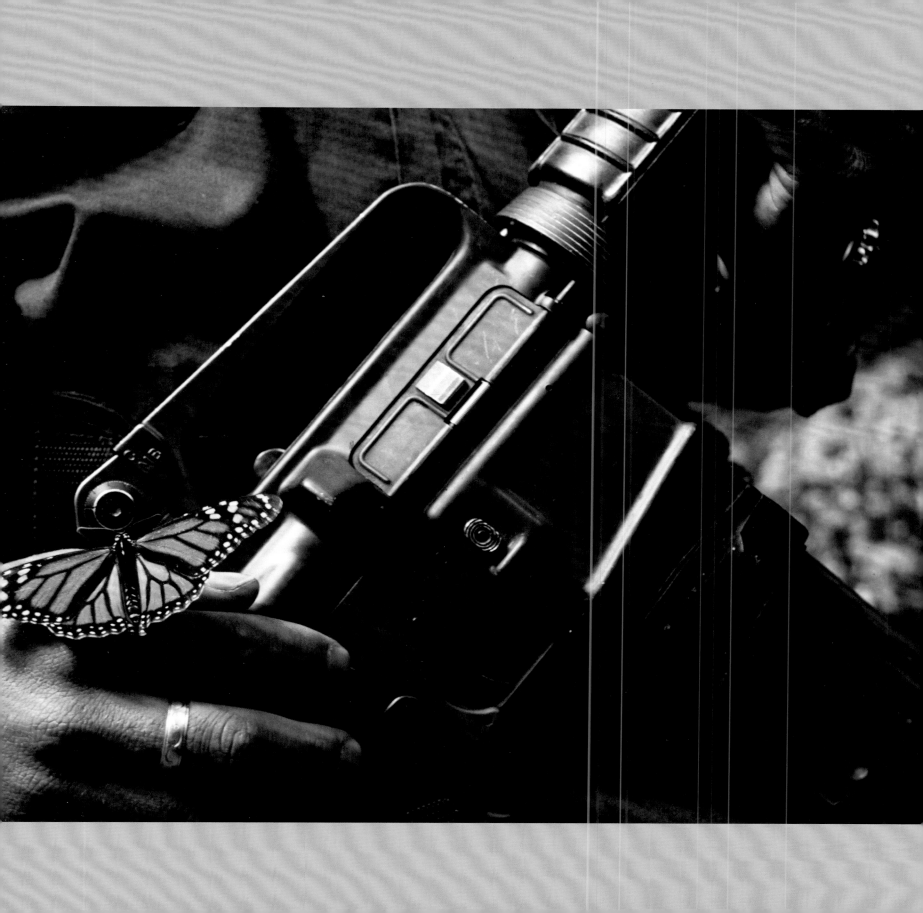

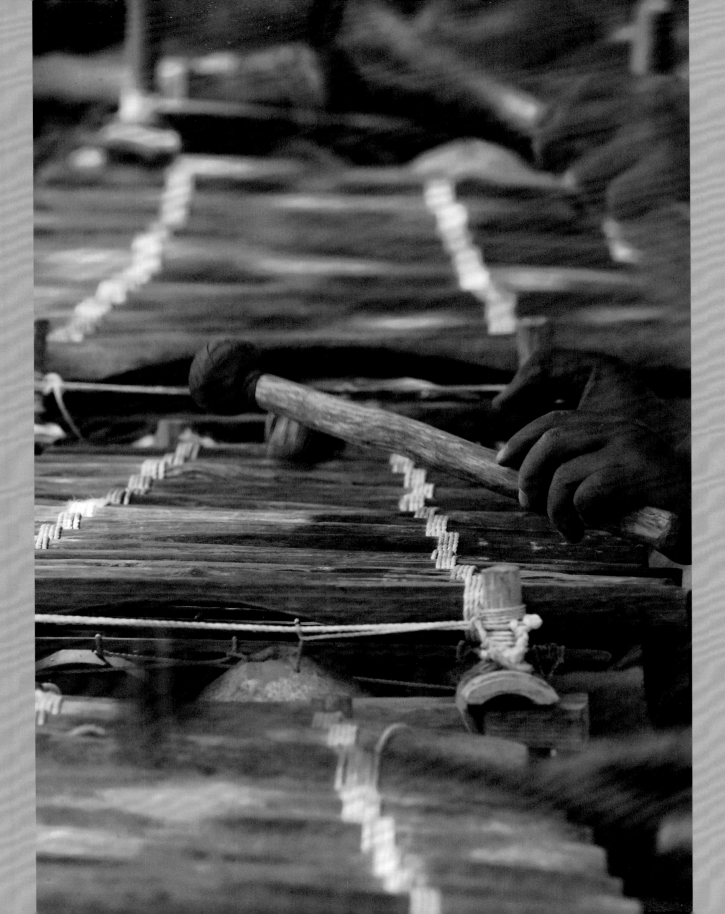

IDLE HANDS
GAMBIA, 2008

The three boys and their father, an unsmiling man intent on tapping the right notes, were lined up in the long, cool shadow of a massive tree. The four xylophones or glockenspiels laid out before them were 'plinking' furiously to produce a cacophony from which 'elements of a tune' would occasionally flux. We were there for nearly an hour and they never stopped. It became a sort of wooden waterfall noise in the background, pleasant but lacking a sense of performance. But it was for our benefit and I liked it very much for that reason, and so before we left I gave the band as generous a tip as I thought reasonable. They smiled graciously, nodded, but didn't stop playing.

Photographically it was difficult. Midday African sunlight was burning up the world and allowing any of it near a picture would produce pretty bad results. In the shade, technically speaking, F-nothing; in the sun, F-everything. A mix would be a horrible mess of bleached out and underexposed rubbish. Because 'out' was out, 'in' was the only way to go. Thoughts, therefore, of a group shot from any angle were unthinkable and it meant going in close and shooting down the line of shade. When the drummer boys were in so were hotspots of hell-light, but by now I had seen the picture I wanted. The gorgeous earthy hues of the instruments are matched perfectly by the musicians' skin tones and the paler cord binding the rows of hollow wooden tubes add perspective to the picture. Luckily for me the player in the middle was the youngest, perhaps six or seven years old, so his arms and hands were tired and resting. I was holding a telephoto zoom, with the monopod in the van – I liked the idea of a slow exposure blurring out the furious beating of the older brothers so that all the attention was on the static sticks and fingers. This would, coincidentally, increase my depth of focus and, along with my long lens, flatten the picture, making the musical instruments into a mosaic of shapes. I had one problem... the knees of the idle player were clad in a nasty camouflage fabric, you can just see a tiny bit of it on the mid-right of the image, so I had to crop it while trying to keep the central composition of the photo as good as I could. I waited, he fidgeted and this was the best I got. I wish he had been wearing shorts, that sliver of cloth annoys me. Almost, but not quite!

149

STICKY FINGERS

GAMBIA, 2008

It's not pin sharp, there was hardly any light, and I don't like that scrap of red on his chest in the top-left. But I like the way the open candy wrapper commands attention in the palms of his hands. This scrap of paper, with the residue of a chewed and licked old sweet, was in its third set of paws in less than a minute and at this instant its remaining contents are being weighed and measured before being handed on to the fourth hungry child. The posse didn't appear related and the hierarchy went from biggest down, from about 14 to maybe 7 (it's difficult to age malnourished kids because they are always smaller than you would think them by western standards). But the unspoken democracy was impressive, the sharing habit instilled through necessity, treats and sustenance being in short supply, so the minute passed in silence and ended with a pristine white sugar-free square of paper and the painstaking licking of 40 fingers and eight lips. It was all watched by my privately educated, white, middle-class, 13-year-old girl – one of the most important lessons she had attended this year, I would say.

Material poverty shouldn't be unpalatable, it should be more perceptible to more people. It's relative, of course: I see some in the UK who have less and suffer for it, but when one witnesses the extreme, of which this is not an example, then I'm afraid their predicament pales in comparison. To have-not is not to have nothing. And to have no hope is the ultimate conscious loss. I have spent time with people with nothing, but their nil was still clean, tidy, sometimes proud, it could even still smile; but once, when driving through Ecuador after the El Nino flooding, I think I witnessed the hard face of terminal poverty. The bus was sucked to a standstill opposite a roadside shack a metre deep in soft mud. Sat outside up to their waists was a family, filthy, cold and hungry on the seats where they would normally loiter to watch the world go by. The 'nothing' they had was gone and when I looked into their expressions one by one, their eyes revealed that all hope was gone too. It was a condition that I've seen just that once and it haunts me. I would have taken photographs had I not been needed to help slide our vehicle over the slurry that had destroyed them. I sometimes wonder what those pictures would have been like.

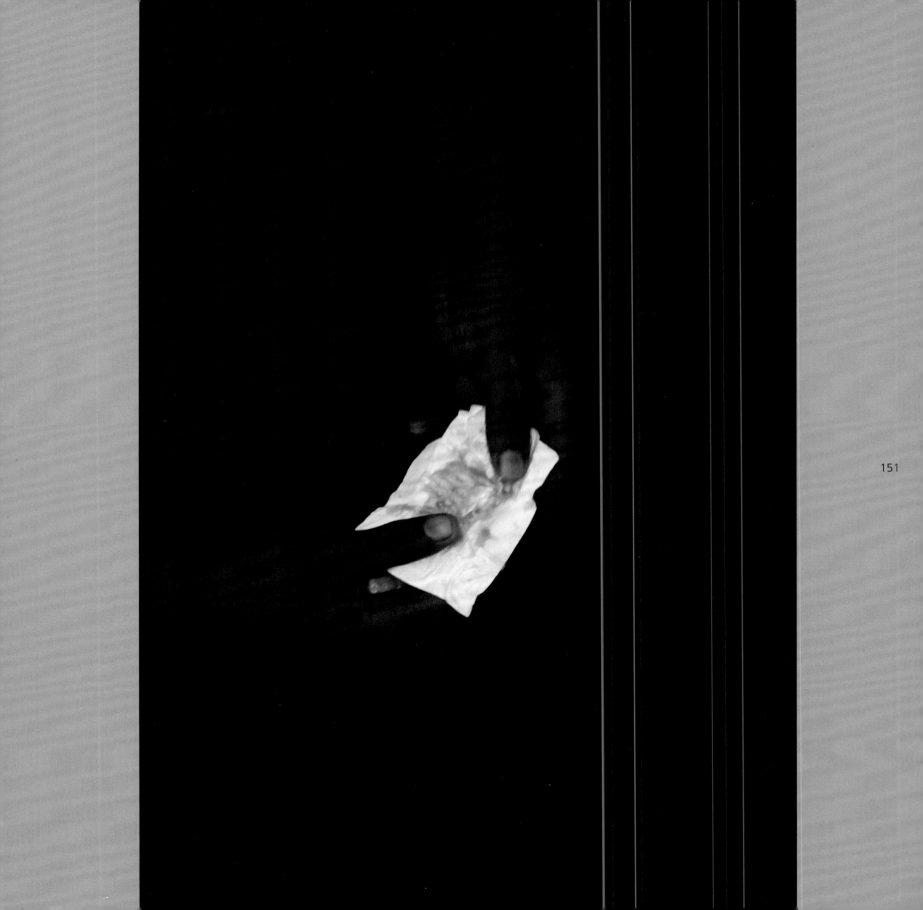

AFRICAN TIME
TANZANIA, 1998

The Maasai of Kenya and Tanzania are pastoralists who live on the grassy plains with their precious herds of animals, zebu cows and goats. Red is their colour and the colourful bead-work one of their most obvious cultural stamps. They are one of Africa's best-known tribes on account of their proximity to the most popular safari destinations; indeed many of the latter are centred on these peoples' homelands – Kenya's Maasai Mara and Tanzania's Serengeti plains. The tourist presence means that many Maasai speak very good English, some French, and a few are very well educated. They are proud, not primitive, but poverty stalks them from the skies and drought is their worst fear. True, some of them have become commercialised, selling crap through mini-bus windows or performing stereotypical dance and drama routines at guest lodges, but before you think, 'what a shame for such a culture to sink to this', or, 'how fake', just remember that the dollars that go into that fire side calabash might be sending a child to school, buying some medicine or putting some food on a table.

When we went to Tanzania in 1998 to attend a Maasai wedding ceremony we sought out a less visited group in the north west, off the tourist route and a little less influenced by all that imports. It was a special experience, we were welcomed and allowed access to their homes and private lives; they spoke candidly, through translators, and we were able to film and photograph everything. They were short working days and the sun rose fast and the light soon became hard and unforgiving, particularly on the natives' dark and shiny skin. Thus by mid-morning I was 'indoors' or going for details. This is one of two of such shots I got which sort of work. It's cheesy and obvious, but the old fashioned digital watch strikes a misplaced contrast with the beaded bracelets and wooden Assegai stave. It's not quite 'caveman with a coke bottle' but you know... The young Moran who owned the piece was very pleased with it despite the fact that the time displayed was wrong. I did fiddle with it to try and set it correctly but to no avail, and such accuracy was irrelevant anyway – he didn't need such a measure of time, the sun counted his seconds and the seasons his days and months. This was jewellery and it was the only watch in the village, a 20th century trophy which he had hunted and won.

153

BUILDERS OF THE WORLD UNITE

NEPAL, 1994

I know, they are not working! It's a global phenomenon! How is it that whenever we see builders they are inactive, lazing, loafing, laughing, mulling, or reading tabloids or drinking tea, or worst sleeping in their vans? Yet, somehow miraculously, the houses, tower blocks, bridges suddenly get finished! Everything except our roads where the species of labourer is not ultimately productive, probably on account of its rarity and strictly dry diurnal habits. But the rest have us fooled, they project abject lethargy, generate a widespread mistrust, but have the last laugh when the job is done. It's a perversity, why do they want to be mocked and moaned about, when they are actually effective and industrious? I know, the new Wembley, Stonehenge – that still doesn't look finished to me, and the 2012 Olympics... that could have been the 'Builders' Armageddon'.

I grabbed this shot while scuttling down a trail a little worse for wear after too much chat and Chang, a local, soupy beer. I liked the way the timber poles 'whited out' the right half of the frame and that it was all backed by the wattled mud wall with its three traditional window frames. Their symmetry further adds to the geometry of the composition and the detail of the doorway with its prayer stone and horns above the lintel gives it a global location. I started shouting to the trio so they would turn around – without their cheerful faces it wouldn't work. Scowls or backs of heads aren't much good.

Paradoxically this happy snap also portrays the deforestation crisis in this region, which is a grave concern. Given the altitude and inaccessibility, the only construction material for the frames of new buildings is wood of the type seen here, and as the population grows, demand for it is increasing the rate of its harvest. Much more is cut for firewood, the only source of fuel for cooking and heating. Cold and hungry westerners trudging through the place dramatically exacerbate the problem which is causing widespread erosion and the subsequent loss of vital 'farmland'; it also increases the risk of disastrous landslides, particularly around the villages where the easy-reach firewood has all long gone.

NILEBITING PERCH

EGYPT, 1988

'Excuse me, is there any chance you could shin barefoot up those shallow steps in the mast, climb right to the very top and then peer down at me smiling, while swaying precariously over the deep rivers of the Nile?'. No, I didn't say that; he suddenly and inexplicably sprang up and within seconds was fiddling about with some problem in the rigging from this lofty perch. All I did was shout 'Oi, mate!' so that he looked down for me to get a shot of his face rather than his arse. In those distant days I was not very confident when photographing people and most of my subjects appear very small in the frame and in the vast majority they are indeed showing the camera their arse. I didn't like people much then so I also didn't really even want to try and make them look good in my pictures. Only later, when I had learned to charm them or not to fear them did my photos of other humans begin to get better.

These days I can instantly rush into a convincing patter to get a chance to make an image. Sounds exploitative, and it is, the whole process is, you are taking something from your subject and even if you fail to capture their unique personality, then at the very least you have taken their time. And I want a result; I've spotted an opportunity and I haven't got a lifetime to realise it. That's not to say that I am not consummately polite or that if my request is declined I don't humbly thank them for their time and say goodbye. Or that this charm offensive doesn't sometimes take hours or even days to reach its conclusion. I'm not impatient, just determined, and so long as I don't hurt anyone in any way, either carelessly or intentionally, then I'm just doing my job. Do I lie? Yes, all the time, my girlfriend's a hairdresser some days and a nurse on others, my family are farmers when I need them to be and shipbuilders, or fishermen or ice-cream vendors, whatever it takes to find common ground, to build bridges across continents, colours and creeds. I'd happily pretend that my father was JFK, my mother the Queen of Sheba and my best friend the Heavyweight Champion of the World if I thought I could get away with it, if it would help me get the picture and that the lie wouldn't upset anyone if it were exposed. I don't want any more arses!

SUGAR SPUN SMILES

MEXICO, 1997

Santa Rosalia is where all the world's dust is mined. This crumbled town half way down the Baja California peninsula is a place where things were made broken: every paving slab, every telephone pole and line, every pane of glass has a mandatory crack. It's hot, and doing nothing all day seems to be the principal local profession. But getting back to the dust; you buy a beer, the barman puts it down, you take a sip, and already there is a dust circle where the glass stood for a minute. On the edge of town is the source of this omnipotent material: a dusty track leads up past a dusty concrete pipe, to a dusty hole in the dust where a shambles of dusty shanty shacks house the 20 people who are not working in the dust mine. Oh yeah, it's grey, the dust is grey.

We had journeyed to this desperate outpost in pursuit of squid. The seas here are extraordinarily rich in marine life, the cetaceans are varied and often wonderfully abundant, and on one of our 'fishing nights' a school of pilot whales approached our rickety and smelly boat. There were hundreds, they slopped by in the moonlight and must have been passing for five minutes non-stop. We went 'squiding' all night and then slept fitfully, coughing, and then mooched about in a dazed stupor. I went out looking for things. It was about six in the evening when I spotted this character, with his rosy bloom of bagged candyfloss. I climbed up on the dust mine pipe and followed him using my 400mm telephoto to remain 'hidden'. I got this picture pretty early on in the hour. It's the cleanest, tidiest and simplest image which is why I can live with it more than the others I got. But it's not the best by any means, because my reportage captured a remarkable and formative hour in my life. This man scuffed up the blanched track to some sorry sheds where a series of children were given joy and happiness, not through the sweet taste of his confectionery, but through his games, his teases, his clowning and all his love of his ability to lift them out of their hellish squalor. They leapt, chased, laughed and smiled until the greyness seemed to fade away and the moment defined that true kindness which the good can manifest when they know someone needs it enough. I shot it all and the pictures could still bring a tear to my eye if I were to let them. Sorry, I just can't give those away, but this is the best technically...

THE GREATEST PHOTO I NEVER TOOK

MADAGASCAR, 2000

In another caption I have written of the frustration while judging competitions of discovering photographs which represent a fabulous opportunity but which do not present the actual picture itself. This is my very own crowning and inglorious example, a chance gone, wasted forever. I'm going to try and make a pathetic excuse, be a bad workman and blame my tools, but in truth I just wasn't thinking and that is unforgivable, it countermands everything I believe in with a camera in my hands. Put your black cap on and don't be lenient with your sentence!

We had made a stop on a small island off the north coast of Madagascar called Nosy Be and had nothing to do other than mooch about looking for pictures and birds. But it was midday, the birds had the sense to take a siesta, the light was horrid and it was stinking hot. We climbed out of the forest and walked along the beach for some air and that's where we came across a stack of canoes pulled into the shade of some thick trees at the edge of a village. There were a few kids about trying to sell us carved boats and fruit, and this girl who had been painted up for a ceremony later that day. It's a touristy spot so no doubt there was a 'ship coming in' and despite offers of all kinds of swaps for their wares, all the merry band wanted were coins. Thus I got her to sit down in the shade and look up at me. The photograph is cropped, the original frame had all of her in... and sand! I want to say things like 'the cross behind her head works for me', or 'the low light makes the most of her very dark skin and white make-up', but why? Just look, look at her face, her gleaming eyes and teeth, what is clear to me is that all I needed to do was to crop in very tight, perhaps forehead to chin. Everything else would go black and I would have been left with eyes, teeth and the lacy patterns. It probably would have been a great portrait. Think, think, think. Never stop searching for the heart of the picture even if you think it's right in front of you.

The excuse: I was using my Leica M6 with a fixed lens, no zoom, and Kodachrome 64, very slow film in these conditions, and I therefore couldn't 'get in'. Yeah, £3,500 worth of kit that has produced some of the world's greatest pictures but wasn't good enough for me – it's rubbish, I missed it.

I KNOW WHERE YOU
GO TO MY LOVELY
TANZANIA, 2001

Stone Town in Zanzibar is an amazing place. Its tight labyrinth of shady streets provides gorgeous early and late light, and challenging contrasting patterns during the sticky heat of the day. It's often difficult to hide as a westerner in Africa when you are looking for candid snaps but here the thick shadows of doorways and the corners of alleyways are a perfect place to lie in wait for a passer-by. Of course you can stand or sit for an hour or two and see nothing to catch your eye, but I don't mind as all the while you can soak up the ambiance and learn so much about the lives of those who come and go. I never take much gear, wear a watch, carry money or even wear my favourite t-shirt, just in case something goes wrong. But if you don't hang around in the back streets you won't get shots like this and while I might think twice in Port au Prince or Bogotá, I'm still happy to walk these ancient ways.

Often uncontrolled opportunities have a defined anatomy and if you can see it then you can predict its possible outcomes and maximise your chances of seizing the moment. For instance, you can spot a nice backdrop or a frame for a subject and then analyse the potential of a suitable subject co-joining with it. This is a very common habit of mine and gives rise to incredible flights of fantasy. Alternatively you can happen across a subject and then begin searching for the picture to put around it, another common occurrence which gives rise to desperate fits of frustration! I think two things if you wander the world waiting for the perfect picture to just happen for you: one, you'll miss it because you will not be used to looking for it, and two, it will not be perfect because you wouldn't have controlled the controllable aspects of it. People who say 'I just looked up and it happened' are just bullshitters; if their photo is really any good they made it so.

This photograph isn't any good but it serves my point. I had seen the frame made by the doorway, liked the holey panels and stained wall beyond and had been loitering to see what appeared. I thought about it and set the exposure before these two boys ran quickly across behind so that when they came back and turned to chase their tyres towards me I was poised with pointing lens. It's not pin-sharp, no follow focus, but I like their shadowy anonymity.

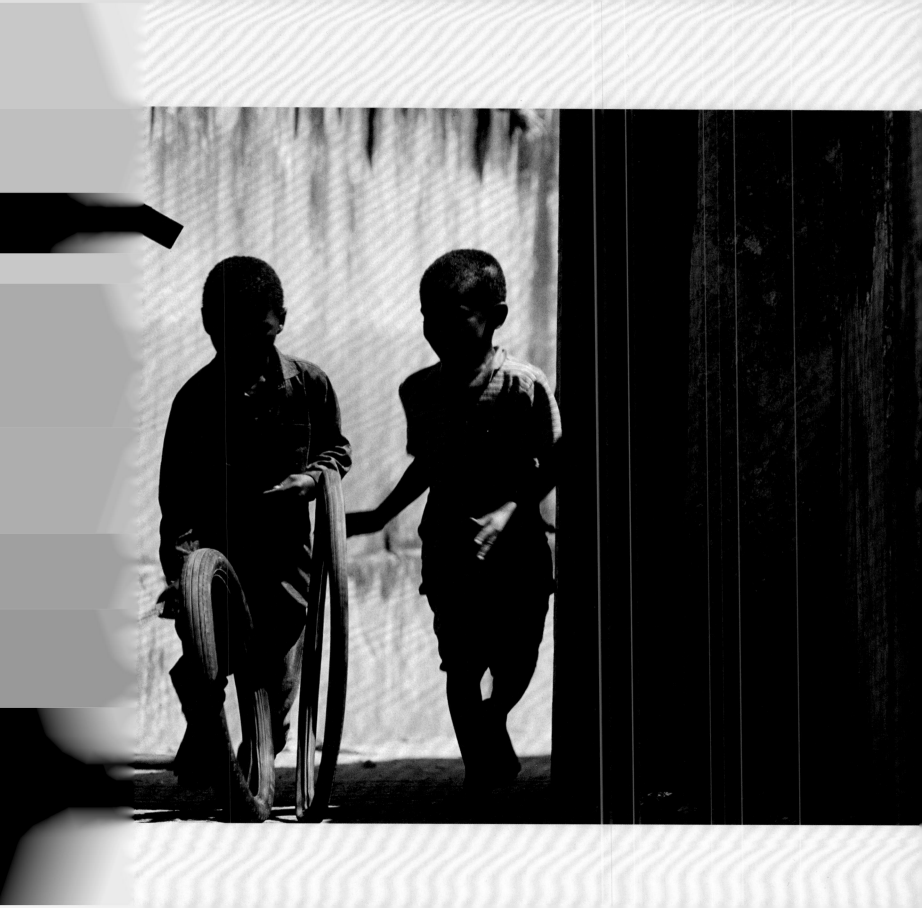

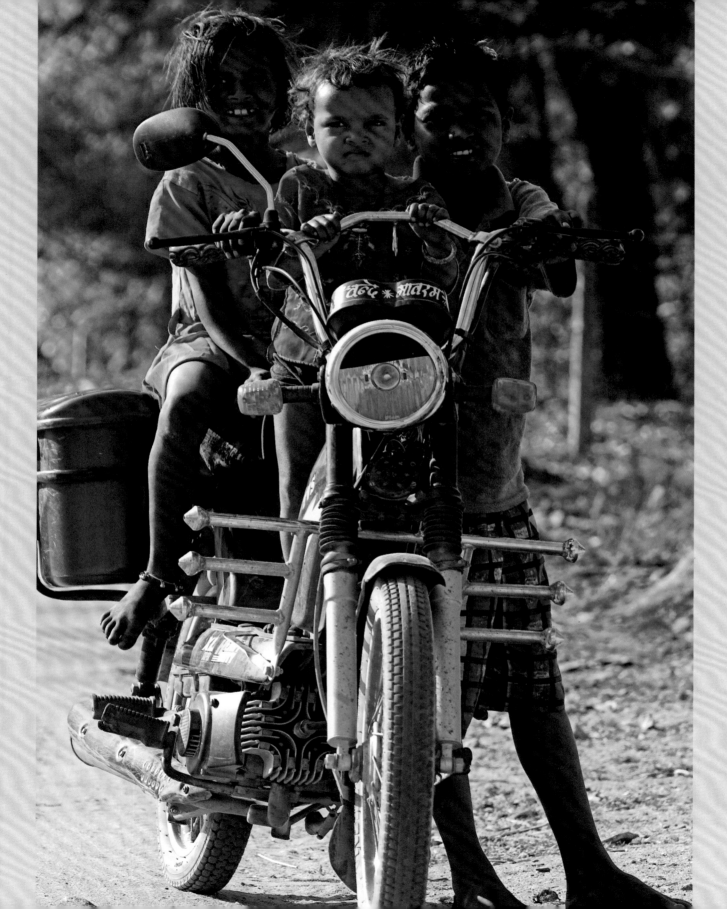

EASY RIDERS

INDIA, 2006

When their dad wakes up on this fine sunny afternoon and looks bleary eyed out of the window into an empty, motorcycle-less yard, he's going to think 'someone has nicked my bike'. He's going to scoot out of his house in his panic pants and start shouting at his neighbours, and when he discovers that his kids have gone for a ride down to Bhandhavgarh National Park to race a few tigers, he won't be smiling as much as this happy trio of Kinevals. His mood will indeed be Evel!

Just for the record: the bike was running and passers-by were paying no notice, and thankfully no one was injured during the making of this picture. But it was irresistible – naughty urchins, cheerily clad on a colourful bike in late-afternoon sunshine, struggling to manage it and prevented from escaping, on the roadside. Much less challenging than trying to find a tiger in any good light and on this particular day certainly more satisfying. India is one of the easier places to find slightly comical opportunities. Health and Safety have yet to be allowed to exterminate good old fashioned common sense and so virtually anything still goes – funny so long as you don't have to go with it. I saw a haystack cycling down a

track the day after I took this photo. There was no visible human involvement, nor in fact any discernible bicycle, no wheels, handle bars, nothing but the large wobbling tower of grass drifting from side to side, 'feeling' the verges in order to sense the direction to progress in. It doesn't translate as a photograph because it's not moving, it just looks like a pile of hay in the middle of a dusty road. I'm afraid you had to be there.

I've messed a bit with this image. The light was quite harsh and directly behind the stunt riders, and thus their dark skin tones were underexposed and the highlights all burned out. So using the RAW file I crushed the 'highlight contrast' as much as I could, brought up the 'shadow contrast' to compensate, gave it a bit of fill light and then put some saturation back in as this had sucked the density of the colours out a bit. A pinch of vibrancy to make it bite did the trick. It took about 30 seconds to make it a usable photograph and that is why digital is better than film and why I always shoot RAW files. If this had been a transparency exposure it would never have worked at all.

165

WEDNESDAY'S CHILD
NEPAL, 1995

The child mortality rate in the winter was 50 per cent in this village through respiratory illness, malnutrition and hypothermia. There were no modern medicines and no doctors. There was a pragmatism which was spoken and accepted – that children die, they always have and will. The strong survive, the weak will not. One night I accepted the offer to forsake my freezing tent and sleep in one of the houses. They are heated by wood fires but there are no chimneys, heat is far too valuable to be allowed to escape, so the whole room where everyone gathered to sleep filled with callous smoke. I managed to find a spot with a cleft in the floorboards towards which I placed my mouth, preferring the thick sweet smell of dung rising from the animals below to the choking fumes. But I couldn't sleep anyway because in the far corner a baby lay crying all night. I got up and stumbled about trying to find it but got 'shushed' by one of my house mates. In the morning I asked why no one had been caring for it and the interpreter timidly told me that they were waiting for it to die.

Wandering through the adjacent hamlets revealed even greater poverty, poorly clothed and barefoot wretches begged for food rather than attention, and when I enquired why 'our village' was better off I learned that it had the fortune to be on the main trail through to China in the north. This meant that the elders could charge tolls on goods that passed through and once or twice a year these included tiger bones, the most lucrative source of taxation. So, this little chap, with his woven booties and jerkin might just have had the edge on survival due to dead tigers, those iconic symbols of our fight against extinctions. Conservation from an armchair in the west has a very limited perspective. Would you take his shoes away?

Amongst the kids that I got to know here he was the most surly and always on the fringes of the games and gangs so I only really got this one picture of him, and it displays his temperament. I like the overall uniformity of the intense ruddy colour, which is real, and almost like a sepia print, (with one exception – his yellow beads), and the flat light hasn't stolen the wonderful textures either. I wonder if he is still alive? I suppose it's 50/50.

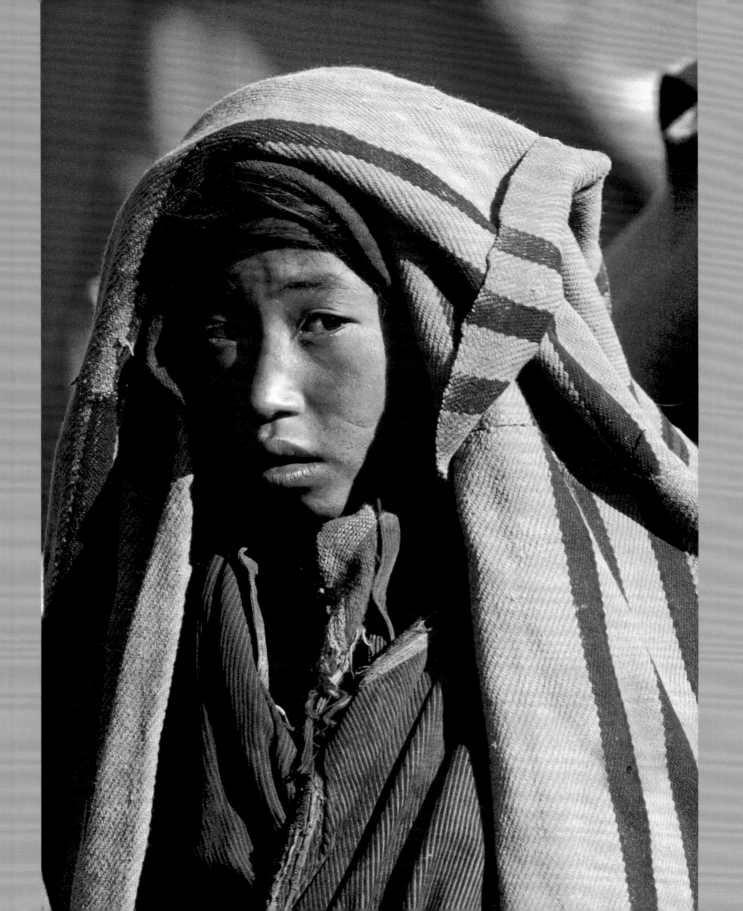

168

FAREWELL PORTRAIT
NEPAL, 1994

This young man had been my camera assistant for the two weeks I stayed in his village. He carried my bags, cleaned my equipment and loaded my films. He also facilitated lots of opportunities and took lots of photos himself which I posted to him. I'm not sure if they ever arrived but I've always hoped so. They were quite good, he listened intently to a language he didn't understand. I took this portrait when he came to bid me farewell as we were striking our camp. He had just presented me with three gifts: two boiled eggs the size of small pebbles and a plastic bag full of Chang beer. The eggs would have been his breakfast and the beer was nice but the real gift was the bag, a limited and coveted resource up here. And that beer was literally in it, slopping around in the bottom, so given that I had to trek down 10,000 feet of bumpy trail I drank it. In return I gave him my thermal underwear, my favourite *Jesus and Mary Chain* t-shirt, into which I secreted the empty beer bag, a penknife and a playing card from my wallet. I distributed the rest of the clothes I wasn't wearing to the other children and wished that I could have left someone my walking boots. We shook hands many times as he and the rest of the excited horde followed me to the huge stone which marked the village boundary, a process which took more than an hour, and accounted for a lot more Chang and blessings, bestowed through the daubing of butter to the forehead. Please don't think ill of me but I cannot remember his name, it's a real handicap of mine – scientific names of woodlice, yes, human names, no.

The blue backdrop is a tent; it's artificial but it sets off his blanket attire well and this in turn frames his face nicely. The dirty grey coverlet isn't exactly the most visually appealing of the local weavers' cloth but thankfully very few of the people here had any western clothes. One girl had a 'Deputy Dawg' t-shirt which she proudly put on whenever she thought I was going to photograph her. I encountered a tribe of 35 hunter gatherers deep in a far-flung Sumatran rainforest once and most of the women 'covered their dignity' with fake Armani tops in lurid colours, which wasn't nice. Still, the next time this lad posed for any photos the snapper would have faced the *Mary Chain* so I'm guilty of ruining a few pictures.

THE HAPPY SONGSTRESS
NEPAL, 1995

I spent two weeks in a tiny Nepalese village in the far north west, far from the trekking trails now so spoiled by the rudeness of the world's too-easily-travelled tourists. We had gone to film a wedding and explore the local marriage system, whereby a woman simultaneously marries a whole family of brothers. Due to the competence of my colleagues, and a healthy budget for a change, I was lucky to have plenty of time and so I set about becoming the community's first official photographer, football coach, ornithologist and clown. The key to my success was a Polaroid camera and the charm of the people. My reward was a remarkable gift, consolidated by this young girl and one of her friends.

I soon recruited a principal assistant and team of apprentices from the rag-tag army of lovely but lousy children, and from dawn to dusk I took pictures. Most of the folk had never seen photographs of themselves before; most of the kids had never seen a photo of any kind! Thus to see, to hold, to own their own portrait was beyond their imagination. I was soon in demand from all the families who were rushing to line up from great-grandmother to new-born before the hearths of their homes. I spent my stock of instant film prudently and won the approval of everyone who would pose, pretend, repeat or ignore me so I could assemble a fabulous collection of candid shots.

Early one gleaming morning I had climbed as high as my starved lungs let me to search for Himalayan Snowcock, failed and was sliding back down the mountain in a sweat. I stopped at a water tank above the village. It was covered in a corrugated iron shell and hidden inside were two of the village girls who had come to draw water. They were singing, and the chamber enclosed and amplified the song which spilled out into the sharp clear air. It was the most beautiful sound I've ever heard humans make. It fell, re-formed, they giggled and continued, it lasted for just a few precious minutes. When they left I noticed that this was one of the singers and for the only second time in my life I left somewhere liking the human race more than when I arrived.

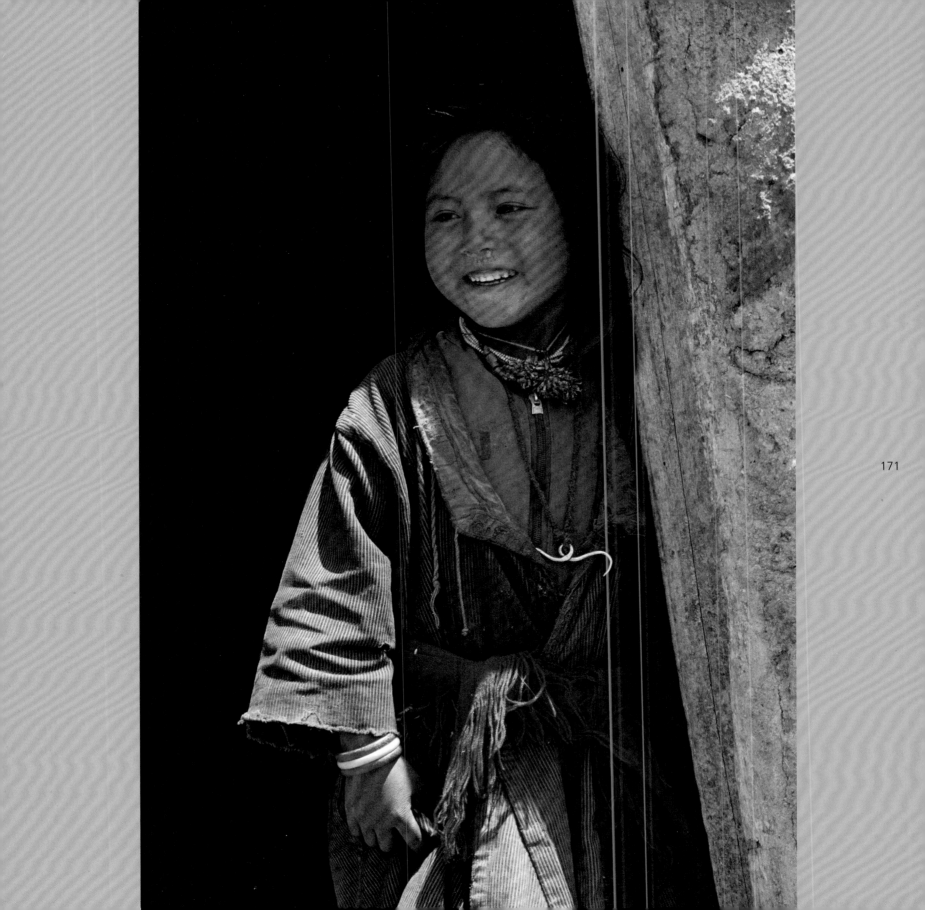

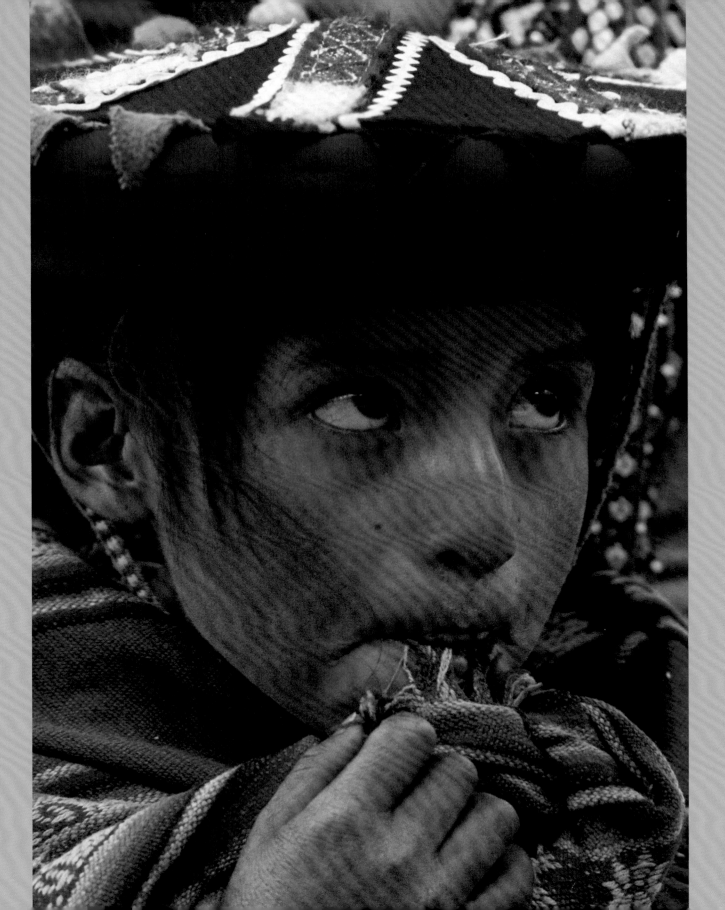

WELCOME TO PERU
PERU, 2003

It's true: as you step off the plane on Hawaii a girl in a grass skirt puts a necklace of flowers round your neck; when you wake up with a hangover beneath a tree in a Mexican square, a Mariachi band will be serenading you; and whichever Incan monument you attempt to enjoy in Peru in spite of legions of the worlds unwashed travellers, there will be a line of pan pipers playing that tune. I'm sorry but maybe this is the point where you can affix the philistine tag; I like music, I like experiencing new music in context, I admire greatly the technical skills of musicians... but a line of blokes dressed in shell suits with some tatty blankets over their shoulders puffing on fags and bobbing up and down in front of a fluffy hat with three dollars in it is not a chart-topper for me. It's an irritating cliché and on the whole I'd rather be in the McDonalds round the corner.

This girl was with a group of pipe-less women at a site which required a minimal hike up a muddy trail and was 'not trendy' according to our guide. Although applying 'trendy-ness' to archaeological sites undermined his credentials, at least it was free of bearded and filthy rucksack-carrying gap year idiots wanting to tell me that if *U2* played here it would be 'awesome'. That's what I heard at Machu Picchu. A lifetime of dreaming through the pages of *National Geographic* and my first visit to this astonishing site was corrupted by that thought. Still, once the escalators are fitted I wouldn't be surprised.

I digress, the girl was being repeatedly told off for something while the older women sang and posed with a cuddly kid goat and had that nervous look of a knowingly naughty child which I liked. The chewing is good, un-posed, but for me the picture needs a little more going on – a smirk, a cheeky look in her eyes, a backward glance, the wagging finger of the elder, I hate to say it, but even a tear or two. I waited, listened to the entire repertoire but nothing happened other than the fact that she cheered up when they gave her the 'goatling' and I took a couple of cheesy postcard snaps to keep the happiness on track. Then I gave them some money. I hate travellers who say you shouldn't pay people for photographs – that it sets a precedent and makes life difficult for the next photographer. Not as difficult as the life of the subject who may have nothing else to sell. Not so much a case of 'getting a life' as giving a little, if you ask me.

173

SCRUB AWAY, SCRUB AWAY...

KENYA, 2004

Dr Ray Damazo is a remarkable man. He inherited a house, opened a rest home, got into a little property development, made some real money, then got into corporate entertainment and made a fortune. He is fair, polite, honest, cheerful and a down-to-earth nice guy. Before all his entrepreneurial enterprises he trained as a dentist and now spends half his year driving around the African bush with a mobile clinic dispensing free treatment to the tribe's people. He funds it all himself and campaigns against stupid tourists giving the children sweets which have a disastrous impact on their teeth and wider health. His wife, Gail, nurses and administrates, and he practices anywhere he can get a roof and power. After *Marathon Man*-style treatment as a child I had not set foot in a dentist for 26 years and he replaced my two fillings. I didn't feel a thing other than the flies tickling my legs and the eyes of 50 Maasai watching in silence through the windowless frames of the shack. Making a film about their work was one of my best jobs ever, I liked them tremendously, proper Americans – do-ers, changers, two of the real stars on the flag.

Word of his clinic's arrival spreads like good toothpaste and even before his truck is unpacked the rich shade of the midday acacias is filled with the red cloaks of the Maasai. Some walk for miles, arrive with two day's modest supplies and plenty come with more than dental disorders. TB and Aids are common and where possible an associated general practice clinic runs in tandem. Babies bawl and the elders banter but no one screams in the chair. There are two reasons for this, firstly, by western standards these people are tough, and secondly Ray is never impatient when it comes to waiting for the anaesthetic to become effective – all his patients arrive and leave with beaming smiles. This girl was no exception. She was waiting with a giggling gang and came to stand where the harsh overhead sunlight bounced back from a wall giving some necessary 'fill' to the otherwise unpleasant contrast between her shiny sepia skin and the shadows made by her nose and brow. It looks flash-lit and in truth I'm not very fond of it, but the unconstrained joy is a pleasure to behold and thanks to Ray she is lucky to have a pretty good set of gnashers.

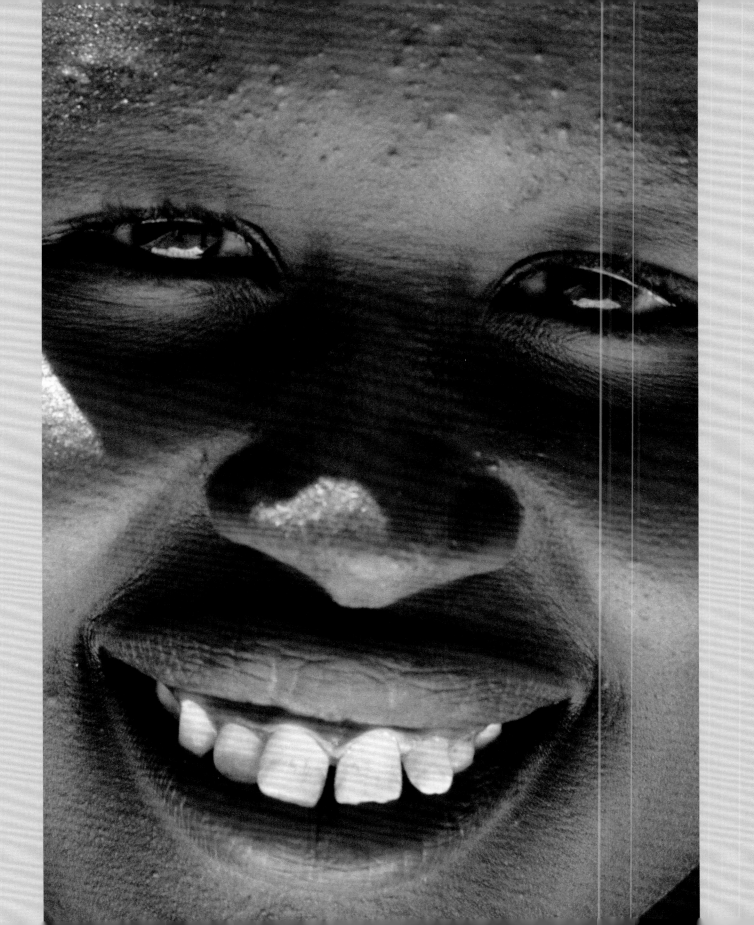

175

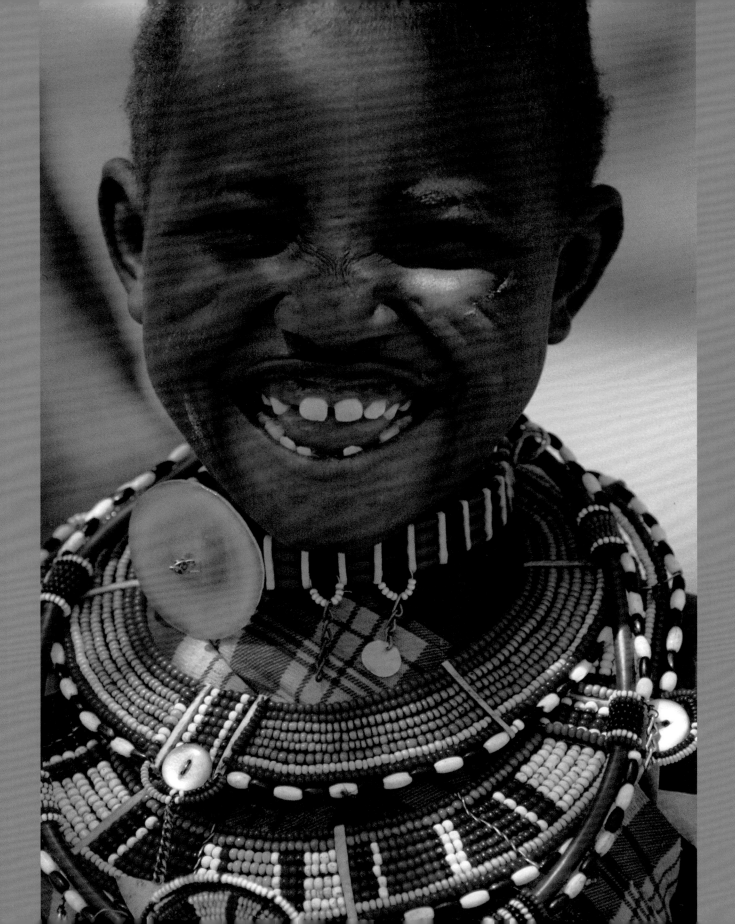

KILLER SMILE!
TANZANIA, 1995

I wonder if aliens smile? If they don't we could be in trouble when they get here. It's the currency of happiness, the fuse for laughter that every human on earth understands; it transcends every language and makes and saves our days. To survive you need a full pocket of smiles with plenty spare to give away to those who can't find theirs when they need them. And when it comes to photographing people there is no more important accessory in your kit. Genuine grins will get you everywhere and keeping fake ones looking real can save your skin. It's a lot harder to smack a smile in the teeth than it is to punch a scowl. When shit hits my fan I keep smiling; I'd keep smiling as I faced the firing squad just on the off chance! I also always pack 'farty balloons'.

You blow them up in Africa, India and South America, let them go and they rise farting into the sky, twisting and spinning in reds, greens and blues, farting into the trees, the seas, the skies. Why? Because I'm afraid that the sound of farting is another currency universally valued by the world's children. I distribute them freely and the furore that follows is the ice-breaker, an instant way to make kids happy and therefore sometimes far more amenable subjects

for pictures. Let's face it, giving is a good precursor to taking. I had one of the best hours of my life in the central square of Cusco in Peru giving flatulent inflatables to the urchins that spend their nights selling cigarettes to tourists there. It was pitch-black, I didn't take a single photograph – it was just great fun. If you can't feed the 5,000 then at least you can try to make them laugh.

He's hysterical because he's got all the beads in the village! There was a wedding on so everyone was beaded to the nines. I got him into the shade of a battered acacia but even so the background looks as hot as it was. My trusty reflector was in the bus but I needed it – a smidge of gold on those gums wouldn't have saved his teeth but it would have saved this portrait from compromise. I traded some of the beads for a music box mechanism that played 'Somewhere over the Rainbow' and I still have them. I've just sniffed them: even now they smell of wood smoke, of Africa, a scent ingrained in his home. The beads you buy from the peddlers through the bus window don't smell. They're fakes.

TOO MUCH CHEEKY COLOUR
GREENLAND, 2008

Megan, my 'not so little anymore, thank you' girl, had been talking to these 13-year-old twins in the new cultural centre in Qaanaaq, northern Greenland. I'd been watching them and wondering quite what teenagers from different parts of the world might natter about, but then I peeped into the smart new computer room with full internet access and was reminded that global distance no longer separates us. They spoke the same language, watched the same movies, listened to the same songs and probably, and sadly, fancied the same heart-throbs. All they needed were some cans of Coco Cola. It's one world alright, which actually isn't alright is it? There are no McDonalds here yet and whale burgers wouldn't fit Ronald's repackaged ethos I suppose; but when I asked them they pulled a 'duh' face and said they'd tried it when they had visited Winnipeg. We went outside, I took some scrapbook snaps for Megs and thought why not grab a portrait.

The 'twin thing' was irresistible of course and this meant squeezing them together, side by side on the horizontal, or in line on the vertical. I plumped for the latter, sat them on a wall and then immediately required my monopod or even better a tripod. The latter was in the UK, courtesy of airline weight restrictions and a teenager's wardrobe requirements, and the former was on the ship on account of me being an idiot. I wanted to compress their faces together to accentuate their shared identities so I needed my medium telephoto. But then I needed as much depth of focus as possible which necessitated a slower shutter speed, which in turn demanded a steady camera, hence the missing monopod. I hand-held at 1/30 and 1/15. You can see the beaded braid blowing about, which doesn't bother me, but if the further girl were as sharp as the other then the photo would have been improved. Luckily it was sunny which helped with the speed, but I'm not too keen on those cheeky highlights – in fact I don't like the overall high-key brightness.

It's all far too colourful, the blue sky, the headbands, the clothes... I processed it as a black and white image and it's much better – it simplifies the picture and makes the 'twin thing' instantly more accessible. With a tripod it might even have really worked!

TOTALLY POINTLESS PORTRAIT

KENYA, 2005

This is the worse photograph in the book. I despise it and myself for making it. I won't proffer a single excuse, escaping ridicule for such a collapse in integrity would be impossible; so I'll just murder it and slay myself, I'll do the decent thing and fall on my lens. Please don't hold it against my family for all eternity. Right, here goes...

This Maasai warrior is an undeniably handsome fellow. He has all the kit too, the regional equivalent of a Prada suit: fine robes in red, the mandatory beadwork, a stout assegai and a hairstyle to die for, delicately and precisely woven into a symmetrical web of plats. His mate was out of focus for a reason, he had all the same accoutrements of wealth but lacked the fine facial features of this beau. Look, it's one shot – the only opportunity – it's not a time for sympathetic compassion because it's about making the best picture you can. Don't have a heart, use your head, and politely and diplomatically orchestrate to maximise your available potential. If there is one thing I did right here it was the casting!

The composition is nearly okay. The foreground star is looking out in the right direction and is nicely posed across the frame, arm to arm – edge to edge, masking any background clutter; the spear isn't perpendicular which may have looked too rigid, the hills have been reduced to a mauve smudge and the other Maasai is filling the gap in the right-hand corner quite nicely. He is also blurred and therefore not competing for attention. All of this was by design, I was back and forward, gently pushing the gents this way and that, tweaking the beads, twisting the weapon, removing stay sprigs of grass in the fore ground – 'umming' and 'aahing' – they must have been bored senseless. Two things: the seam in the base of the spearhead isn't very nice and the guy at the back seems to be falling to the right for some inexplicable reason. But they are not the death of it.

It's the postcard, it could be there on the rack, on the travel book cover, it's a definitive version of just the sort of image I spend all my time trying to avoid, trying to de-imagine, ignore, ridicule. It's appallingly contrived, so tried-too-hard, so crass. I'm sorry, even more sorry to the two gracious chaps whose time I cruelly wasted.

SAVED BY BACON
KENYA, 2001

A total lack of self-control gave birth to this, one of the very few of my own photographs which I like...ish. We had an appointment to visit a Maasai boma somewhere outside the Mara and although I am normally very particular about punctuality, on this occasion I thought I'd take my time in true African style. I don't mind this attitude to time, it's their way, it's their country, I'm a guest and when in Rome... it would be rude to get uptight or frustrated by it and it's not their fault if we wish to rush around manically heart-attacking every objective. So, as we travelled towards the village I kept asking the driver to pull over. A lion here, an elephant there and then just when we should have been arriving, up pops a cheetah with three cubs – well, you've got to haven't you? Besides, which idiot organised to film a dance at sunset... Umm, me – I thought it might look nice.

So we arrived an hour late in the pitch black and I must confess to having been mildly amused to see Maasai tutting and tapping their battered watches in the flickering fire light! Not so happy about the fact that we had packed no lights – a problem I deftly but selfishly side-kicked to our cameraman. His solution was to line up the performers singe-ingly close to the blaze, one of the benefits of working in a continent not dogged by Health and Safety. No one was burned and the shots through the flames were great even if everyone did look a bit sweaty! When the frenetic show finished we all repaid our debt to the participants by spending lots of dollars on trinkets. I got a great fly whisk fashioned from a wildebeest tail from one of the elders and a knobkerrie with a car gear wheel at the nasty end.

In the interim I took this picture. I got one of the village kids to point my torch at this dancer and took a series of slow exposures on transparency film at shutter speeds of around an eighth through to a second, maybe two. I had an idea what it may look like, the beaded jewellery and red clothing had 'firework' potential and the yellow beam of my torchlight would warm it all up. I like the fact that her noble nasal profile is preserved but that her features are smudged away; it retains the human form in the abstract and reminds me of those damaged and disturbing portraits painted by Francis Bacon.

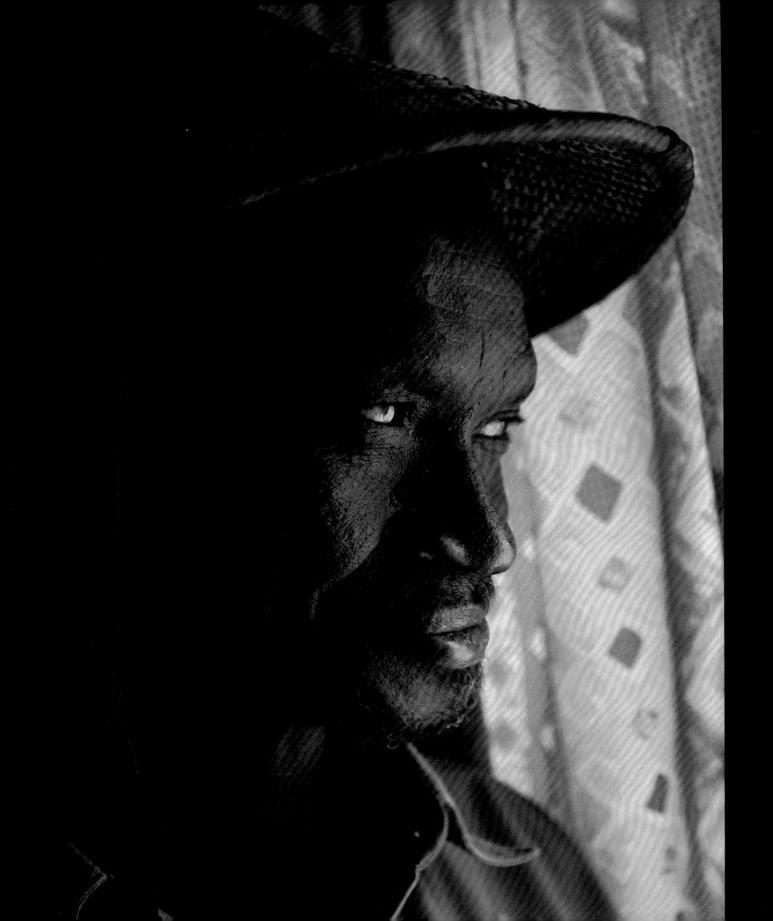

THE STONEMAN

GAMBIA, 2008

I'm a sucker for old stones and Stonehenge has no earthly rival in archaeological romance in my opinion. I've been lucky to have 'done' many of the 'National Geographic Collection' of the world's historic sites, minus Angkor Wat and Easter Island, but that damaged ring of rocks on the Wiltshire plain still sends a shiver down my spine. I just can't help standing there trying to build a time machine that spins me back through all the days and years that these mysterious megaliths have stood in that sacred ground.

On the River Gambia's northern bank are a whole series of 'stone sites'. These are so un-Stonehenge and yet unified through their primal simplicity and parts of their purpose. But the earth here is scorched brick-red, sunbirds squeak in the thorn trees, goats and children play amongst the circles, and there is no surly security. The most visited site is Wassu. When you arrive a xylophone band strikes up in the shade of a big, thick tree and this humble man greets you with a lovely smile. He invites you into his office to purchase a ticket to visit the stones and the museum in the thatched hut next door. A tour is included. His office and the museum, which is basic but very good, are immaculately clean and tidy, he is the perfect host.

He told me he had been here for 'many years' and chuckled. I asked if I could take photographs and if he would pose for me. He modestly agreed and self-consciously followed my directions. His office door was covered by the drawn curtain which is in the photograph and with the sun bleaching through it his complexion and colour were gorgeous, just golden. I took five images but it was obvious that I only really needed this one. I showed him the photo on the digital screen and he asked if I would send him one. When he wrote his name on a scrap of paper it said 'Stoneman'. I consider it an honour to have met him and to have been afforded his hospitality; he was one of the nicest men I have happened upon in this way. If I had the means I would offer to take him to that hill north of Salisbury to see my 'henge to repay his kindness. I wonder what he would make of the reception the visitors here get?

As for the photograph, I like it because I liked him and I don't think there's much wrong with that.

MAP OF HER AGES
GREENLAND, 2008

I'll get it over with; it looks better in black and white. The rich colours are all a bit putrid and it was taken under artificial light; but I've corrected it, the white is white, but 'yucky' is how I'd describe the hues. Anyway...

This Inuit woman was busy fiddling with a tray of seal oil/blubber, scraping it towards the lip which was aflame and heating a small suspended pot. There was hardly any light emanating from this source so the only hope was to use the overhead tungsten bulbs or resort to flash. There are no flashed photos in this book. Flash scares me, it is so difficult to use well, to employ without it showing and in most instances it murders every opportunity that begs for it with harsh, horrible, lightening-lit white light. I'd rather have nothing, go home empty-handed rather than hating an ugly picture. Of course with the right gear and a considerable degree of dedicated practice and discipline it can be made to work. But on a lightweight day-trip to this community with little time to experiment you would have to be confident to pull it off, after all there is no nipping back for another go.

So with a paucity of light to play with the sensible option would be to photograph the lady face-on, but I liked her face more when it was compressed into a narrow strip from forehead to chin, squeezing all the creases and contours into a crescent between her crown and chest. This angle exaggerates the patina of her age and also the facial features which characterise her race. The headband helps when it comes to framing as it effectively contains her face between forehead and the two dangling braids and its relatively clean design further aids this. Luckily her lips match the cherry-coloured beads, although I'm not too keen on the turquoise constellation nestling around her neck. The half-star of silvery hair adds interest at the top where otherwise it would be bland. I knelt down in front of her and rested the camera and lens on my knees, clamping myself as rigidly as I could. But then I made a deep-rooted mistake – this is the whole frame. I should have shot it much looser and cropped in, this would have offered me more depth of focus at the same shutter speed. I didn't because I'm still stuck in 'transparency mode', still composing with finality at the point of exposure. I'll get over it, I'll get digital in the end.

186

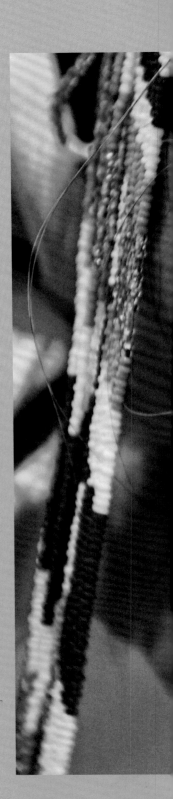

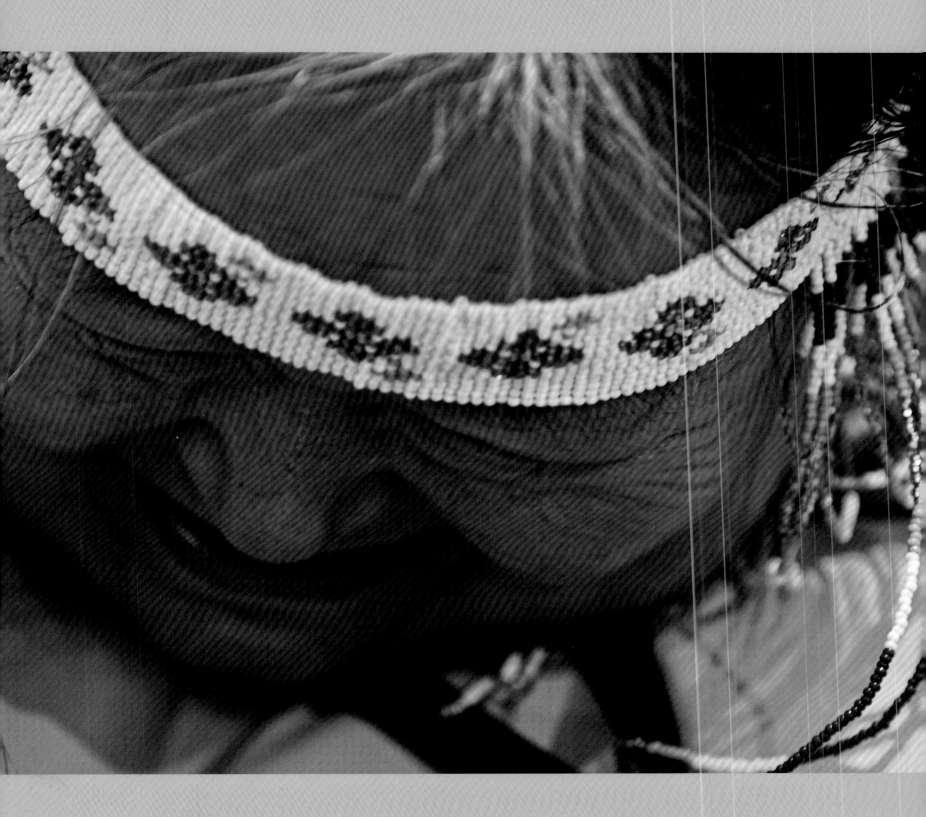

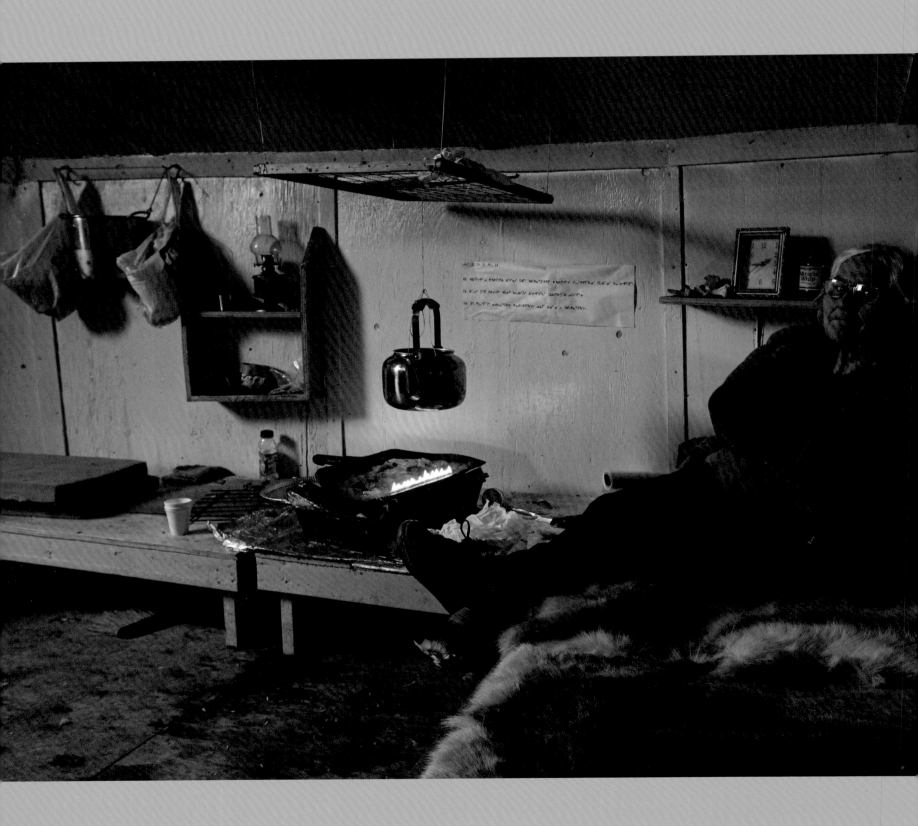

FADING PAST
GREENLAND, 2008

The Qaanaaq settlement is standard Inuit shack-attack: peeling paint and roofs, patched-up porches, the odd splash of colour, a flotsam of smashed snowmobiles and rusting rubbish, all slumped under a terrible tangle of telegraph cats-cradles. The last 'Sod House' squats alone on a coarse grassy hummock overlooking the shallow beach. It's an architectural outcast and, in truth, beneath its blue plastic tarpaulin it looks like its days of hanging on are numbered. No surprise, because 100 metres up the hill stands a brand-new visitor and cultural centre. It is totally incongruous and looks as if its dropped from space; it's also a place which is designed to celebrate a culture which is so impatient to embrace the 21st century that it's committing suicide. It's so well resourced that it's shocking and the building wouldn't be out of place in London, Washington or Tokyo. Elsewhere a library, computer room and café/kitchen neatly complete the bizarre anachronism. You can see the sad 'Sod House' from the rear window.

While in the centre we met a local celebrating his 88th birthday. He looked his age but also fit and cheerful, slow but sure in his movements and diamond eyed. I watched him and wondered at the remarkable ability humans have to adapt, not to survive in hostile climes, but as individuals. Here was a person born in a veritable 'stone-age', who had evolved from igloos to the internet in a single lifetime, and he was smiling away, amazing.

Spartan best fits the décor of the 'Sod House' (it reminded me of T.E. Lawrence's place at Clouds Hill in Dorset): hard benches with reindeer blankets, a basic tool kit, some dried Ptarmigan pinned to the wall and the tray of seal blubber with its flickering cooking flame. But sat in here for a half an hour I learned more about the rapidly fading past of northern Greenland than the new centre will ever offer. It was cramped so I had to go for the wide-angle and I obviously used the natural light making lots of slow exposures to get one when my subject was still. I'm not sure I like the sparkling glasses.

WINSTON 'ZACK' NISBET
ST KITTS, 2008

This charming man didn't seem to have a stitch to wear. Winston Nisbet put the 'T' in tatty t-shirts and the bare in threadbare shorts. That's why he is peeping round the door, he's not naked, it's just that he didn't want his portrait to show his 'old clothes' and his 'photo shirt' was hung up to dry. He had previously 'caught me' photographing bits of the exterior of his remarkable museum on Central Street and then insisted that I follow him in for a tour. I was reluctant, not because of his state of undress, but because it was magic hour and the pretty streets of Basseterre were glowing with honeyed hues. I demurred and didn't regret it as the interior is an Aladdin's cave of dusty treasures which are stacked and packed in precarious piles, jammed into cupboards and drawers or hung, strung or bunged into every available volume in these few rooms. I could begin to list the sorts of objects that contribute to the cascades of clutter but it would be pointless – everything is here!

This is the island's entire history in a ramshackle shack, it is a repository of all the things that individually would mean little but together amount to an invaluable resource. And while it's a chaos to me, it's not to Winston, who whirled around whipping specimens from secret cubby holes and enthusiastically extolling their virtues and historical importance. As much as I tried, it was difficult to stay with him as my eyes tried to absorb this topsey Tardis of turvey trinkets. The walls and ceilings are papered in photographs torn from magazines and then covered in crooked and cracked frames full of fading faces from the past. If you ever get the chance to squeeze into this wonderful space and meet the curator you must – it's completely unique. It should be declared a world heritage sub-site and he needs some real support to keep it together.

Accepting and working with his 'no torso' mandate I got him to peep around the doors. As much as I wanted to reveal the interior riches I'm afraid Winston's face tended to get lost in the shambles. Full body might have worked, but hey, I was his guest! So I asked him if he would step outside and look back in and I cropped tighter. I like his expression: it's true, and the daylight shearing through the shutters adds a graphic smack to the scene. And I couldn't agree more with the sentiments of his sign! Ha, ha, ha.

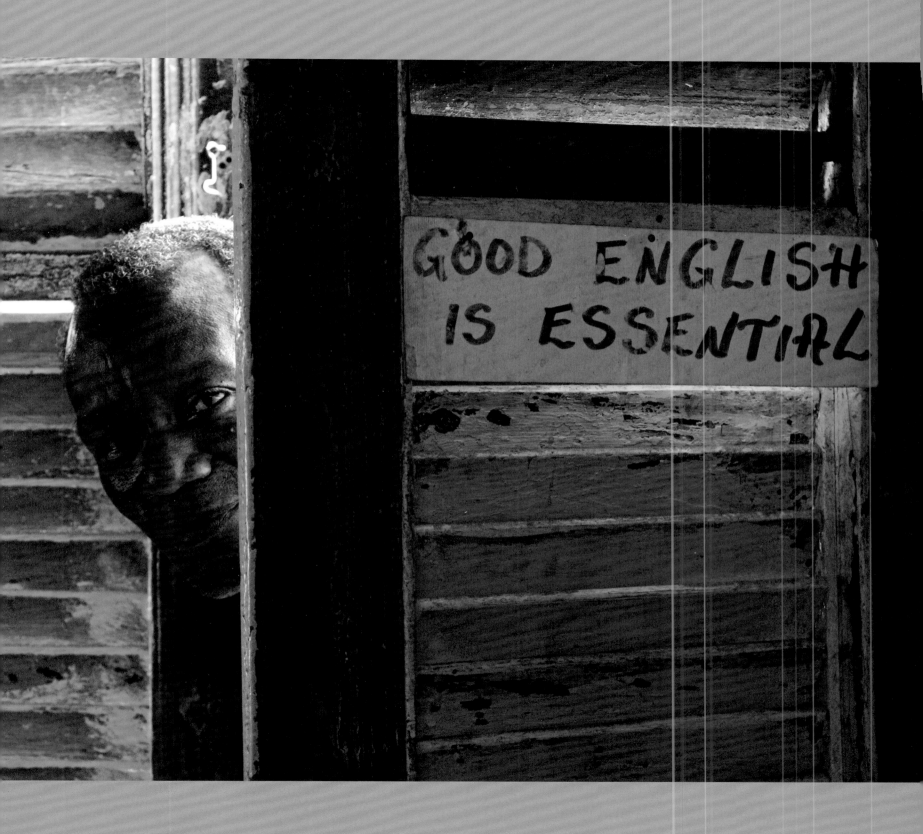

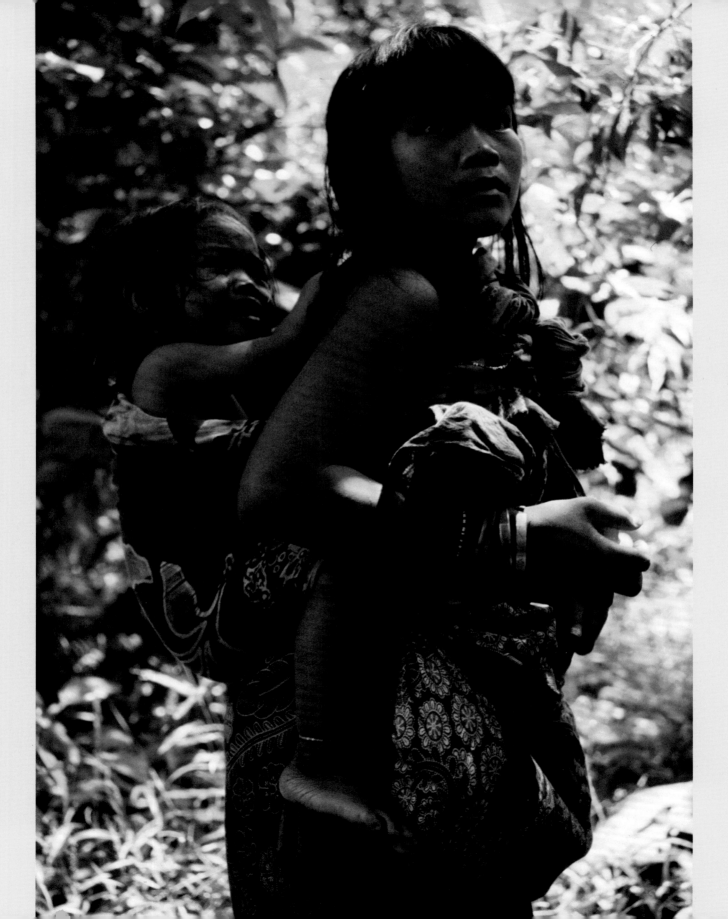

HUMAN RARITY

SUMATRA, 1998

I grew up learning to appreciate all life but our own. When I was marvelling at ladybirds tickling my fingers it was a simple choice, the little red beetles were beautiful and perfect, the warty, scruffy gang of wretches lined up at the bus stop were neither. That's the superficial view of a child, but as I matured things got worse, and it's accurate to say that aside from the equally shallow attraction I developed for Audrey Hepburn, I really didn't like people at all. Imperfect, flawed, destructive, an ugly species in all senses, I found so little to like about homo sapiens that I never allowed it to deflect my fascination, respect and admiration for the rest of the planet's fauna. Until I was 38 when I enjoyed an epiphany. It was seeded by the Nepalese songstress, enhanced by the Mexican candy floss salesman and sealed by this woman and her kin. Because she, and they, were perfect.

We had an outside chance of an audience with a tribe of hunter gatherers in an isolated fragment of rainforest in north western Sumatra, and knowing how increasingly difficult such opportunities are to come by, I gambled three days of the BBC's time and money and went for it. After an eight-hour drive through devastated forests we were to meet a man wearing a pink t-shirt on the road side. He would bring the tribe out to us for a brief encounter. No maps, no mobiles, no guarantees – little hope, but a once in a lifetime chance. We arrived, the pinkie vanished into the forest without a word, we waited in a hot glade where insects tried to deafen us and after two hours they appeared. The males came out first, replete with loin cloths and spears, dragging a half consumed bush pig. They were cautious and only when they felt secure did the females and young appear. We spent 40 minutes with them. They were different: they didn't covet our cameras or clothes; they didn't care about our trappings of 'progress'; they didn't gaze in awe or stare in envy; they were supremely confident and moved with effortless grace through the environment in which they lived. They were faultless and at last I had found humans I liked. I looked at them and felt pathetic – de-humanised, inept, a fake, an organism out of touch with its life. And despite their dwindling number and precarious existence they made me realise quite succinctly that it is we, not only them, who are destined for extinction.

IF YOU DON'T ASK YOU'LL ONLY REGRET IT

CANADA, 2008

The cultural display began in the sports hall at 11 and it was just what I expected. On a warm, sunny morning in an extraordinary location, the bulk of our visiting party crammed into a dreary strip-lit shed where a distorted, reverberating and largely incomprehensible commentary boomed around the vacuum for an interminable hour. The contributors may have been good and the content was probably interesting, but the setting was awful. I tried using a wide angle on the ground to put the fur-clad cast in incongruous context with the building and the ranks of tourists but as they were up against the back wall I couldn't get behind them. Thus I determined to snare one of them at the end and ask them to pose somewhere just a bit more interesting. Outside was brilliantly sunlit, 'F Squinty' as I call it, and I searched for a location where I could pose my subject to make the most of the contrast between his or her attire and the modernity which is ravaging these communities. A sign for an internet café, a brand new snow mobile, a satellite dish... but nothing was forthcoming. So I thought, damn it, go down-market, forget 'Nat Geo' – think 'cheese', and here is my slice of Roquefort.

As soon as the 'show' finished I joined the throng taking happy snaps of the children for a while and then produced my secret weapon – photographic candy, the Polaroid. Instant pictures make instant smiles which make willing models. Tried, tested and successful globally. With his three-minute photo tucked into his jerkin I led the mini Nanook out to my predetermined perch on an iceberg that was wedged on the beach and began snapping him against the backdrop of the bay. The sun was annoying, but after a series of sitting, standing and leaning poses I found some shade and got this. I've taken the colour temperature down and added some 'fill light' and I suppose that the little fellow is undeniably cute and for some that appeals. Given more time, and there wasn't any, I would have tried something more interesting amongst the bergs which were a feast of potential lighting effects. Given even more time I would have got his mum to replace that nasty piece of string that is attached to his Caribou antler sun shades with a nice strip of seal skin!

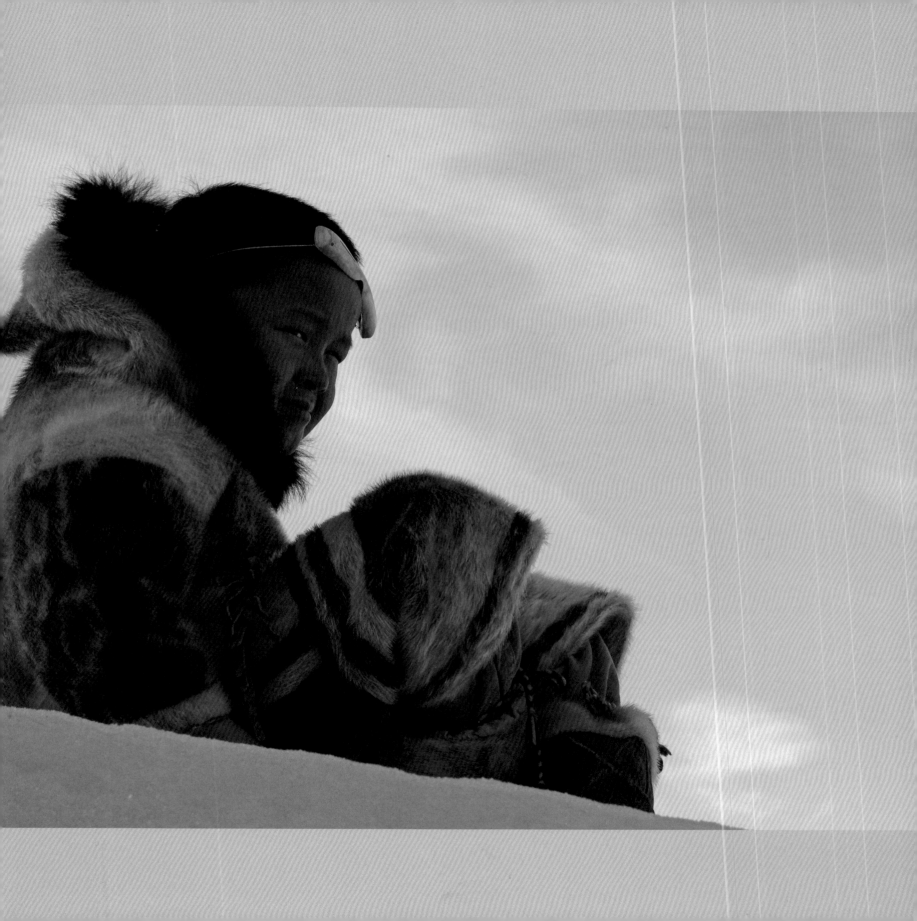

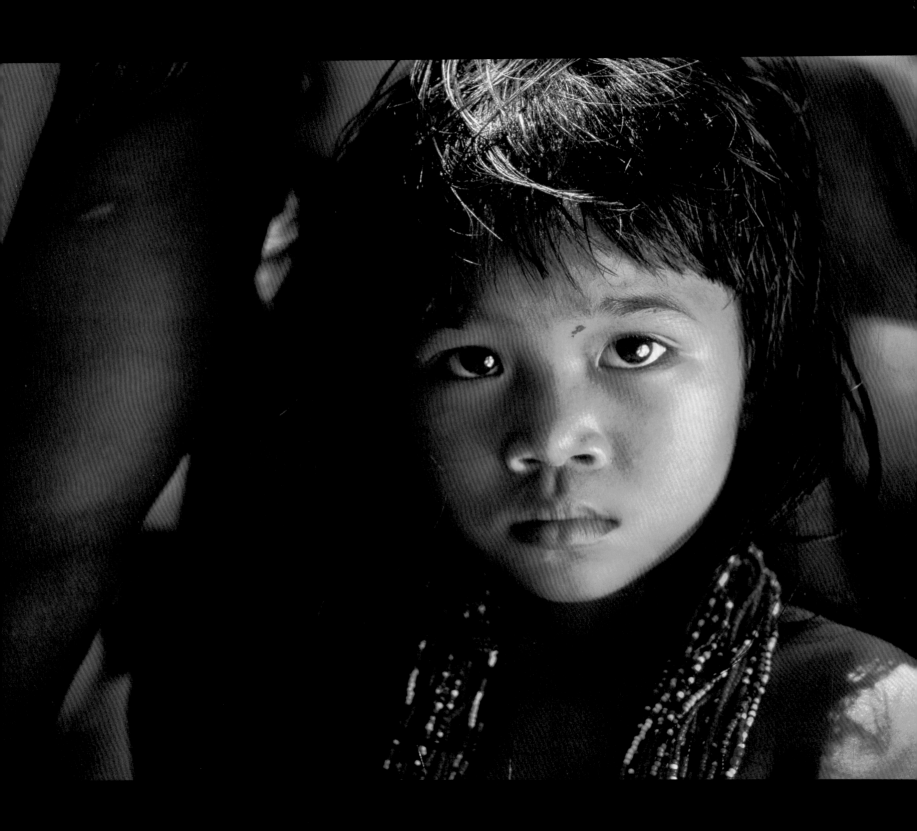

ANOTHER HUMAN SPECIES

SUMATRA, 1998

This child was one of the 35 members of an Orang Kubu tribe that we were fortunate to meet a little over fifteen years ago in a remote part of Indonesia. We spoke to them through two sets of interpreters, asking them how they lived in the forest, what they ate, where they sheltered and whether they thought there was any credence in tales of another ancient hominid relic called Orang Pendek, a mythical creature said to inhabit the region. They told of the legend but these were a people who had little time for frippery and a surfeit of superstition in their difficult and dangerous lives. The local villagers, police and military think of them as animals and if they are harmed or killed, which often happens when they visit settlements to trade goods such as tobacco, nothing is done – no investigation, no prosecution, no justice prevails because 'how can you punish a man for killing a dog?'. As a consequence they were immensely cautious about bringing their women and children out to meet us and our audience was short but incredibly special. I took a few portraits but it was difficult, I was directing and presenting and it was only down to my complete trust of the finest of camera and sound men that I got any stills at all.

This girl was sat in the lap of her father and elder brother and it's probably the best shot. The lack of brilliant emerald green foliage peeping through any gaps in their limbs helps to reduce distractions and the uniform rich brown of their skins again ensures that all the attention is focused on her face. The coloured beads aren't too bad either but what makes the portrait is the look of absolute vulnerability which radiates from her huge round eyes. This has been admittedly enhanced by the big circular 'catchlights' produced by my reflector, but her soul is bared, she is a child born out of time, literally.

Since our visit I have heard from our contact in Indonesia that the tribe was ambushed in a village and a number of the members shot and killed, including two teenage girls I also photographed and the man who contributed most to our interview. Whether this girl survived and what has become of the others is a mystery. Vast tracts of the adjacent forest have recently been felled to plant palm oil for bio-fuel. Maybe it's in the tank of my car. This world is no longer big enough for some of us and it's too little for others.

THE REAL THING
GAMBIA, 2008

For me this is it. The one-thirtieth of a second when I have come closest to making the moment perfect. Of course I would change things, that's the eternal agony of making photographs, we always know how it could have been better, we cannot ever be satisfied. You might say 'a tripod might have helped, a little more of her face in focus would be nice', but no, I was ducking and diving to peer through a whole crowd of children jostling to drink, I'd never have got anything with a tripod. You could also say 'it's a bit tight, it would be nice to see more of the context', well only if you wanted to be distracted by her bright blue school uniform, and besides I wanted that firework of wet light to dominate everything. It's what it's about – water, thirst, need.

We were in a school playground in a small and remote village in the north of Gambia when the lunchtime bell sounded and the entire horde descended on the pump. The larger kids began to crank it enthusiastically while the others waited by the pipe. When the flow started they stretched their hands, passed old plastic bottles and used lids and cups to collect each precious sip of water. The drinking binge lasted for about ten frenetic minutes until all the smaller ones had slaked their thirsts and then the older girls, who had continued to draw the water throughout, took their turn. I used a telephoto zoom to 'get into' the tap and quickly tried a range of exposures balancing a compromise between the shade and skin tones, and hand-holding the lens on 400mm. I could instantly perceive the potential and began to try to realise it. Much of the time I couldn't see the water through the crowd, or the drinker was 'not right'. I ended up with the choice of two, in this one there are no distractions and the water looks better.

It's beautiful – the water, backlit and brilliant, radiates fresh and clean, it sparkles and shines, it's exploding with the gift of life. And her fingers! Slippery and silvered, they are not cupping but pressing this vital requirement into her lips. I like the abstract anonymity of her face because she can therefore become 'the thirsty child' for a continent with so very many of them. So that's it: it's simple, exciting, composed, it wasn't an accident and it's important. It's a result, my best, the best I can do. Almost.

198

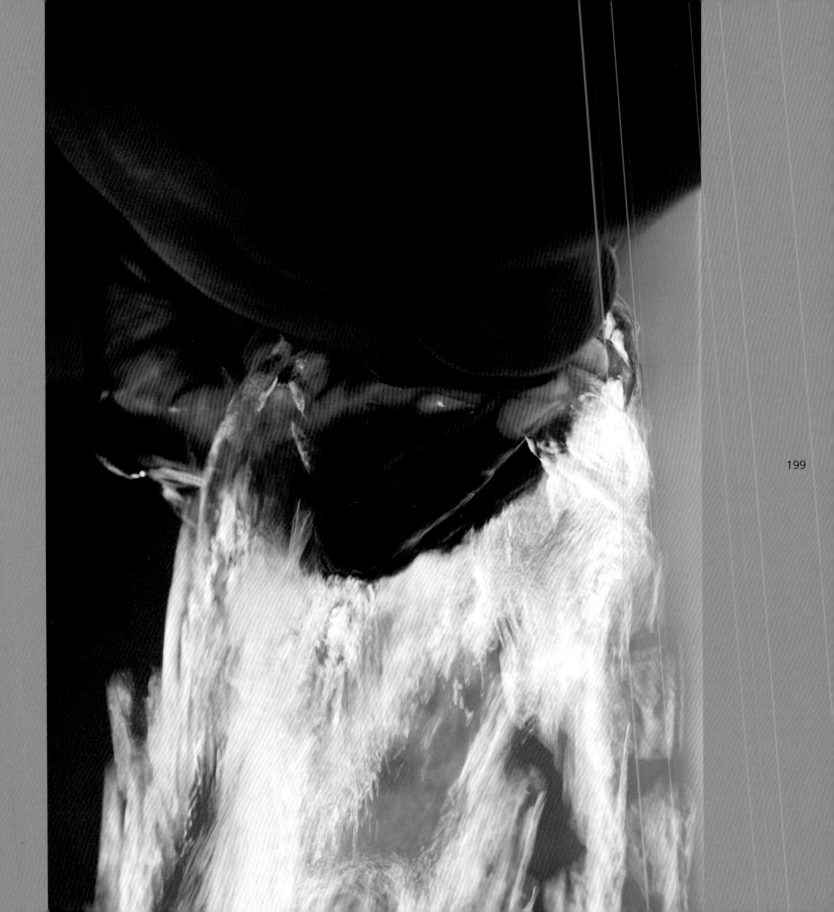

TALE END
BOTSWANA, 2010

Bizarre isn't it, hard to believe that on such a huge creature this odd spatulate, bristle-fringed paddle would be an effective tail. Of course tails are an important organ used for displaying, balance, whisking flies, propulsion, insulation, attacking aggressors, distracting predators, in prehensile form even gripping and in some species... helping to spread urine and faeces which act as scent markers. Nature has made use of the tail. In this species it grows over a metre in length and weighs about ten kilograms. Youngsters will sometimes hang onto their mother's or aunt's tails as they move through the bush but their principal purpose is to swish about to repel flies from the places that the trunk simply cannot reach. Sadly poachers make use of elephant tails by removing the hairs and weaving them into bracelets – please don't buy them, you'll just be fuelling their murderous trade.

I took this photograph using a gold Lastolite reflector to light the tail with the first strong rays of the morning sun, it wasn't easy, its owner kept moving it and ultimately I couldn't get the shot against the plain background I desired. I had no choice but throw what was there out of focus. As usual I'd like to try again. I suppose I could... go all the way back to Africa, set up and spend another morning messing about trying to get a better picture of an elephant's tail. But life is finite so I employ a method which I call the 'stop shot'. It's that image which I know is not perfect but which is reasonably the best I can do given all the opposing forces – principally time and money, but also time and other opportunities. Without this embargo I'd end up spending my life on an extended project devoted to the perverse pursuit of obtaining the perfect photograph of the arse end of elephants. But it's so difficult to walk away, so painful to look back at pictures which I know beyond doubt I could have done better if I had just one more go. And sometimes, years afterwards I capitulate and 'have another go'. But the results are almost inevitably very disappointing – failures, useless. The reason for this is obvious I suppose, photography is about the moment, it's not about technique, the components, the light, the subject, your mood, it's about a unique complex of all of these and more, and that's why it's important you get it right then, now, forever. No pressure and the very best of luck!

DEDICATION

Search and find one wholly beautiful moment and make it yours forever.

EQUIPMENT

I shoot using Nikon cameras, currently with a D3X, robust, reliable and giving large files from its generous sensor, a D800, which although not as rugged gives me delicious 70mb captures and when there is little light I switch to my D3S for an amazing breadth of ISO and the fastest frame rates of all. In front of these I mount a 500mm F4, 200mm F2, 100 and 200mm Macros, 14mm F2.8 and 17-35mm F2.8 and 70-200mm F2.8 Nikkor lenses. But in truth I rarely carry all this, too heavy, so my main tools are the 500 and 200mm, I prefer primes to zooms. I have various flashguns and other gadgets, the angle finder I use quite a bit with the camera on the ground. I'm a keen tri and monopod user and have a range of excellent Manfrotto devices. I only shoot RAW files and all, every single one, goes through Adobe Lightroom but I only very rarely use Photoshop. Here I 'mess' with levels, colour corrections, blacks and add moderate sharpening. I've been using this equipment and software for about ten years and I have no plans to change; it's good, has never let me down and allows me to concentrate on the real job of finding and making pictures.

ACKNOWLEDGEMENTS

I'd like to thank David Foster and Gerry Granshaw for persevering in the quest for publication, Jenny Price at Nikon UK for the loan of a slide scanner, my editor Joel Simons at Blink, and Ros Kidmund-Cox for being positive but pragmatic about the pictures and prose and Nikon (UK) Ltd for service support and loans.